BUDDHA

BUDDHA

THE LIVING WAY

PHOTOGRAPHS BY DEFOREST W. TRIMINGHAM

Essay by Pico Iyer

Foreword by His Holiness, the Dalai Lama

RANDOM HOUSE · NEW YORK

Photographs copyright © 1998 by deForest W. Trimingham

Essay copyright © 1998 by Pico Iyer

All rights reserved under International and Pan-American Copyright Conventions.
Published in the United States by Random House, Inc., New York, and simultaneously
in Canada by Random House of Canada Limited, Toronto.

LIBRARY OF CONGRESS CATALOGING-IN-PUBLICATION DATA

Buddha, the living way/photographs by deForest W. Trimingham; essay by

 Pico Iyer; foreword by his Holiness, the Dalai Lama.

 p. cm.

 ISBN 0-679-45784-4 (alk. paper)

 1. Buddhism. 2. Buddhism—Pictorial works. I. Trimingham,

deForest. II. Iyer, Pico. III. Bstan-'dzin-rgya-mtsho, Dalai Lama

XIV, 1935–

BQ4022.B83 1998

294.3—dc21

 98-17635

Random House website address: www.randomhouse.com

Printed in the United States of America on acid-free paper

9 8 7 6 5 4 3 2

First Edition

TO MY WIFE, DOROTHY TRIMINGHAM

CONTENTS

FOREWORD HIS HOLINESS, THE DALAI LAMA

MORE THAN 2,500 YEARS HAVE PASSED SINCE BUDDHA SHAKYAMUNI, the historical Buddha, taught in India. He offered advice to whoever wished to listen, never insisting that other people follow his teaching by threatening or using forceful tactics. Many people throughout the world still follow and appreciate the path he revealed. By contrast, history records many tyrannical leaders who have tried to impose their doctrines or ideologies at different times by force but whose influence has barely survived a hundred years. Therefore, it is clear that real change, whether of the individual or of society as a whole, is achieved only through voluntary acceptance and that people accept something voluntarily only if it is based on truth and reality.

To begin with, the Buddha was an ordinary person like us, experiencing suffering and caught under the sway of disturbing emotions. But through steady personal practice, he became enlightened. And just as the Buddha achieved such a state through systematic practice, we have the potential to become like him if we choose. For Buddhists the most important thing is to relate the Buddha's teachings to our daily lives. We need to examine whether they are really useful or not, whether they make sense or not. We have to relate them to our own experience. If we feel that they are useful, we put them into practice. The point is that it is only through developing our inner qualities and refining our inner mental states that we will find inner peace.

People pay respect to Buddha Shakyamuni because he possessed a benevolent mind that contributed to the peace and happiness of others. He presented a path that leads to the achievement of inner peace and ultimately to the complete enlightenment of a buddha. Yet his advice about ethical behavior, calming the mind, and developing a correct view of reality can contribute to inner peace whether we consider ourselves Buddhists or not.

The Buddha's main focus is on the marvelous practice of compassion, caring less for ourselves and more for the welfare of other sentient beings. He also explained phenomena's lack of intrinsic existence and the nature of emptiness. His teachings have something to give us all, even in lands far from the Buddha's own experience and in times very different from his own. His fundamental message of compassion, discernment, and universal responsibility is as relevant today as it was 2,500 years ago.

These pictures show the stillness and calm at the heart of Buddhist practice, even as they show people applying these principles in daily life. One of the central themes of Buddhism is the value of meditation, of peacefulness and concentration. This is something anyone from any background can learn from. And the fact that so many young people are still joining monasteries and nunneries of all Buddhist traditions suggests that something essential in the human heart will continue to respond to these truths in the future.

McLeod Ganj, India
March 1998

BUDDHA IN THE ROUND PICO IYER

A LITTLE MORE THAN A DECADE AGO, CAPTIVATED BY IMAGES AS vital and haunting as the ones included here, I decided to take myself off to the ancient Japanese capital of Kyoto, to live for a year in a Zen temple. I wasn't a practicing Buddhist, and I knew next to nothing about what Buddhism meant, but I'd been calmed and quietly transported by the poems I'd read of the eighteenth-century solitary Issa, the sutras fluttering in the background of Kurosawa movies, and, especially, the clarifying elegance of all things associated with the Zen aesthetic: the empty room, the raked-sand garden, the lightning slash of bold calligraphy.

I took a bus to Los Angeles, therefore, and then a plane to Seoul, another plane to Tokyo, another bus across town, another plane, a bus, and then a taxi, and I found myself standing outside a small temple in the back streets of Kyoto in the falling dusk. A young, shaven-headed monk pulled open a heavy door and told me that I was welcome to stay, for 3,000 yen ($25) a night, with breakfast overlooking the rock garden included. Around us on the little lane were carp-pond tea-houses, four-story pagodas, temples from the time of Shakespeare.

I made myself comfortable in my small, bare room, and from where I sat could see a peacock spire, soothsayers' homes, the maples turning red and gold against the eastern hills, and all the exquisite exactingness of the only wood-and-shoji area left in bustling Japan. Next morning, at first light, I awoke to the sound of clappers from

next door and murmured chants, incense seeping into my room as a solemn gong resounded.

The main appointments of the temple, though, were vehicles, great and small—in other words, bicycles, mopeds, motor scooters, and full-blown Kawasakis, forty or more of them stashed in every corner of the quiet compound. My first morning, as I looked out upon the garden, the young monk suddenly approached, peddling furiously a baby blue tricycle, Donald Duck on its mudguard, his pale face spherical beneath his bobble cap, and recited to me the names of all the American cities he'd visited; later, his elder came up to me and silently passed over a sheaf of snapshots from his holiday in Europe. At night, when I went out in search of high enlightenment, I found the two of them sitting at a low table, cheering on the Hanshin Tigers on TV, and calling out, "Catch you later!" with a warmth no doubt encouraged by the empty beer bottles all around.

The monks with whom I'd found myself were kind, hospitable, and self-effacing to a fault; my only real complaint against them was that they were human, flesh and blood, not at all like the bodiless spirits I'd imagined. And much as the wooden stick, or *kyosaku,* shocks Zen students out of sleep, their Goofy mugs and Honda Hurricanes nicely slapped me out of my romantic reveries.

A little later, when I spent a few nights in one of the Five Great Temples of Kyoto, I was to learn, even more forcibly, that Zen has pre-

cious little to do with contemplating nature and composing depthless haiku, and everything to do with sweeping leaves and cooking noodles, polishing the temple's hard floors on one's knees and chopping wood at dawn in a boot-camp hierarchy perilously close to that of the English boarding schools in which I'd put in far too many years.

So, inevitably, I turned tail and fled into the hubbub of a modern Japanese metropolis—and instantly found Buddhism all around: in the simple attentiveness of a shopgirl in the Takashimaya department store, bowing to her customers as (traditionally) to the Buddha nature within them; in the mother in McDonald's, teaching her small son to pour his sister's Coke for her; in the salaryman maintaining a pose of stoic calm as he's told of his father's death while the cherry blossoms and fireflies and posters of James Dean all around speak of life's impermanence.

It was a good lesson, and one I could never have learned had I stayed at home in California, musing on Kawabata novels and the snowfalls of Hiroshige (though, in fact, I could have learned it if only I had got in my car and driven down to the Zen center in the dark mountains behind Los Angeles, where later I would watch thirty Western students, all in black, walk barefoot through a freezing night of stars, endure seven days and winter nights of meditation without sleep, and gather each morning at 2:00 A.M., in an unheated hall, to chant the Heart Sutra before listening to an eighty-nine-year-old Zen master from Japan tell them how he'd come to America to teach people to laugh).

Yet it is a lesson that every step one takes in modern Asia reinforces, as one sees that the silent common thread linking half the world's people together is not an exotic thing, on a pedestal, and swathed in incense (though it can be that, too, now and then), but rather a homespun reality as everywhere as air, a fact of life enacted in the Bolim Buddhist Department Store along the busy streets of downtown Seoul, in the eyes on the sides of Nepalese stupas following Californian backpackers into lasagna joints, in the crush and confusion of crazy Bangkok, where, in the midst of belching trucks, glitzy shopping malls, and winking girlie bars, suddenly you will see a flash of gold—a monk in his saffron robe, waiting for a bus.

I remember my first day in Rangoon, many years ago, going to the Sule Pagoda at the heart of town and finding, to my surprise, that the towering golden stupa really was the heart of town, a combination marketplace, bulletin board, schoolroom, and civic center where gossips clucked and boys eyed girls and toddlers chanted and half the population came to pass the night, barefoot on its marble floor.

That evening returned to me as soon as I looked at deForest Trimingham's vibrant and pulsing images of Buddhism around the world, in part because they are so inescapably human, even with their lyricism, and in part because so many of them spin like a mandala with all the whirling energies of Buddhist devotion, its reds and golds, its glowing statues, its ornately carved doorways that seem to open onto a world of candles and sutras and scroll paintings teeming with forces both wrathful and benign. When first I set foot in Tibet, twelve years ago, it felt as if I were stepping into a whole universe that shook and spun with the pulse of Buddhism. Buddhas were painted on rock faces and cliff tops, and stones were piled up to form homemade shrines, while prayer flags carried thoughts unceasingly into the blue, blue heavens. In the great temples and monasteries of Lhasa, even after twenty-six years of brutal Chinese occupation, I could hardly move for the wizened old women and young exiles from Delhi and wild bandits in red-tasseled hats crowding in to spin prayer wheels, and perform ritual three-part prostrations, and gather, with tears in their eyes, before photos of the exiled Dalai Lama on the altars of small chambers

lit only by flickering butter lamps. Buddhism for them clearly had little to do with texts; it was as immediate as this hospital, that court of law, this breath.

Anyone who travels through Asia today, in fact, travels through a web of Buddhist images, rites, and, most important, values, and to a remarkable degree it is those moments that lodge inside the heart. For myself, I can remember taking an extended holiday from a little cubicle in New York's Rockefeller Center and riding on the back of a farmer's motorbike to see the delicate stone Buddhas sedate in the thirteenth-century Thai capital of Sukhothai; or climbing for three hours, alone on a winter's day, to visit the Taktsang temple, or Tiger's Nest, which clung impossibly to the side of a cliff in rural Bhutan. I remember visiting the twenty-nine caves of Ajanta, in central India, where Buddhas lie in shelters along a wild and crescent-shaped ravine, and seeing the gray Austin, in the lovely Vietnamese imperial city of Hue, preserved to recall the monk who had driven to Saigon to immolate himself in 1963. Most of all, in the 3,000-temple plains of Pagan, in Rangoon, in Bangkok, and everywhere, I remember the long, silent lines of monks and nuns, begging bowls extended, walking from hut to hut in the dawn.

Nowadays, as we see, often every day, those same unchanging images greet us in Samye Ling in Scotland (where Western monks undertake ten-year training courses), and on Canal Street in New York, through that Thai monk in Wimbledon, or this red-robed nun from Düsseldorf. Suddenly, many of us can go around the world to Buddhist lands long inaccessible to us (Mustang, Sikkim, Tuva), and suddenly, too, they can come to us—to that Tibetan restaurant on the rue Saint-Jacques, or thanks to the monks transcribing ancient texts onto computers in medieval Thimphu. When my parents were young, fewer than 2,000 Westerners had set foot in Tibet in all its history, and

the Dalai Lama was a figure almost out of legend; today, the Fourteenth Dalai Lama, Tenzin Gyatso, seems a part of the neighborhood almost, laughing with rabbis in New York and conferring with Green Party activists in Berlin, playing with reindeer, tapping into the Internet, and addressing crowds of 20,000 in concert halls usually reserved for pop stars. When, last year, I asked the Dalai Lama about the fate of Buddhism, he told me, with typical serenity and optimism, that the teachings' life span was predicted to extend for at least a couple of millennia more.

Buddhism has been known in the West, of course, ever since Marco Polo first brought back reports of the Buddha's life, and Henry David Thoreau produced the first English translation (via the French) of parts of the classic Lotus Sutra. It's been as intrinsic to the culture as Chinese temples in San Francisco and Sanskrit scholars in the British Museum. Yet recently, its presence has dramatically intensified, as the latest Cambodian and Vietnamese immigrants have built temples in Orange County and Louisiana, while more and more Westerners travel East to study philosophies long unavailable to them. Buddhism, which took on new forms and accents as it passed to Laos, and Mongolia, and Sri Lanka, is now developing its latest face, in what could be called Western Buddhism, a practice with its own festivals and pilgrimage sites in Vermont and rural France.

The Buddha looks out at us today from the paintings of Odilon Redon, and speaks to us in the pages of Jack Kerouac; he sits next to that bottle of perfume in a fashion ad shot by Irving Penn, and presides over a spirit house in that trendy new restaurant in Hollywood. He walks in the shoes of Keanu Reeves (whom once I saw stepping through the streets of fourteenth-century Nepal, acting as the Buddha in the movie *Little Buddha*), and he appears on new birth certificates every day (even I, though Hindu born, was given, as many Indians are,

the first name of the Buddha, Siddharth). The single greatest development of the twentieth century, the historian Arnold Toynbee once wrote, might prove to be the spread of Buddhism around the world.

Perhaps the greatest testimony to the versatility and practicality of Buddhism, in fact, is that it has long been central to cultures by no means predominantly Buddhist. Often, at dawn, I've driven out to see the volcanic stone Buddhas of the great ninth-century mandala mountain of Borobudur, in Java, emerging from the jungle in the world's largest Islamic nation; one snowy night in the foothills of the Himalayas, I watched maroon-robed monks with yellow-crested hats blow long horns from the rooftop of a temple to mark the Tibetan New Year in India, home to 800 million Hindus. Some of the greatest Buddhist monuments surviving are the colossal 150-foot figures of Bamian, in Afghanistan, home now of an Islamic revolution, and the paintings and statues of Dunhuang, in what is technically Communist China. Even relatively secular Hong Kong boasts a temple with 12,800 Buddhas and, on Lan Tau Island, the tallest outdoor seated Buddha in the world, 70 feet high.

As Christmas Humphreys (whose name alone brings home the same point, a British judge named after Christ's day of birth, serving as one of our foremost explicators of Buddhism) once wrote of Buddhism, with typical matter-of-factness, "To describe it is as difficult as describing London."

THE MAN WE COMMONLY SPEAK OF AS "the Buddha"—Siddhartha Gautama—was born, by most accounts, around 566 B.C., into one of the leading families of one of the small tribal republics that prospered just south of the Himalayas, in what is now southern Nepal. It is a flat, subtropical plain of tigers and wild rhinos (the site, these days, of the famous Tiger Tops Lodge), yet Siddhartha was raised in idle pleasure in a walled garden of pavilions. A soothsayer named Asita had told his father that the boy would grow up to become either a conqueror of the world or its redeemer, and, preferring the familiarity of the former, the feudal ruler had resolved to keep his son shielded from all signs of suffering.

One day, however, the heir to the enchanted garden broke out of his protected world and chanced to see an old man, trembling as he leaned upon a stick. Later he saw a body in the throes of sickness; and later still, a dead man (and, in counterpoint, a wandering monk with simple robes and begging bowl). And so, one night when he was twenty-nine, cutting off his long hair and abandoning his silken robes, sorrowfully leaving a young wife and son behind him, Siddhartha stole out of his false paradise and went into the forest in search of truth.

For the next six years, he studied under celebrated Hindu yogic teachers and committed himself to the most strenuous austerities, sleeping in graveyards and resting on beds of thorns, eating just one grain of rice sometimes and holding his breath till he almost expired. Having explored these paths intensively, he concluded that asceticism could be as much a trap or delusion as luxury—the starving man's eyes could be as fixed on the dinner table as the gourmand's. The Middle Way, he decided, between extremes of indulgence and privation, was the one least ensnared in craving.

So, coming one day to the town of Gaya, at the age of thirty-five, the ways of teachers and asceticism exhausted, Siddhartha sat down under a peepul tree (known later as the Bodhi, or Wisdom, Tree) and resolved not to move from there until he had found enlightenment. He sat and sat, through six days and nights, until, one full-moon night in May, he passed through an understanding of all the processes and principles of life, and, by the time the morning star arose, had found a truth and reality beyond the cycles of birth and death, or time and

space. He had become a buddha (the Sanskrit term for "Awakened One").

By all accounts, Gautama was not much inclined to try to pass on his wisdom, not least because, having learned everything he knew by experience, and alone, he knew better than anyone that all a true liberator can do is encourage the self-liberation of others. His greatest achievement had been attained while sitting alone under a tree, simply meditating, and far from all the priestly intercessions and ritual, the philosophizing and superstition that afflicted the Hinduism of the day. If the Buddha's teaching has a cornerstone, it is, in fact, "Do not go by hearsay, nor by what is handed down by others, nor by what is stated on the authority of your traditional teachings" (one reason, of course, his philosophy has so attracted such models of youthful questing as Hermann Hesse's Siddhartha and Somerset Maugham's Larry Darrell).

Yet he could not deny that he could be of assistance to those "with a little dust in their eyes," and so, for the next forty-five years, Gautama wandered the plains and cities of the central Gangetic Plain, shedding what light he could on the principles of self-study and self-sufficiency (in, it seems, some lost demotic tongue more accessible than the high liturgical language of Sanskrit). The heart of his teaching was "Be ye lamps unto yourselves. Take the Self as your refuge. Take yourself to no external refuge," and, concomitantly, the recognition that the roots of our afflictions lie nowhere but in ourselves. Once, coming upon a man looking for a woman who had robbed him, he asked, "What is better: to look for the woman or for yourself?" Another time, he taught his followers simply by holding up a flower.

The instruction afforded by Gautama was a profoundly everyday one, I think—he did not talk much about gods or faraway Here-afters—and a relatively modest one, conducted largely in the form of questions, Socratic debates, and silent meditation. "We ask and ask," his disciples once complained, "and you sit still and smile." To an illiterate villager, he counseled mindfulness even while drawing water from a well, and to a mother grieving for a son, he suggested looking for a single house where death had never visited. Never a supernatural figure, he admitted that he had scarcely been stronger than temptation himself, and had often been frightened while alone in the forest. Much of his teaching, surely, came simply through his being, with its happy blend of eye and heart, as the great explorer of religions, Huston Smith, suggests: he showed how kindness could be made useful and pointed by discernment, and wisdom could be softened and made human by compassion.

Yet the inarguable fact of the Buddha's life is that it was transacted in the world, and so, inevitably, the reformer who wanted to free people from dogmas, teachers, and institutions soon found people creating dogmatic institutions around him. The Buddha appointed no successors, and none of his teachings were written down at the time: he was just a finger pointing at the moon, he always implied, not the moon itself. Yet soon a monastic community had formed around him, and a set of truths was being hammered out; the first serious schism in Buddhism was actually started, some say, by the Buddha's own cousin Devadatta. When at last the Buddha died, at the age of eighty, in around 486 B.C., passing away, as he had been born, in a grove of trees, his final words were "All created things move on. Strive on with awareness."

For more than four hundred years, the teachings of the Buddha were passed from monk to monk, held only in the memory, until, in the first century after Christ, in Sri Lanka, the first set of Buddhist writings was collected in what is now called the Pali Canon. And as,

in subsequent centuries, Buddhism began to fade in India, it took root through much of Asia, with one central dividing point coming to the surface: Some Buddhists, following what they called Mahayana (or the "Great Vehicle"), espoused a teaching that extended to as many people as possible (hence a *yana,* or "raft," that could carry many), and their form of Buddhism came to predominate in China, and thence in the other parts of northern Asia that embraced Buddhism, such as Korea, Vietnam, and Japan. Others, left with the title Hinayana (or "Little Vehicle"), and originally known as followers of Theravada (or the "Way of the Elders"), hewed to the doctrine of solitary contemplation, generally in a monastery, and their practice prospered in Sri Lanka, Burma, and Thailand.

The Theravadins, in a sense, concentrated on following the Buddha's words, and tried to go it alone in the footsteps of the actual individual who delivered his first lecture in the Deer Park in Sarnath in around 531 B.C.; the Mahayanists, by contrast, followed the Buddha's example, reflected in his decision to come back into the world after his enlightenment, to help the rest of us. Extending their faith to laypeople and married priests, they dwelled less on his person than on the principles he embodied, which they set within an elaborate, swirling cosmogony of illuminated buddhas and tormenting demons. Later, in Tibet, a third branch would grow up, called Vajrayana, or the "Thunderbolt Vehicle," which fashioned a sophisticated spiritual technology whereby enlightenment, it was said, could be reached in a single lifetime. Out of one man's single path were born a hundred different philosophies.

Also, of course, a huge panoply of images. By some accounts, the Buddha himself had asked, true to his assumptions, that no images be made of him, and so, for centuries, the faithful portrayed the enlightened soul in the form of a tree, which offers refuge and keeps grow-

ing, or the Wheel of Law (which appears to this day at the center of India's flag). The oldest Buddhist sites resonate with images of just an empty throne, a deer, even a single footprint.

Yet no teacher has ever managed to outlast his followers, and the first images of Siddhartha Gautama appeared, from the hands of Greek stone carvers, in the Roman-inflected area of Gandhara in the second century A.D. It's telling, though, and apt, that the Buddha characteristically adopts a different face for every place he visits, as if to remind us that in each place he must serve a different constituency, and all of us, essentially, make our gods out of our own needs and preferences. In Thailand, the Buddha often has the delicate arms and tapering fingers, the sinewy grace, of a local dancing girl (or angel); in Japan, he is more often sturdily bronzed, a steady figure of samurai authority. In the lovely gilt bronzes of the Mongolian Zanabazar, he returns to being a delicate princeling, while in Polonnaruwa, in Sri Lanka, his reclining figure stretches for forty-five feet; elsewhere, in Tibet, for example, he sometimes disappears within a whirl of spinning images and flames. When you visit the Sanjusangendo Temple in Kyoto, the Hall of Thirty-three Bays, you are met by a huge rectangular force of golden bodhisattvas, or enlightened beings who have come back to the world to help us, arrayed in serried ranks. Everyone who visits, a Japanese friend once told me, will find the image of their mother somewhere among the 1,001 life-size figures.

That, to me, is the living essence of Buddha: a deeply human figure who appears to us in a form and figure we can recognize and hold close. In Eikando Temple, in Kyoto, the Buddha is depicted looking over his shoulder, in the manner of a mother checking on her wayward flock; in Kurodani Temple, just a few minutes away, he resolutely faces us with a father's strength. Blending tenderness with steadfastness, the Buddha represents the quality we ideally associate with par-

ents, which is that their highest fulfillment comes in encouraging our own; they are only happy when we are.

The other characteristic that is central to the Buddha, and that every traveler knows from statues and paintings, is his poise. He seems to sit in a state of absolute alertness yet relaxation, unattached to the world's values and distractions yet not unmoved by the cries of its suffering. Krishna plays, Jesus suffers, Islam whirls us into a dazzle of flowing patterns—but Buddha simply sits, and in his sitting is his being, and his teaching.

On busy days when I'm in San Francisco, I often go to the Japanese garden in Golden Gate Park, where a large bronzed Buddha sits, and just the presence of his still figure stills the commotion in me. The weirdly elongated hands, the pebbled hair, the lotus underneath him, I hardly notice; what touches me is just that one hand, raised, as if to say, "Be calm," and the other, with just a finger curled, as if to say, "Come closer."

I AM NOT, AS I SAY, A Buddhist, and I leave to scholars the business of thrashing out what Buddhism really "means." But as a traveler through Buddhist countries—a tourist in Buddhism, so to speak—I have often been humbled and moved by what strikes me as the simple core at the heart of its teaching: that the central fact of life is suffering, and the central purpose of life is easing that suffering, in our own lives and those of others. One cause of delusion is desire, and it is itself rooted in another, the illusion of a separate self; release comes with the clear, unflinching understanding of a reality that mocks such passing trifles.

Of all philosophies, Buddhism is one of the most reasonable—in the sense that it extols reason and holds to nothing that cannot stand up to reason; the present Dalai Lama, for example, enjoys nothing so much as meeting with physicists and psychologists, and learning about how the latest scientific discoveries can sharpen and refine his thinking. That profoundly empirical, open-ended quality has prompted some people to argue that Buddhism is not a religion at all—certainly, talk of "God" is not essential to it—but rather a branch of moral philosophy, or even (as Tibetans call it) a "science of mind." I think of it as, most usefully, a kind of practical training for our lives (and so our deaths), from which we can gain as we do from our tai chi sessions or daily workouts in the gym.

For the Buddha, I suspect, his teaching was only as good as its usefulness in the here and now. When one is afflicted with an arrow smeared with poison in one's side, he famously said, it hardly matters where the arrow comes from, or what kind of bow delivered it; the main thing is to pull it out. So, too, with our lives—more essential than speculation or endless ratiocination is just the fact of relieving pain. The Buddha I often think of as a doctor of sorts, with exactly the blend of sympathy, understanding, and specialized knowledge we look for at our bedsides; he's here to offer help. "If what I've said is useful to you, please take it away and use it," the Dalai Lama says; "if not, ignore it." Zen monks, always on guard against fixation on images, have been known to keep themselves warm by burning Buddhas.

It is this very down-to-earthness, and even skepticism, that has doubtless helped Buddhism to find a home in so many different cultures, adapting to countries founded around Confucianism, Hinduism, Shintoism, the Tibetan folk religion of Bön, and, now, the Information Highway. It is a philosophy that asks questions as much as it provides answers (when the Buddha was asked about metaphysical issues, it is said, he traditionally said nothing), and those who meet the Dalai Lama are often taken aback to find that he's more eager to draw wisdom out of them, whoever they may be, than to lay down truths.

Nothing at all, he always tells his startled followers—not the teachings of Buddha, not the words of the Dalai Lama, not religion itself—should be taken on trust. Devotion has its place, but it is most meaningful when confirmed by rigor.

AS FOR THE BUDDHISTS THAT I'VE MET, many, of course, are as fallen and fallible and worldly as the rest of us, and, in any case, it makes little sense to generalize about a tradition that extends to perhaps 500 million people in the world's oldest and deepest cultures. Some Buddhists marry, others refuse even to touch the sleeve of a woman's dress; some, in Tibet, explore the highest, esoteric reaches of Tantric magic, while others believe that salvation comes with just the ritual recitation of the Buddha's name each day.

In Thailand and Burma, every man joins a monastery at some point in his life, which means, happily, that every life is to some extent lit up by the selflessness and sense of focus exemplified by the Buddha; yet it also means, less happily, that monasteries are often hiding places for drug dealers and rapists on the lam, who simply crave a realm wherein they can live for free, supported and respected by the community. In many parts of Asia, companies vie with one another to build the tallest, grandest, most expensive Buddha, and the statues that result are monuments mostly to ego.

Since Buddhism is a part of daily life for most of its adherents, it is, willy-nilly, entangled in the world, as a lotus grows out of mud: in Bangkok, you find Buddhas in the strip clubs, and girls in tiny bikinis bow and pray to the Buddha every time they come into or go out from their neon workplace; just down the street from where I write this, in the old Japanese capital of Nara, near the Great Buddha of Todaiji, a fifty-foot statue first erected here 1,200 years ago, and protected even now by the largest wooden building in the world, Buddha hand puppets are on sale next to stuffed animals and rock 'n' roll telephone cards. Some Buddhas come (most appropriately of all) in the form of candles, which melt and wither as you use them, until they find new life with a new purchase.

Buddhism, in short, has never been further from reality than any other such discipline: as I write this, policemen are searching for the killer of a Japanese Buddhist monk in the Buddha's birthplace of Lumbini, who had been working on a Japanese World Peace Shrine, while gunfire again imperils the great thirteenth-century *wats* of Angkor. Buddhist fundamentalists are in the news, and Buddhist demagogues, Buddhist cults, and Buddhist power brokers (the U.S. State Department even used to have an Office of Buddhist Affairs). Wars have been started over custody of the Buddha's tooth, and this year three of the Dalai Lama's inner circle were found murdered in their beds, apparently at the hands of another Tibetan Buddhist faction.

And yet, at the same time, I've been touched, very often, by the care and devotion I've met in many Buddhist lands as a traveler, and, as Buddhism gets transmitted around the world, many of us have been renewed by the invigorating sight of Buddhist students bringing their principles of responsibility, calm reason, and forbearance even into the political arena. Aung San Suu Kyi in Burma refuses to hate her oppressors as stubbornly as she refuses to give in to them; in Cambodia, respected monks have worked tirelessly for peace, taking Buddhist teachings into the refugee camps of the Khmer Rouge fighters who killed the monks' own families. The Vietnamese Buddhist Thich Nhat Hanh actually coined the term "engaged Buddhism," and, from his center in Plum Village, France, he reminds us that "the miracle is not to walk on water. The miracle is to walk on the green Earth."

The heart of Buddhism, after all, which sometimes can get lost in philosophy and festivals and headlines, is compassion—and if you

truly believe that I am as much a part of you as your own arm or toe, it only stands to reason that you will try to take care of me, and of that tree over there, and of that AIDS patient too. "The whole purpose of Zen," one Zen master in Kyoto once told me, "is not in the going away from the world but in the coming back"—even all those years of meditating in a silent zendo have meaning only if they can be brought into the suffering of the moment. A buddha, really, is someone who sees, and awakens, the buddha nature inside you.

Thus "Buddhism" is a highly relative term, by which I mean only that many a Buddhist scroll is alive with a thousand "buddhas," with Maitreyas (or future buddhas) and Manjushris (or gods of wisdom), with goddesses of compassion and images of Siddhartha and figures called Amitabha (the buddha of the Western Paradise) and Shakyamuni (or the sage of the Shakya clan). "Buddha," as the scholar Edward Conze writes, "is not the name of a person, but designates a type," and the Gautama we see represented is just one in an apostolic line that stretches far into the past and into the future (in much the same way, perhaps, as the Dalai Lama's spirit, Tibetans believe, takes life in one boy after another, or, indeed, as a flame is passed from one candle to the next).

The most visible Buddhist in the world today, the Fourteenth Dalai Lama, is, in fact, an illustration of many of the most fundamental principles established 2,500 years ago, even as his life is described in two recent Hollywood movies and his speeches are broadcast live on the floors of London dance clubs. For one thing, as a serious student of the Buddha, he prefers not to have disciples, only what he calls "spiritual friends"—and, conversely, in the manner of Shantideva, the great Indian Buddhist who advised us to "be the pupil of everyone," he willingly takes instruction from backpackers and wandering monks who look like tramps. "Unlike Catholicism," he told me recently,

"Buddhism has no central authority," and when I met him on the day after he'd won the Nobel Prize, his main concern was finding a chair in which I would be comfortable.

Above all, he shares himself most vividly in his gestures—the full-throated laugh, the bright, alert eyes, the way he clasps your hand between his own or condenses twenty years of metaphysical teaching into the simple, practical conclusion "My religion is kindness." He's seen 1.2 million of his people killed, more than 6,000 of his monasteries ruined, and most of his life conducted in exile, yet his most striking quality is an infectious, irresistible optimism that tells us over and over that kindness, hopefulness, and forgiveness only stand to reason.

Thus even as Buddhism struggles to survive in Tibet, it is acquiring new life in the Karma Ling center in France, and in Boulder, Colorado, and in Tibetan monasteries all over India, where exiles from the "Land of Snows" have brought Buddhism back to the land of Buddha's service. The very forces that have set about annihilating the teaching in Lhasa are helping to propagate it around the world in its latest incarnation, and Buddhism prepares to enter the twenty-first century with a whole new set of homes and voices.

Indeed, the one other aspect of Buddhism that shines out from deForest Trimingham's photographs is the one that somehow catches inside so many of us who've traveled around Asia: the smiles and wistful friendliness of all the monks, no taller than your waist, sent into temples by their families at the age of five or six, who breathe such impish life into the old buildings. Everywhere you go in the Buddhist world, you see them, exchanging mischievous glances over their sutras, playing hide-and-seek around their prayer halls, memorizing tomorrow's texts much as the Dalai Lama (who recites his sutras while riding his exercise bike) once did, and much as children might every-

where. I remember once drawing raccoons for a large gaggle of tiny *gaylongs* in the remote courtyards of Tongsa Dzong in Bhutan, and seeing my Instamatic disappear into the excited hands of several young monks in Lhasa's Drepung Monastery, on a break from their prayers. In Chiang Mai, you'll often come upon a seven-year-old in a candy store, stashing his treasures inside the simple orange shoulder bag he carries on his arm, and in Burma, at dawn, you'll see a tiny nun, in a peach-colored robe, walking out of the morning mist toward you. The most erudite high lama in America is now believed to be reincarnated in a small boy in Seattle, and others are claiming new lives in children in Spain and southern India. When last I was in the Dalai Lama's home in Dharamsala, in northern India, I spent much of my day just watching the red-robed teenage monks do what their ancestors must have done three hundred years before: play tag along the rooftops, study for exams, and conduct ritual debates all along the sunlit terraces of their whitewashed monastery.

Thus Buddhism continues to gain new lives even as old ones are snuffed out, and we often refer to tiny babies as "Buddha-like" because we see in them a quality of alertness and humor and wisdom that's mysterious. One of the happier tenets of Buddhism is that bodhisattvas, or redeeming spiritual offspring of Buddha, may be all around us, even in the unlikeliest places. Like, in fact, the one pictured on page 99, Kannon-sama—the Japanese version of the Goddess of Compassion—who stands in front of the eastern hills on a quiet back street in Kyoto, just a few yards from that temple where I arrived many years ago and where, I suspect, the monks are spinning the wheels of their Donald Duck tricycle even now.

Nara, Japan

EDITOR'S NOTE

THIS BOOK WAS CONCEIVED TO BE READ LIKE A BUDDHIST SCROLL. It could unravel as if it had no beginning or end and at its center would be nothing. The void at the center of the Buddha spirit cannot be represented—to attempt such a representation would be folly. The spirit remains undefinable.

In the hundreds of Trimingham photographs there are mountains, rivers, stupas, temples, rituals, Buddhas, and views of people all over the world engaged in Buddhist practice: praying, meditating, and teaching. The geography ranges from the Himalayas to the southern tip of the Indian subcontinent and on to Indonesia, China, Burma, Japan, Thailand, Colorado, Vermont, and California. To discover a visual rhythm and structure we divided the book into five parts. Once the editing was complete we joined the sections without breaks, seamlessly, to provide the continuity of the scroll.

The book opens peering through a doorway out on to a great Himalayan mountain landscape. We follow the mountains and rivers, noticing temples high up on remote pinnacles, until the structures of the Buddhist sites, the stupas and temples, become more pronounced than the landscape that surrounds them. The architecture becomes more complex and elaborate, and eventually we find ourselves confronting the great wall of the city of Lhasa, followed by the emptiness and sparcity of a Kyoto retreat. Behind these structures lurks the image of Buddha and his gaze. Behind the gaze is the emptiness itself accompanied by the sound of a bell, a gong, or the smell of incense. The final part of the book is devoted to the images of the Buddhist practice through which the historical roots of tradition are joined to the present in what the subtitle refers to as The Living Way.

—MARK HOLBORN

BUDDHA

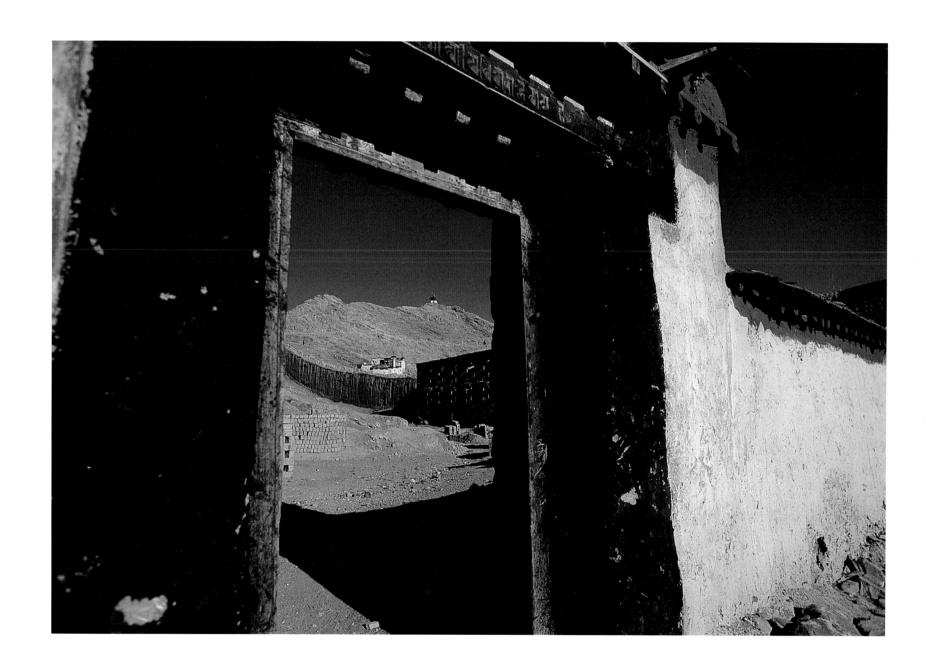

The outskirts of a monastery in the Lhoka region of Tibet.

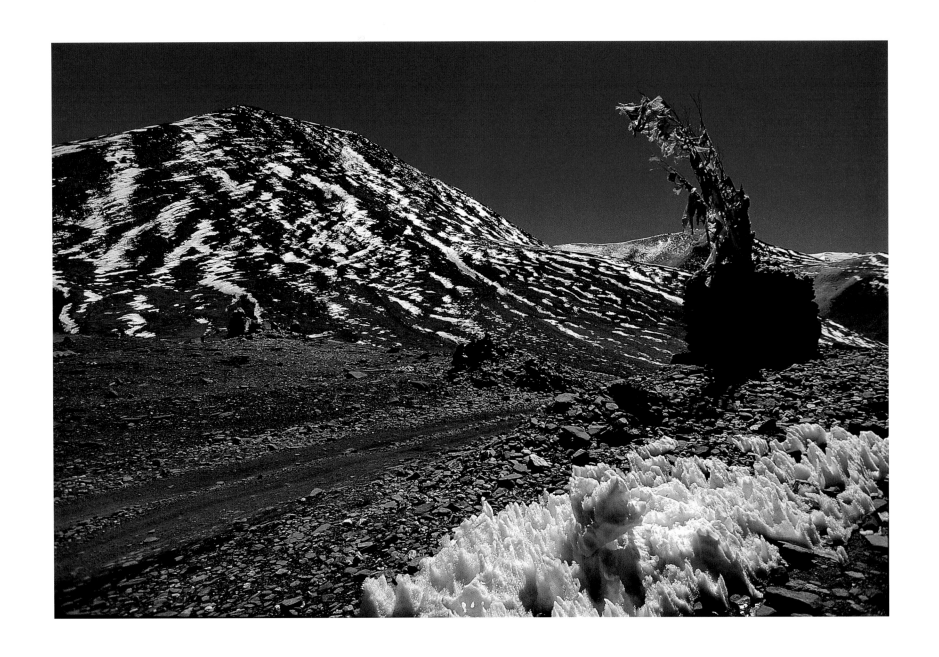

Prayer flags on the Karo Pass, 16,437 feet up in the Tibetan Himalayas.

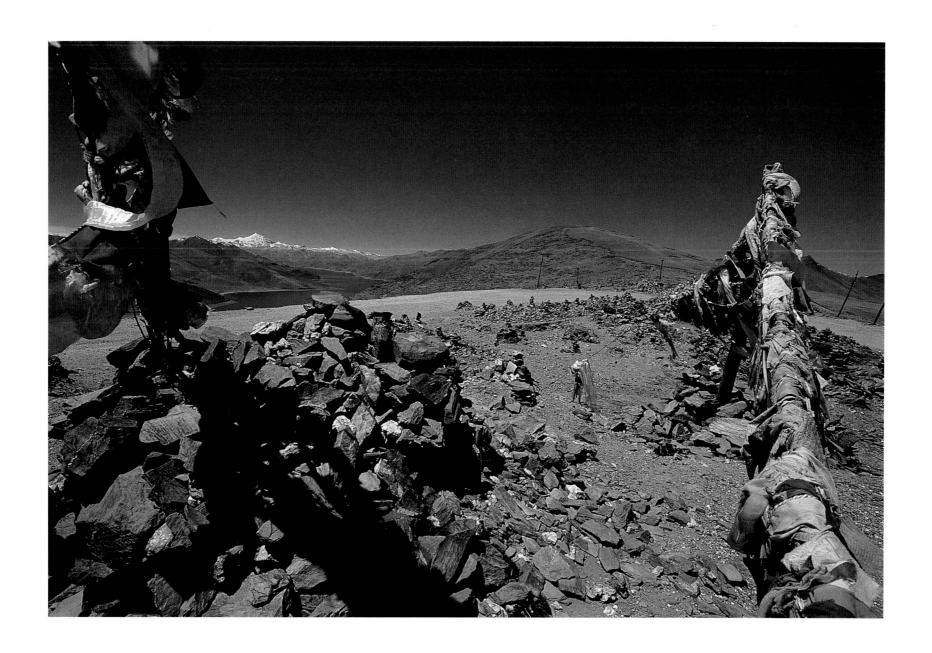

The prayer flags are left out so that the wind will carry their messages around the world.

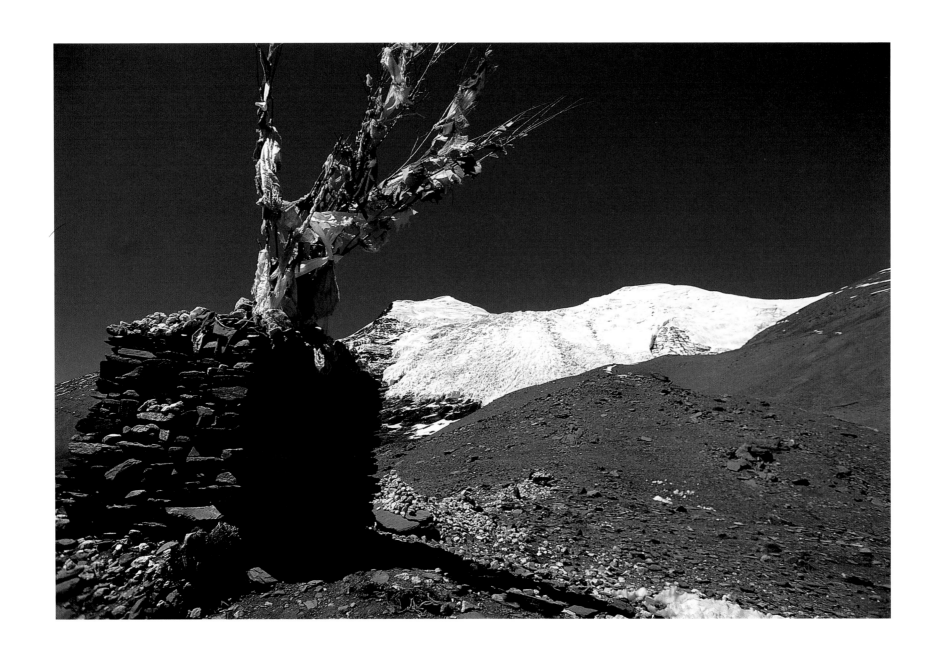

The Kampo Pass, on the way to Gyantse, in Tibet.

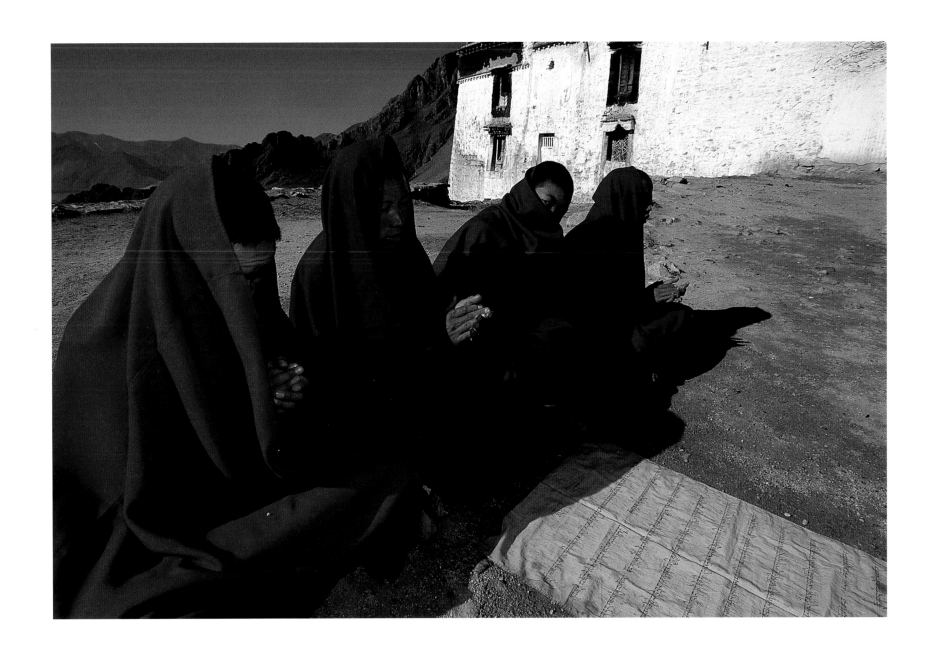

Monks chanting beside a prayer flag in the Drepung monastery, Lhasa.

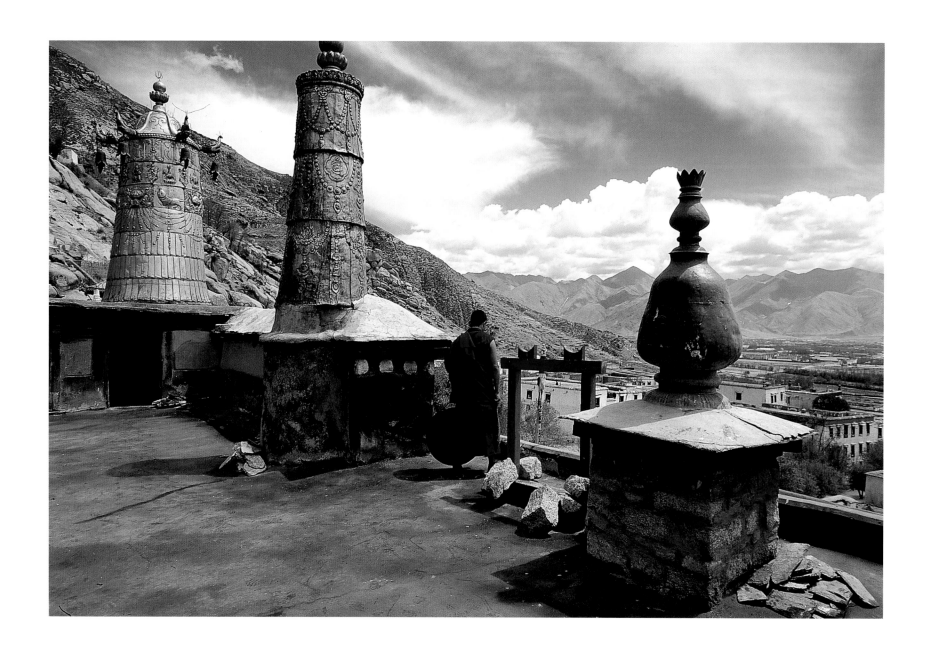

The Sera monastery, overlooking Lhasa.

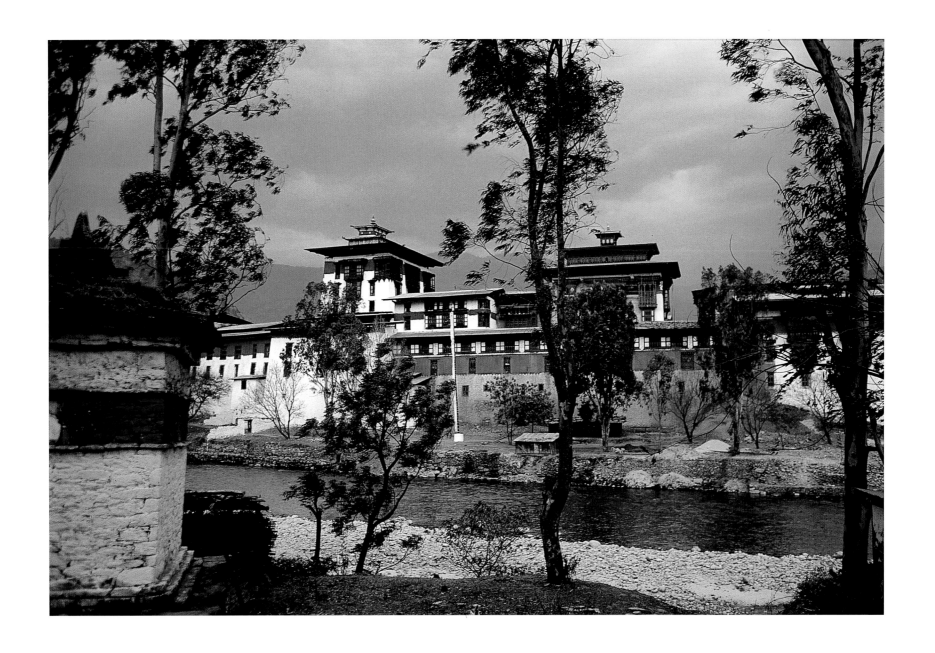

Punakha Dzong, the winter residence of the chief abbot of Bhutan, the "Land of the Thunder Dragon."

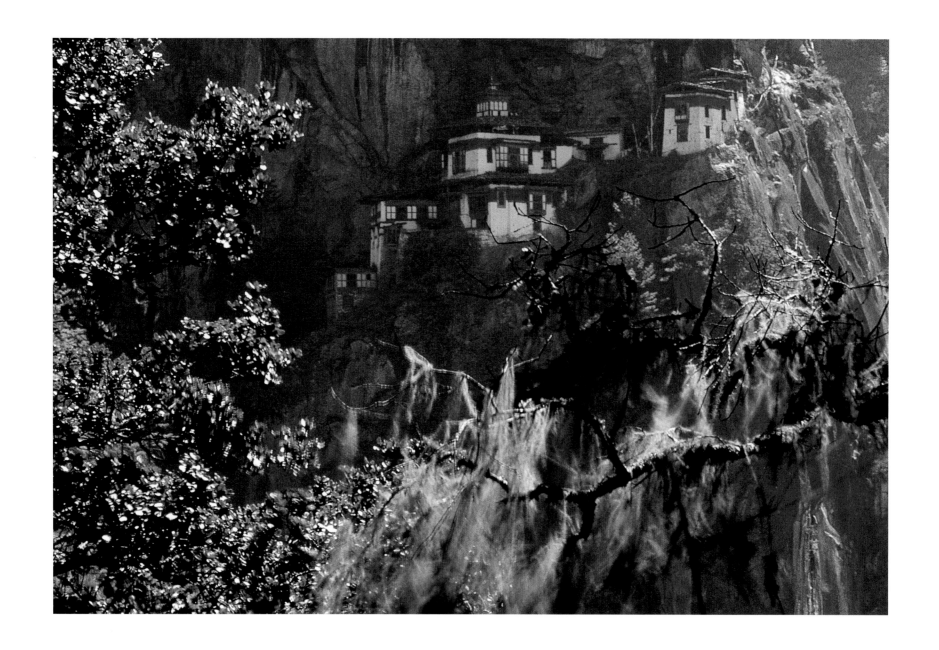

Taktsang Lhakhang, the "Tiger's Nest," in Bhutan. One of the most sacred sites in
the Buddhist world, it was destroyed by fire on April 19, 1998.

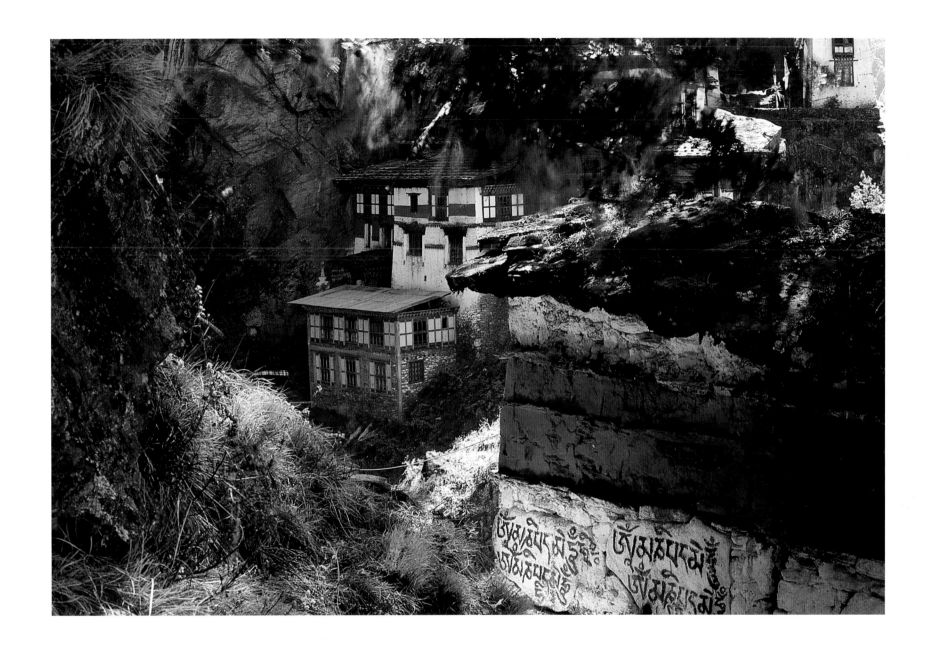

Om mani padme hum ("Hail to thee, Precious Jewel in the heart of the Lotus"),
the essential mantra to Buddha, is inscribed on a wall near Taktsang.

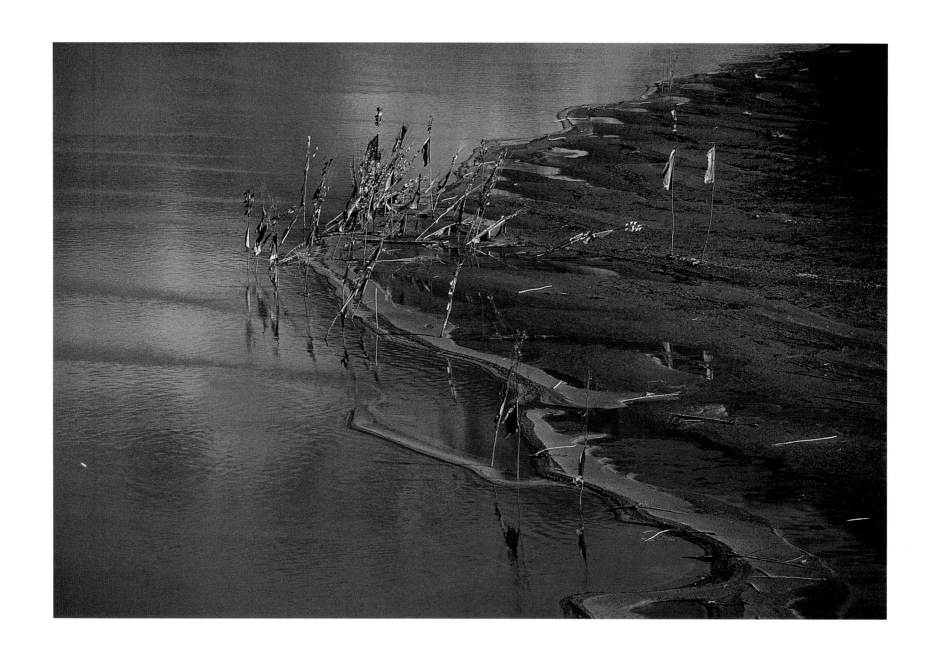

Prayer flags on tall poles along the shore of the Yarlung Tsangpo River, near Zedong, Tibet.

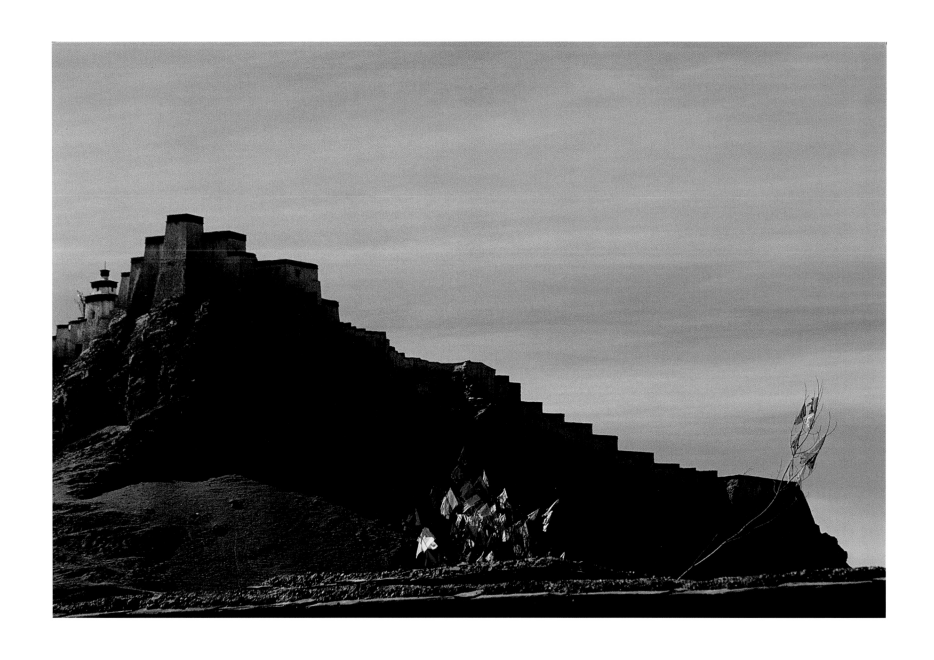

The fort above the Tibetan town of Gyantse overlooks the Kumbum *chorten* and the Palkhor monastery.

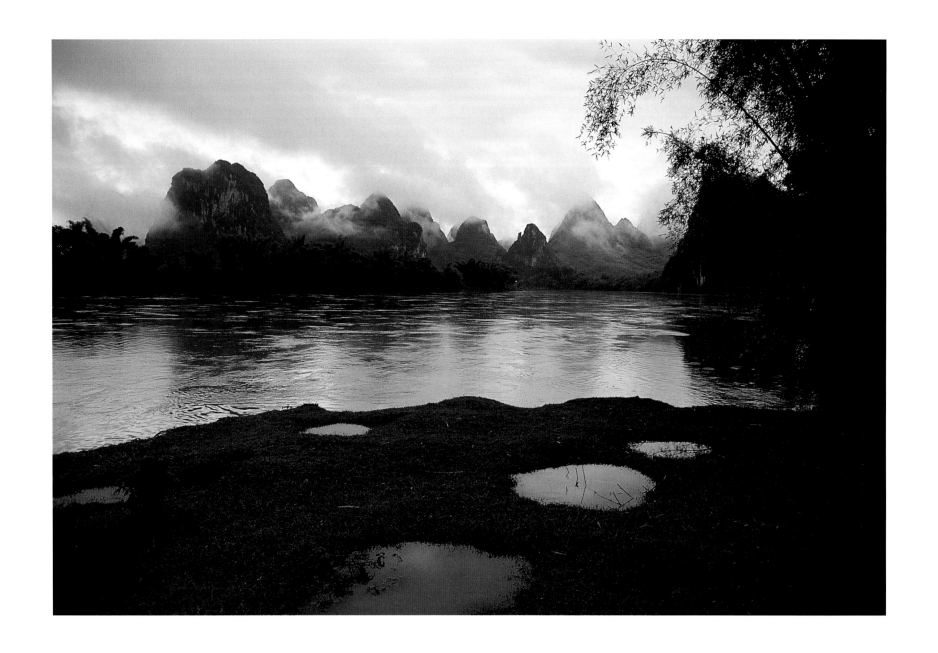

The Li River near Guilin in southern China.

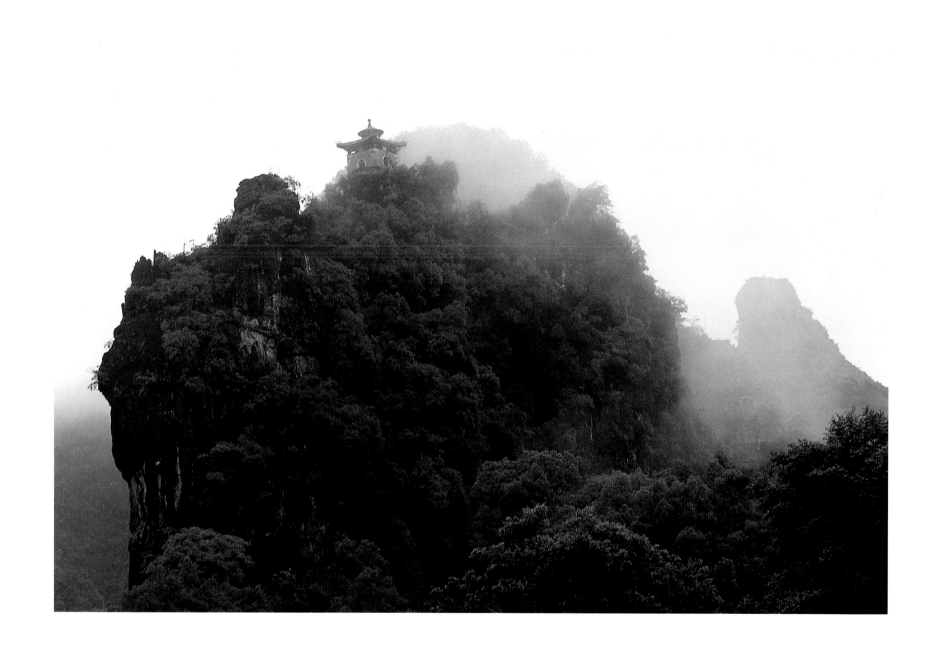

A temple above the Li River.

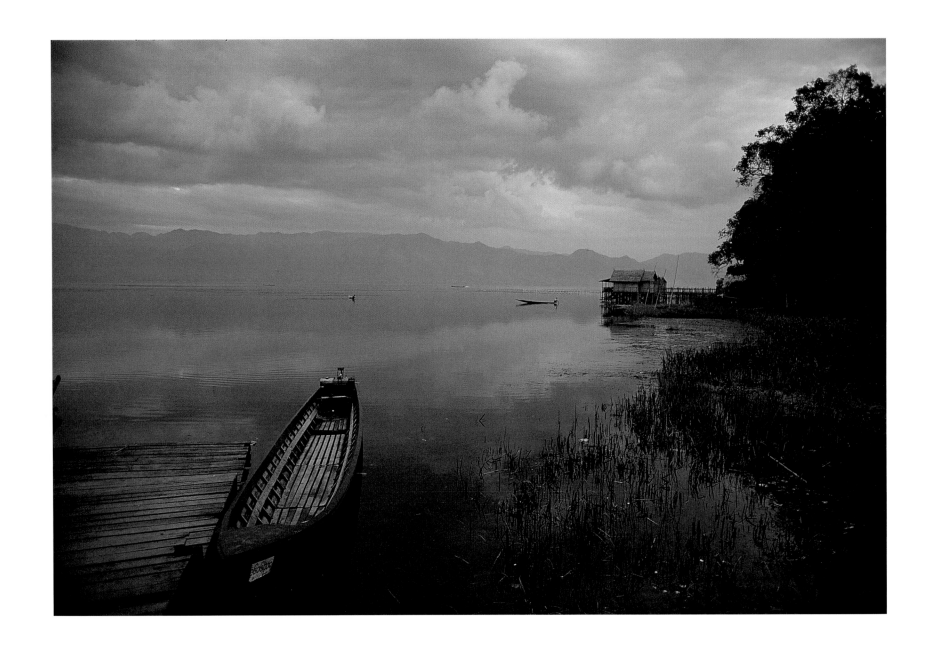

Lake Inle, in the mountains of northeastern Myanmar, the former Burma.

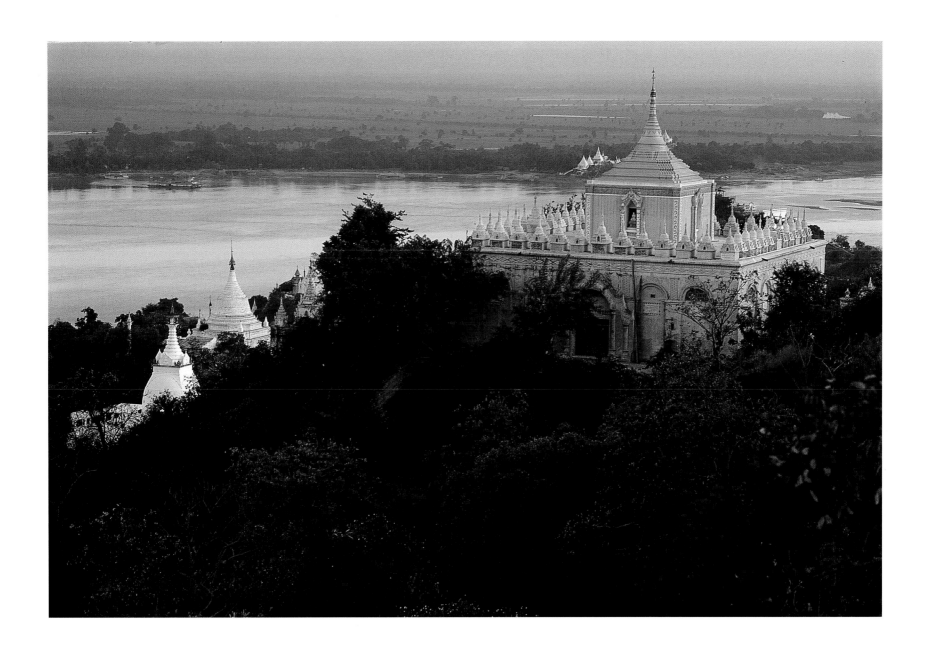

Thatbynnu Pagoda in Pagan, overlooking the Irrawaddy River. Pagan was
the spiritual and dynastic center of Burma for over twelve centuries.

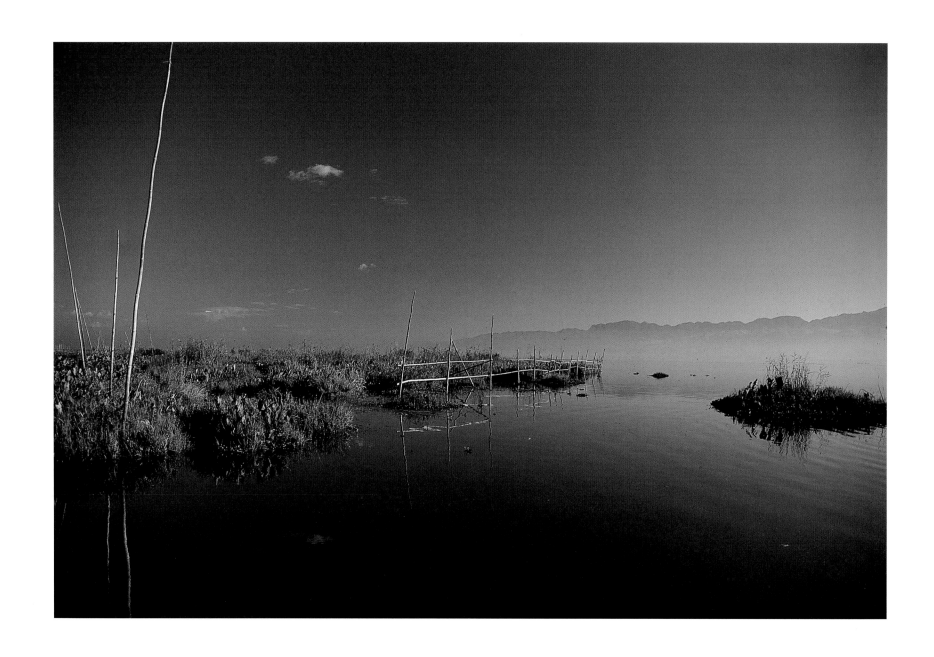

Gardens float in the shallow water of Lake Inle.

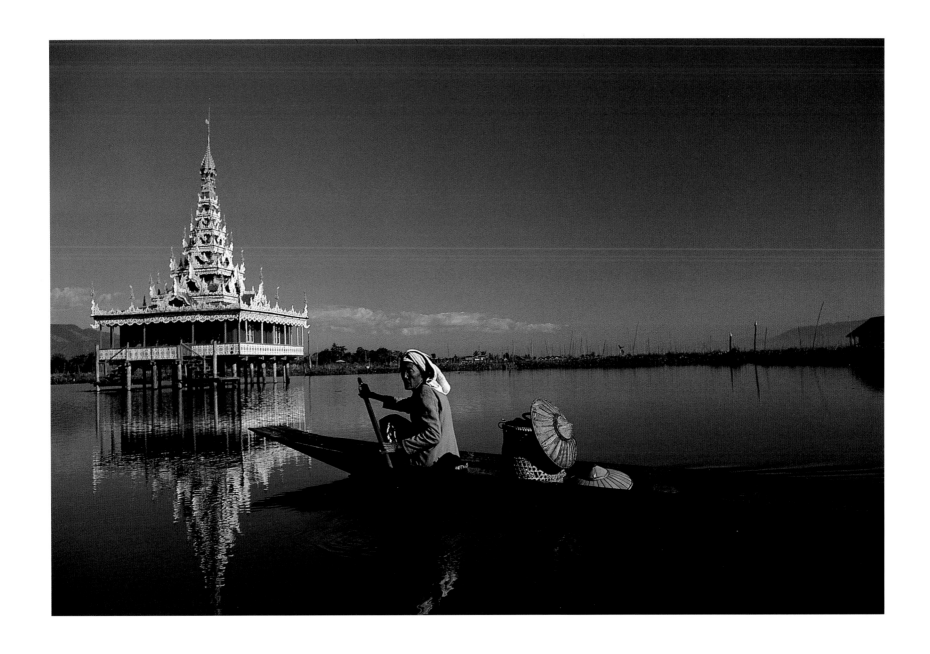

Lake Inle.

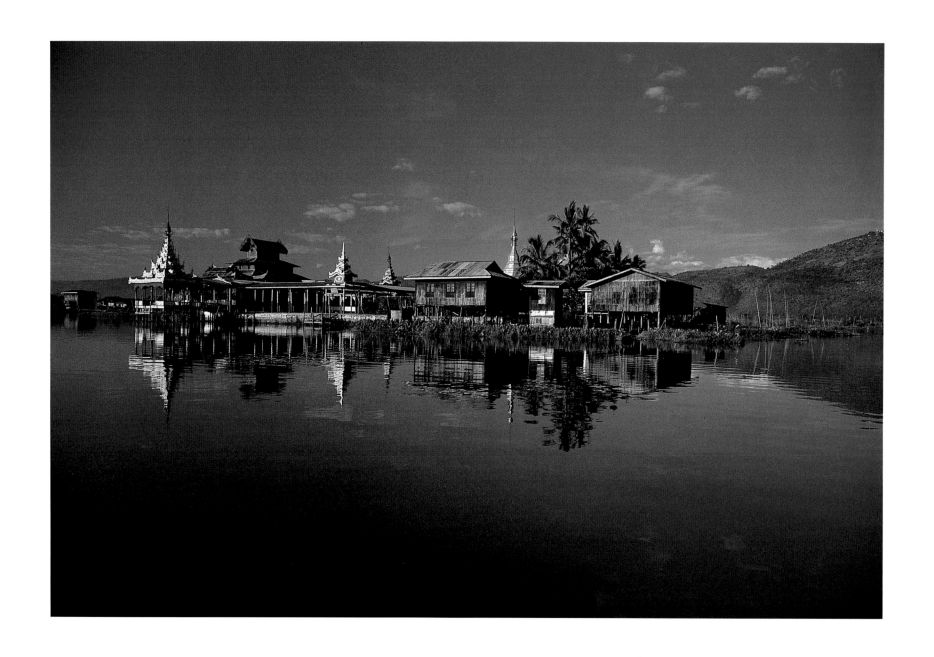

Village pagodas on Lake Inle.

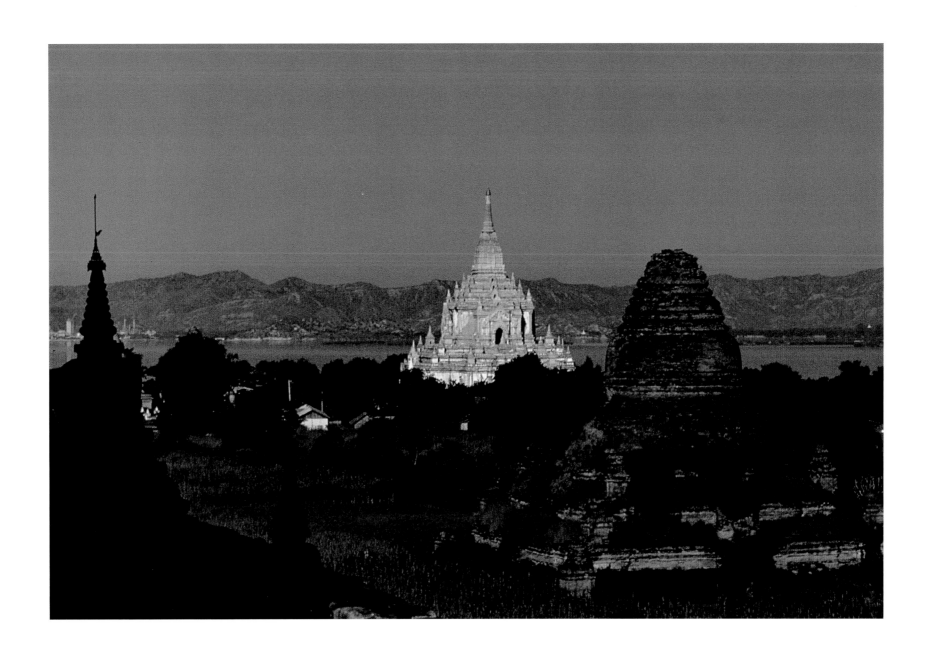

Two pagodas in Pagan, one of which has not been restored.

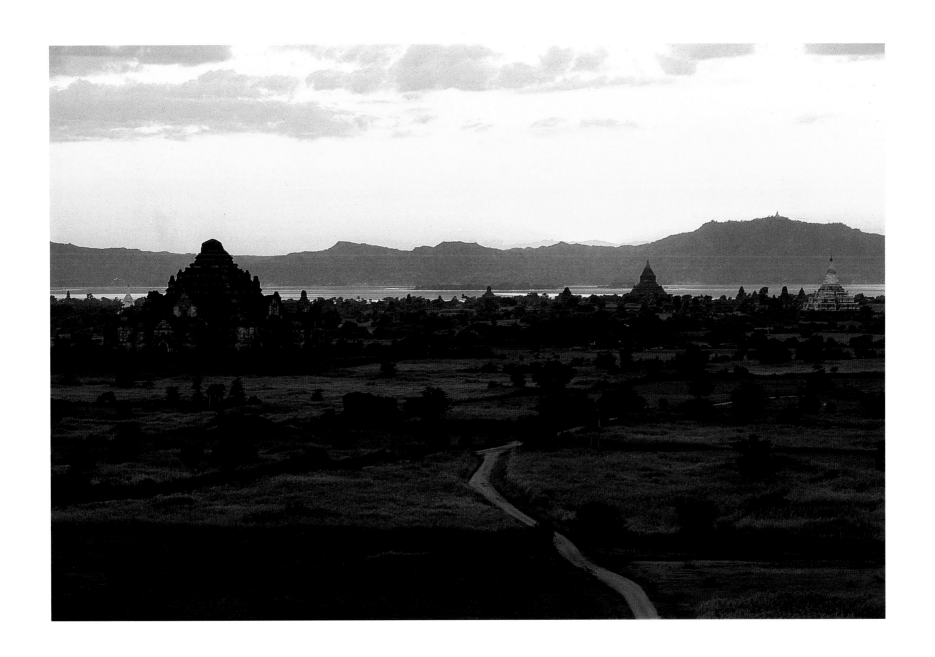

The Pagan plain extends for about sixteen square miles along the Irrawaddy River.

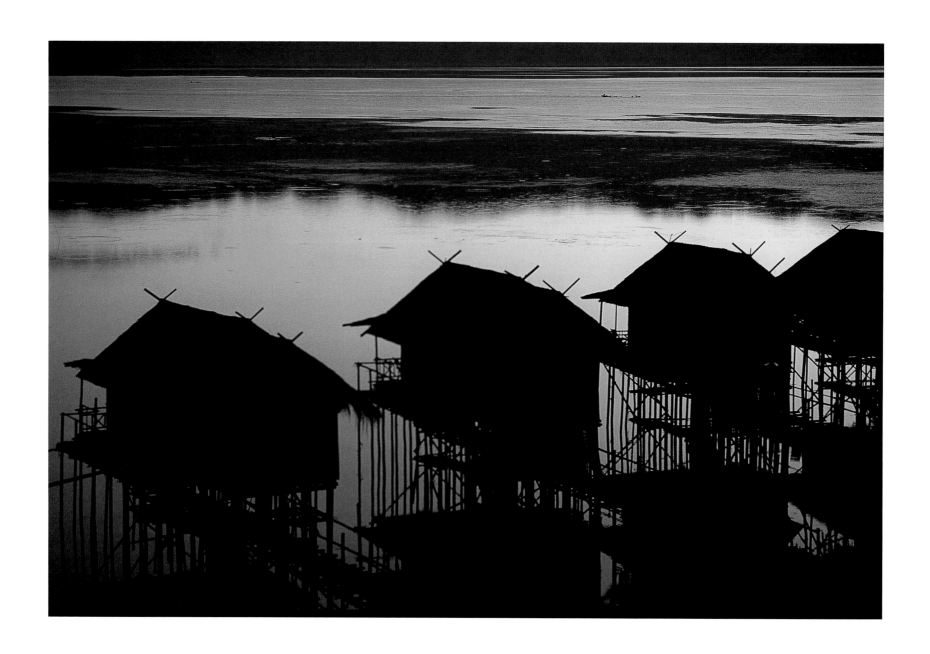

Houses on stilts on Lake Inle.

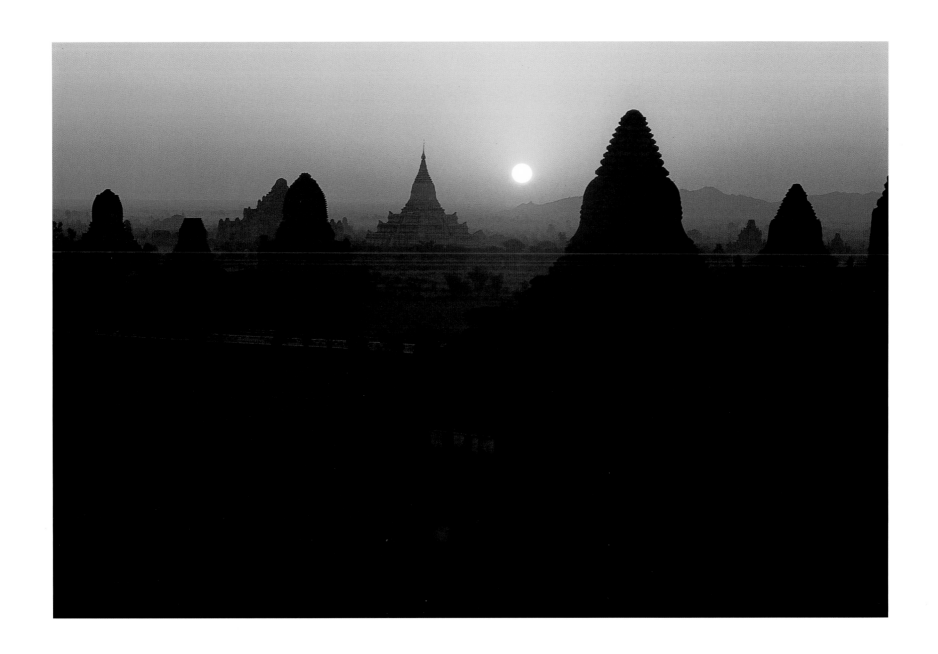

Dawn over Pagan.

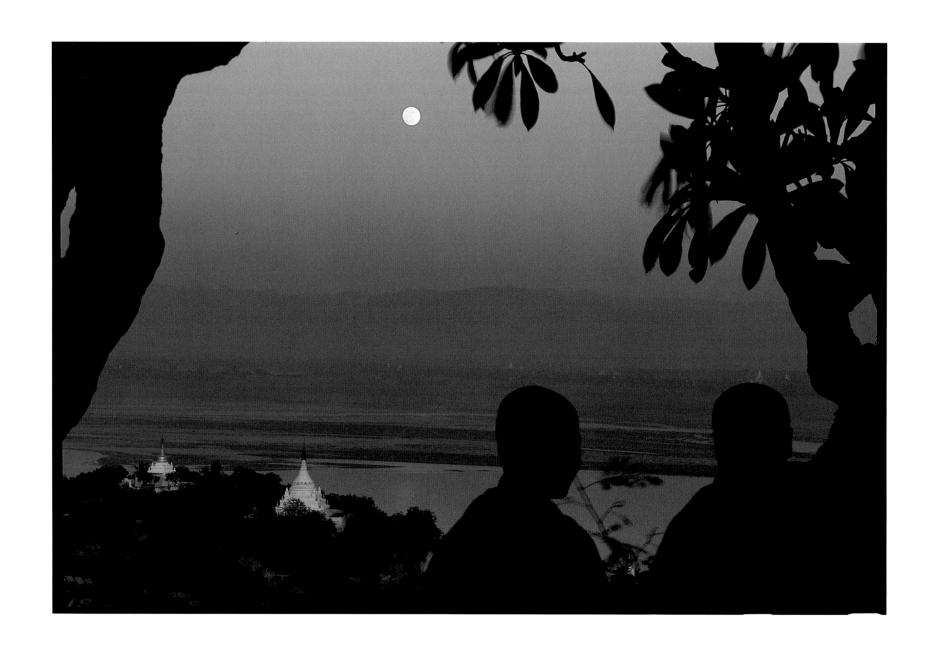

Two nuns at moonrise, on Saigaing Hill, overlooking the Irrawaddy River.

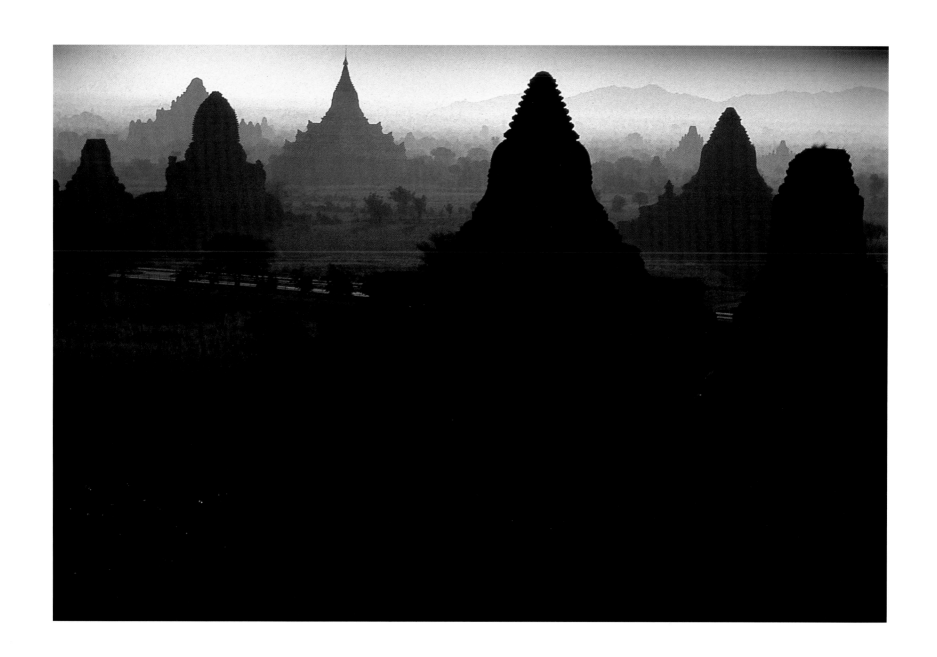

Early morning in Pagan.

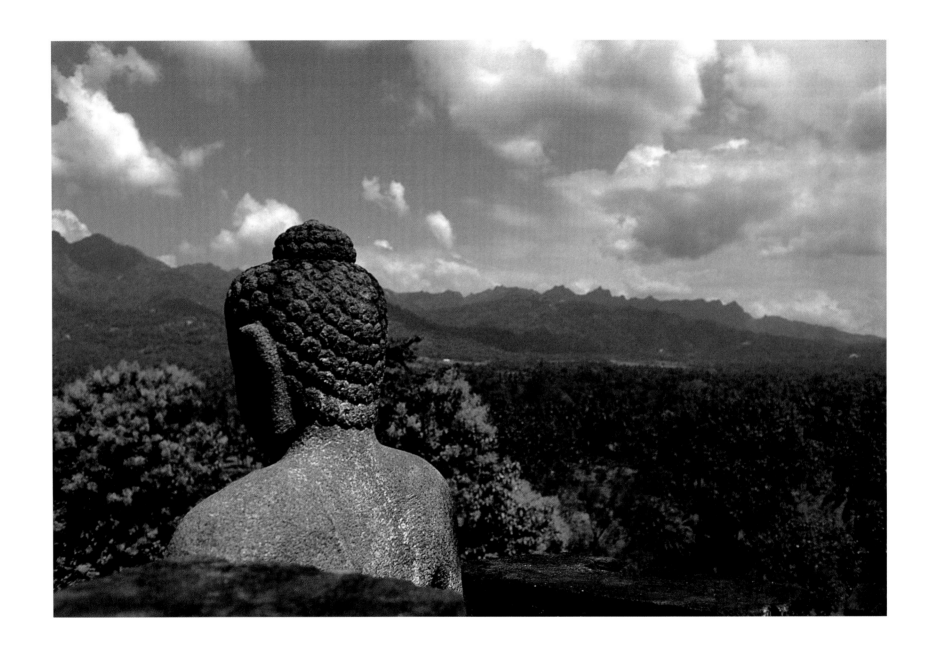

A Buddha head at the Borobudur Stupa in Java. Stupas were originally memorials
containing sacred relics, but they can also be symbolic, as here.

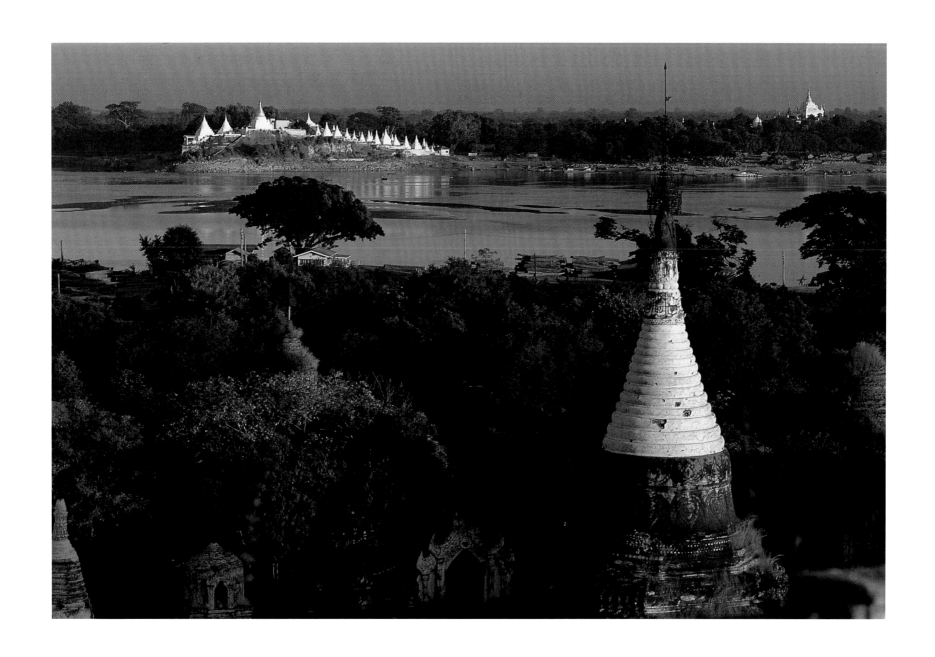

Stupas on the Irrawaddy River, in Myanmar.

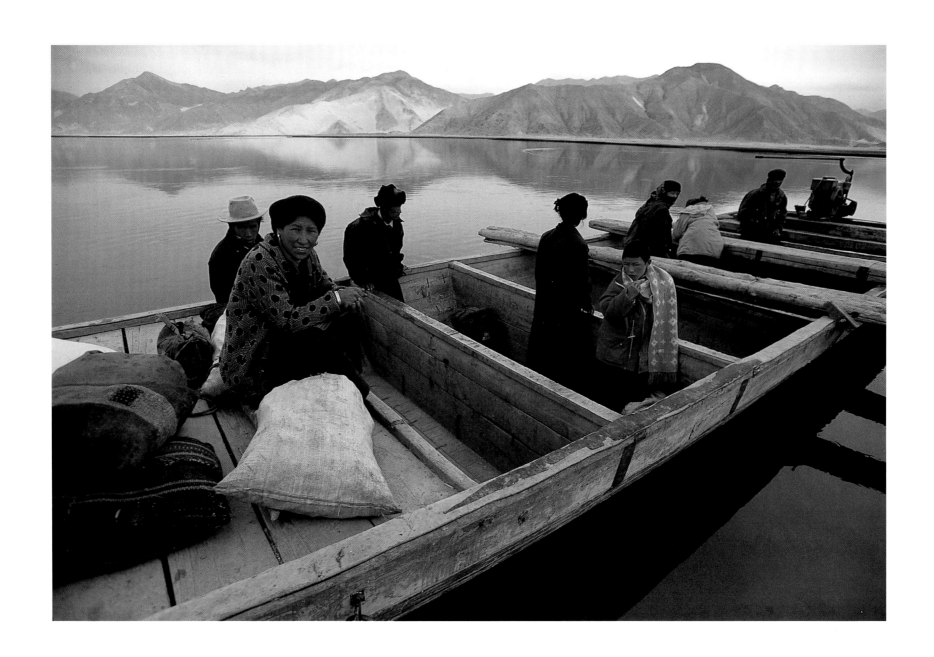

A ferry on the Yarlung Tsangpo River, near the Samye monastery in Tibet.

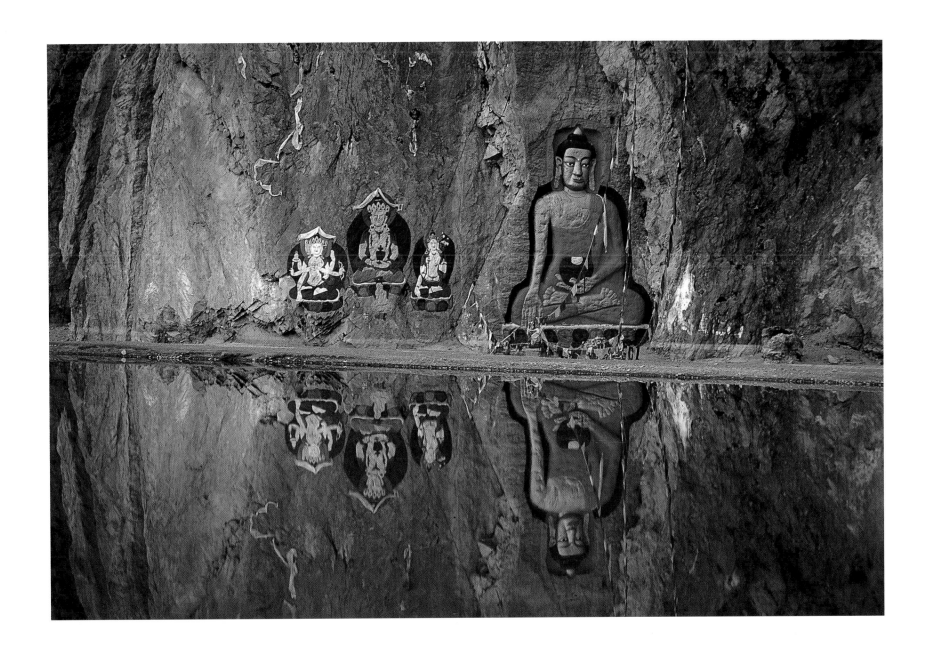

Eleventh-century rock carvings on a cliff near Lhasa.

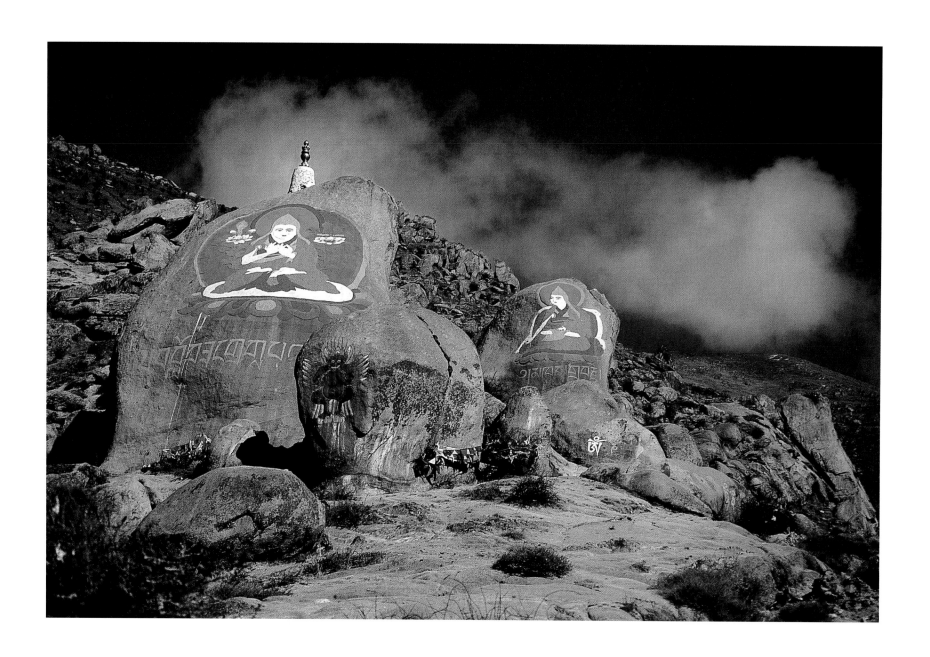

Paintings of famous teachers on rocks on the route to Samye monastery.

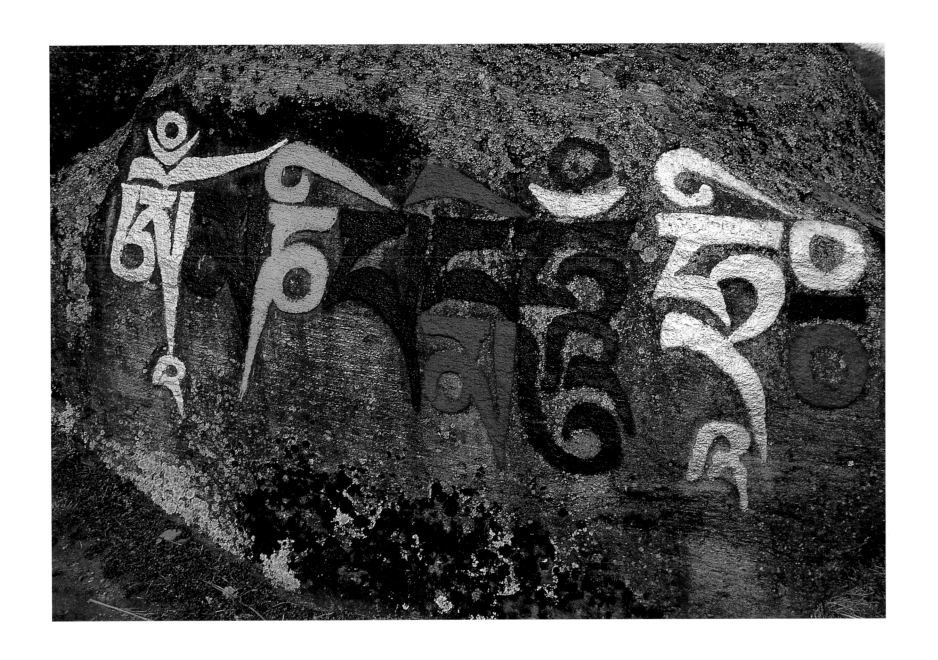

Om mani padme hum painted on a rock in Tibet.

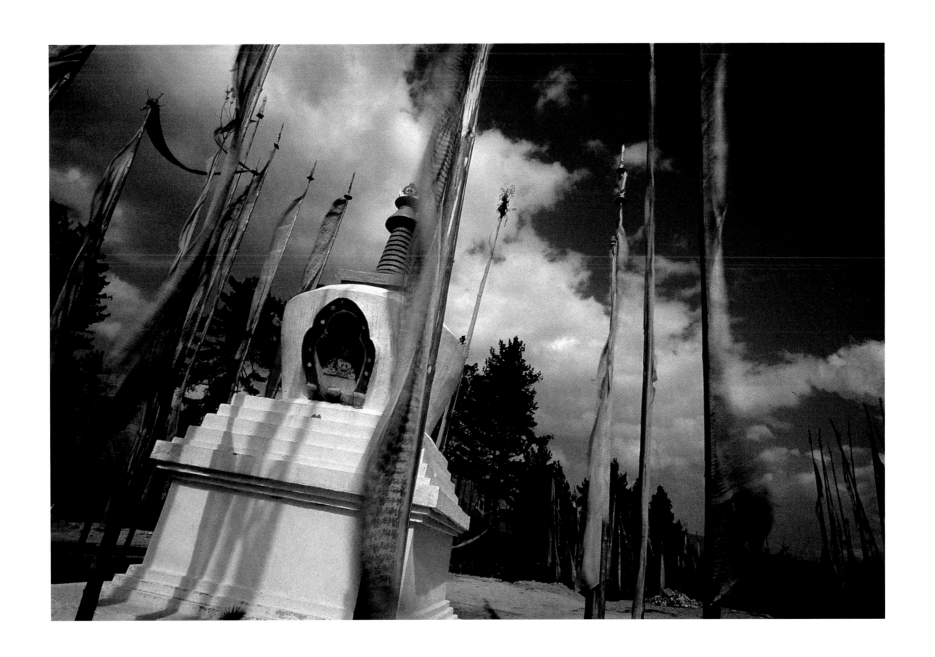

A stupa with prayer flags on a mountain pass between Tongsa and Jakar in Bhutan.

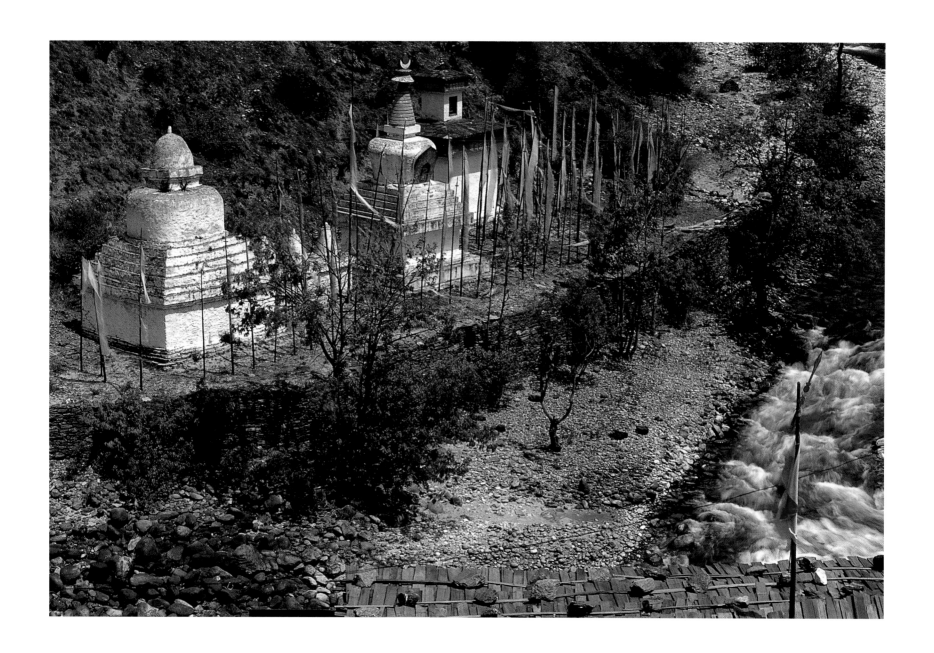

Three *chortens,* or stupas, on the road from Thimphu, the capital of Bhutan.
They are in the Nepalese, Bhutanese, and Tibetan styles.

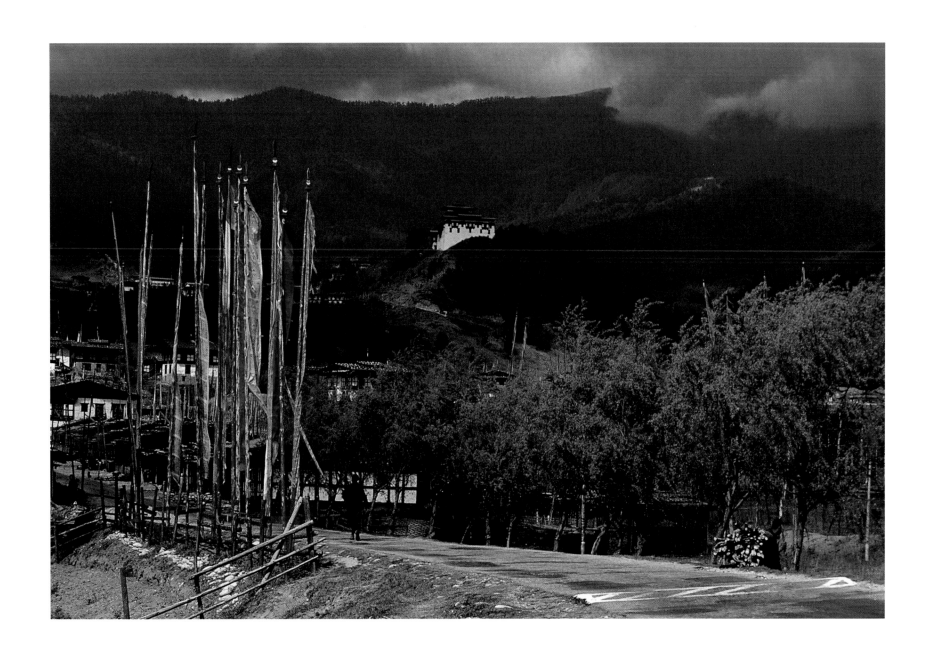

A *dzong,* or fortified monastery, sits in the hills above Jakar, in the Bumthang Valley of Bhutan.

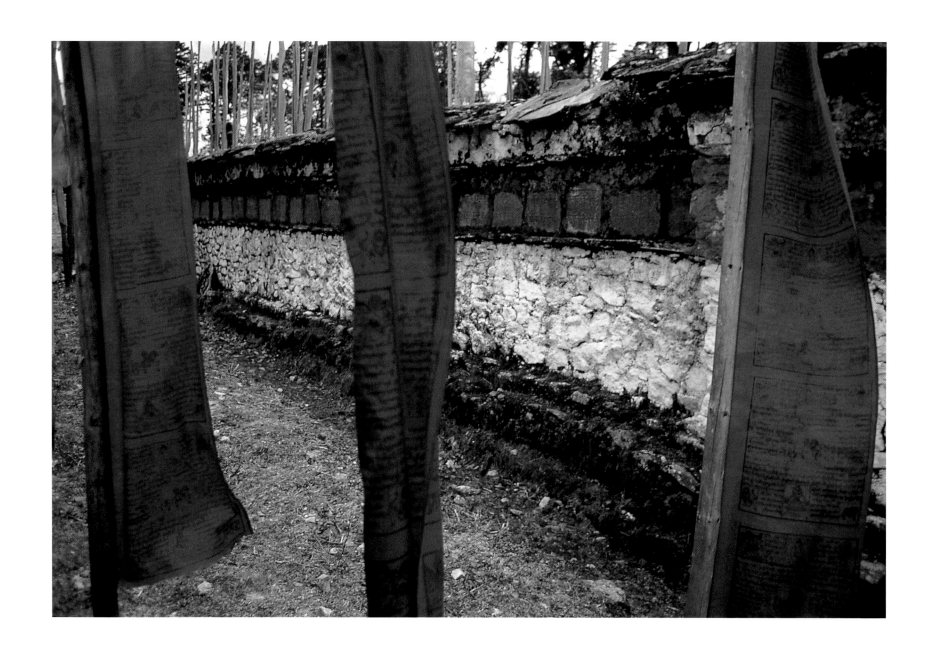

Prayer flags line a wall in Bhutan on which prayers are also inscribed in slate.

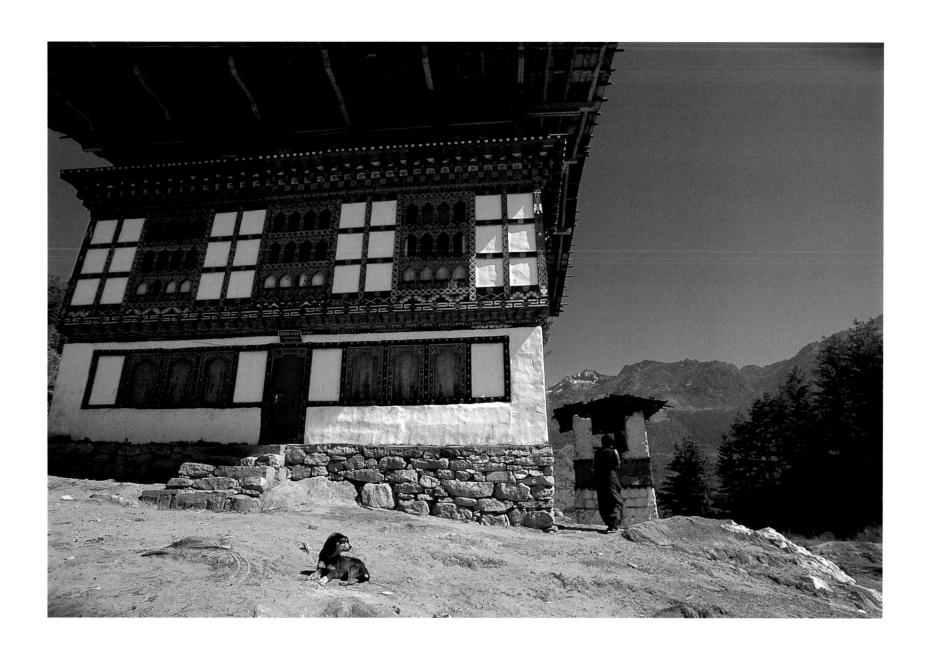

A house in the Paro Valley of Bhutan, near the Tibet border.

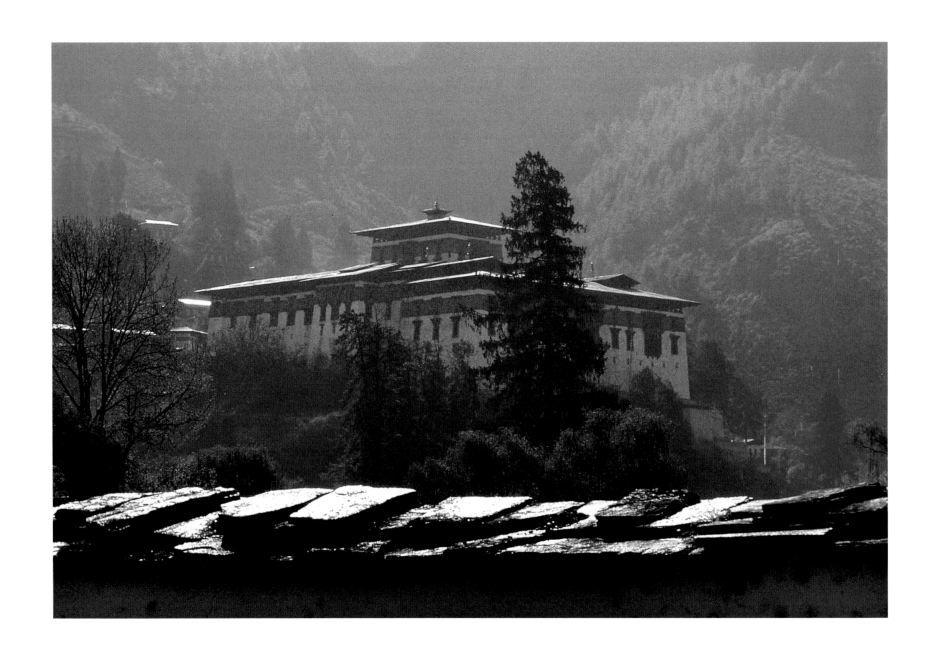

The Paro Dzong, the administrative center of the Paro Valley in Bhutan.

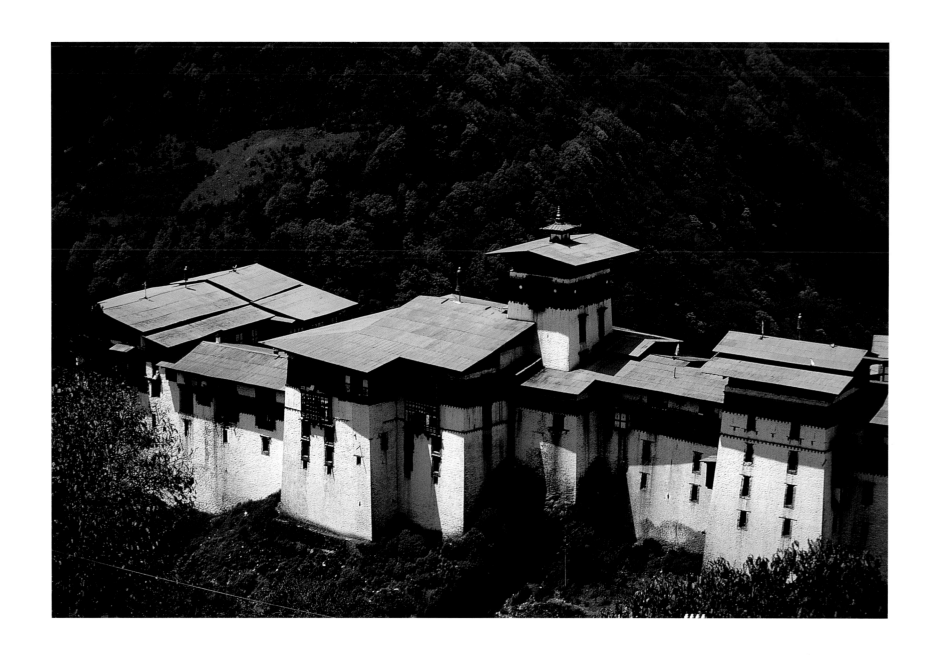

Tongsa Dzong, the largest *dzong* in Bhutan.

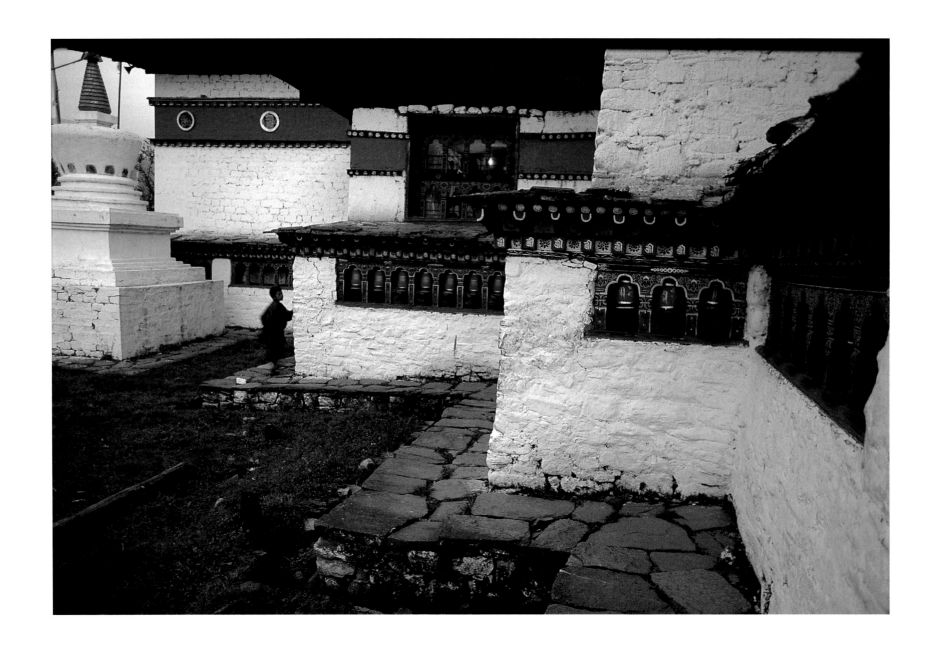

Khyichu Lhakang, a monastery in the Paro Valley, Tibet.

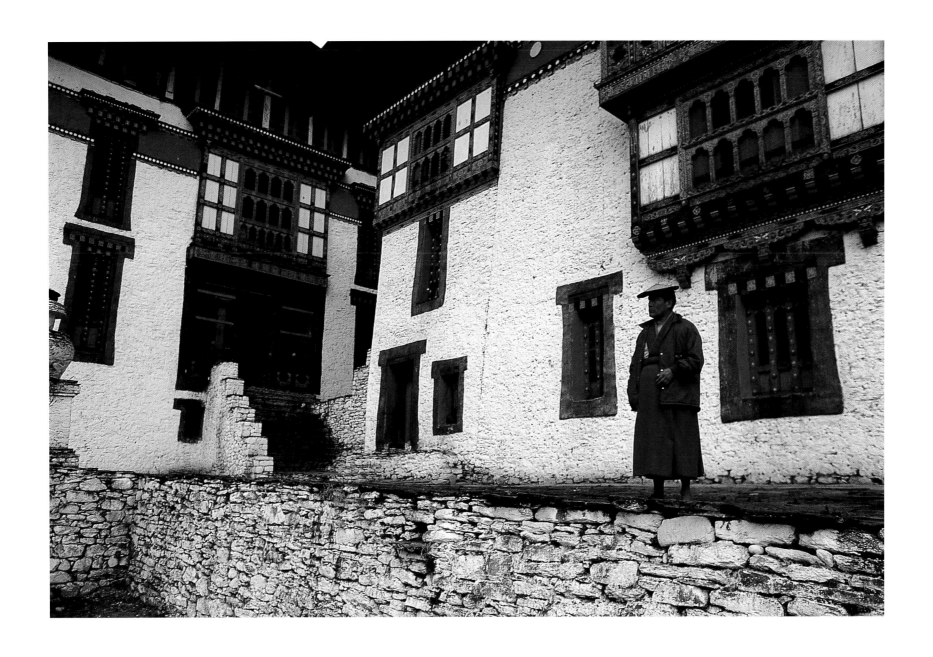

Kurje Lhakang, a monastery in the Bumthang Valley, in western Bhutan.

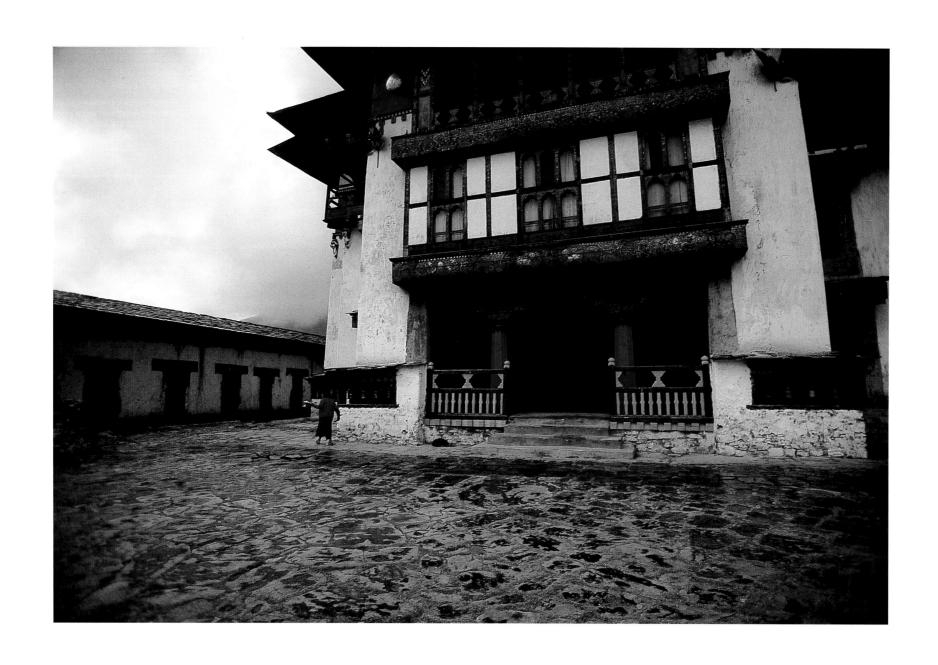

The central courtyard of Gantey Gompa, in Bhutan.

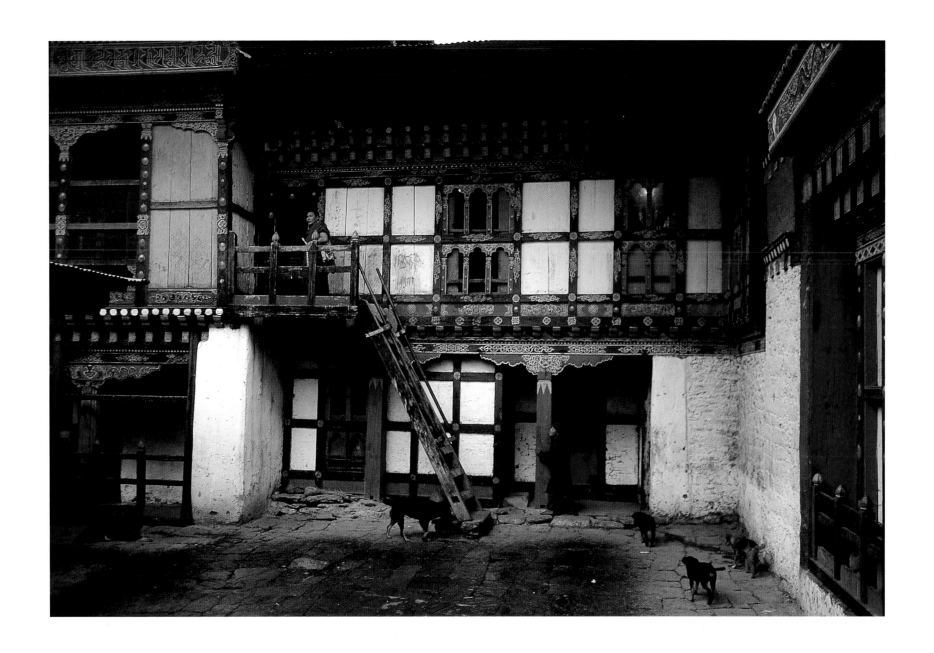

The rooms of the head monks at Gantey Gompa.

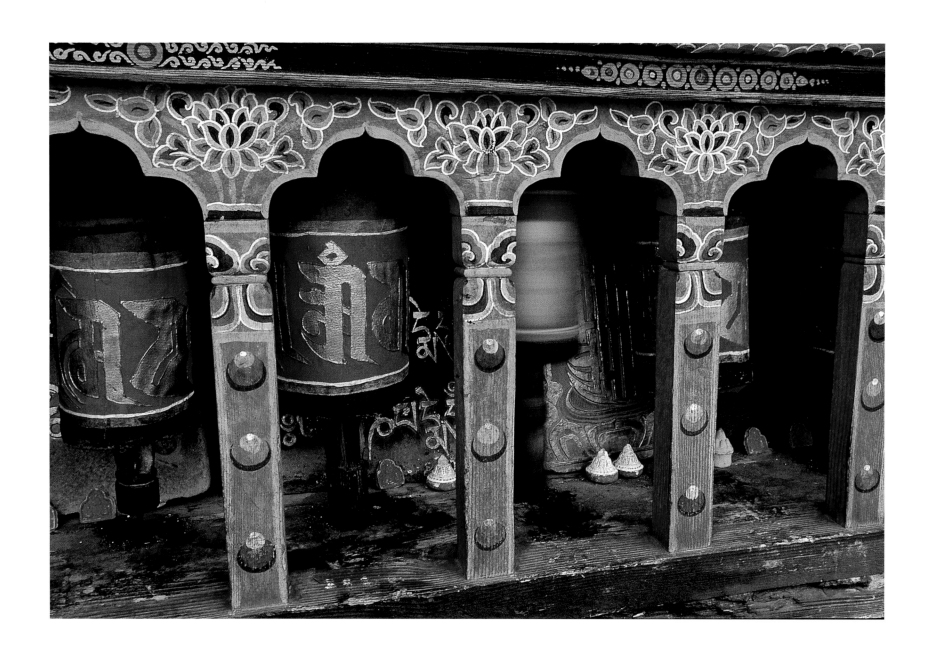

Prayer wheels sometimes contain hundreds of separate prayers.

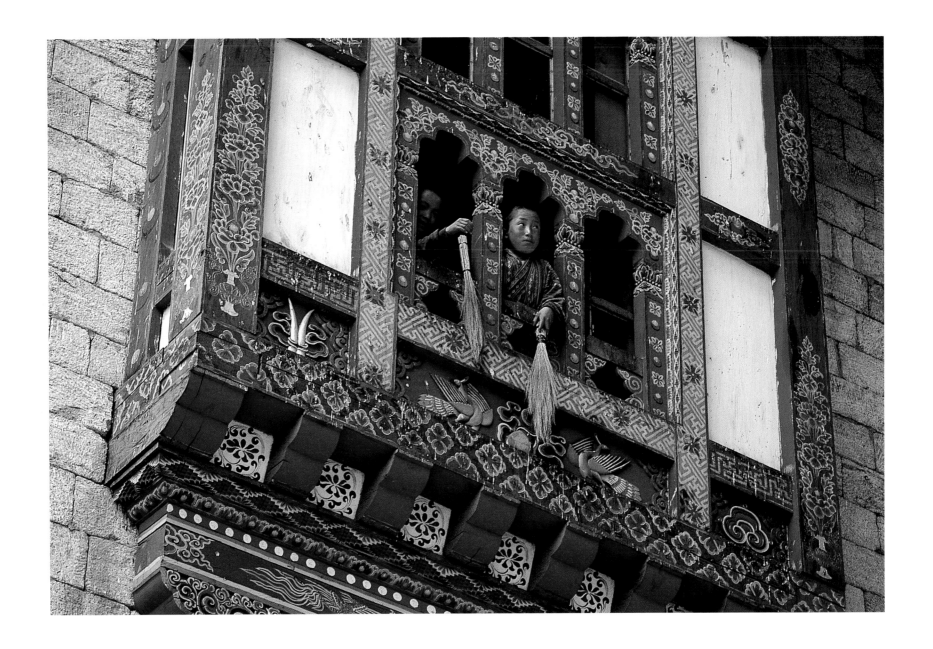

Novices with grass brushes at Kurje Lhakang, in Bhutan.

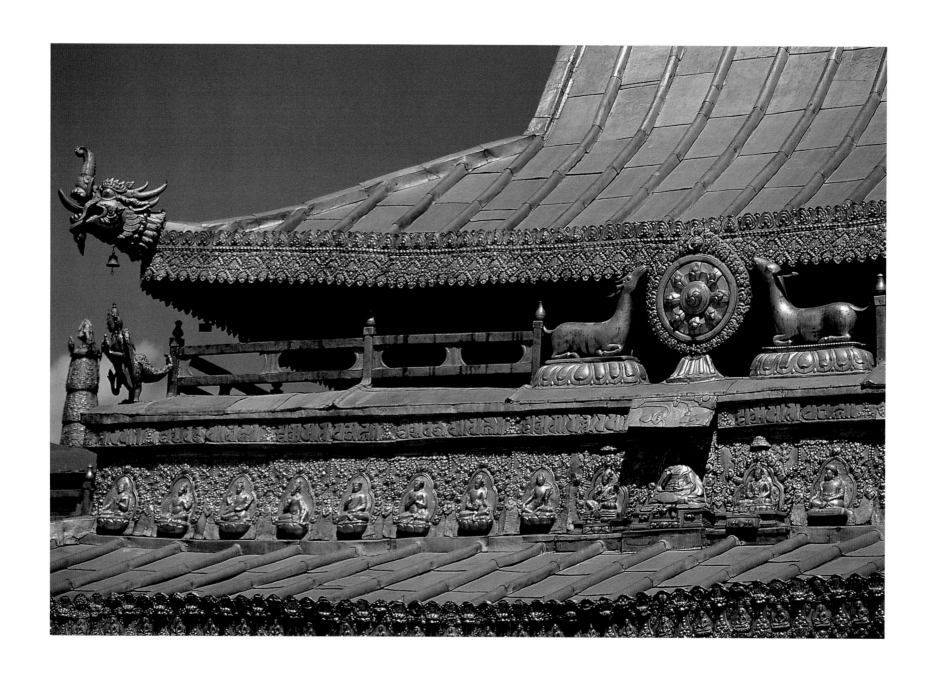

Jokhang Temple in the old city of Lhasa. It is the spiritual center of Tibet.

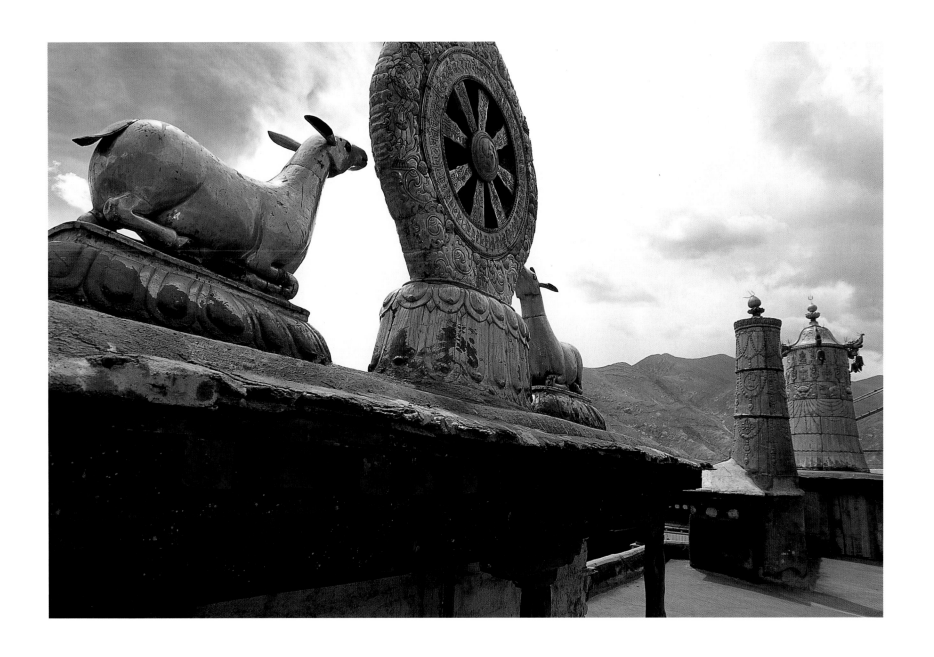

The wheel of dharma at Jokhang Temple, which symbolizes the Buddha's enlightenment.

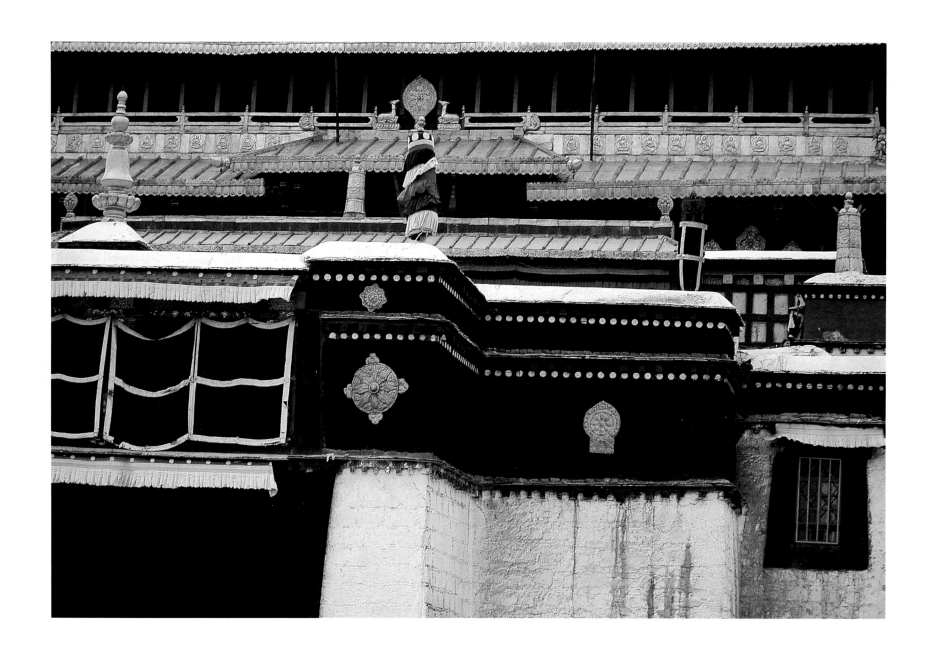

The Samye monastery, founded in the eighth century, was Tibet's first monastery.

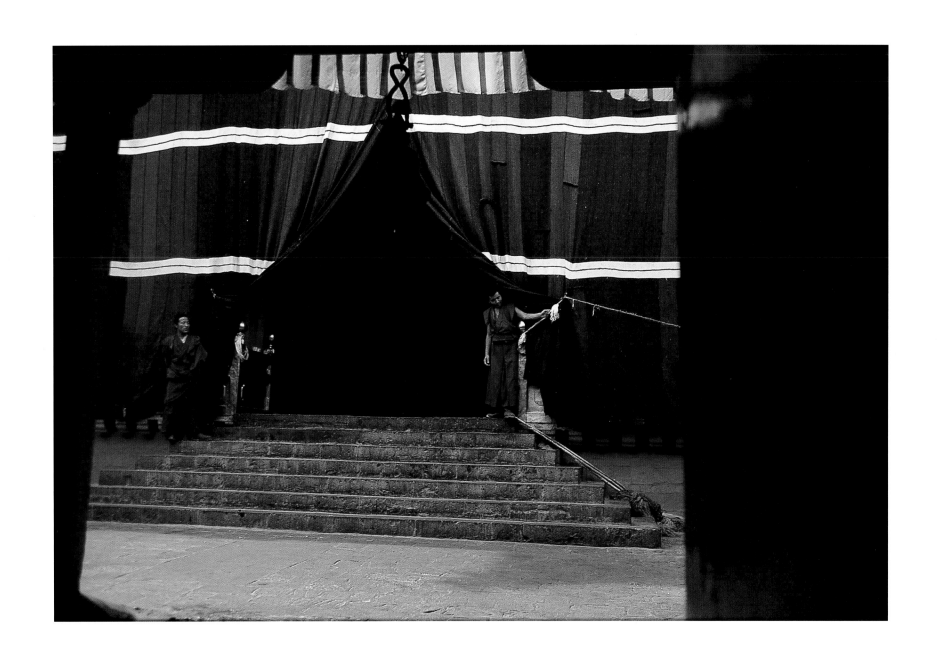

Drepung monastery in Lhasa.

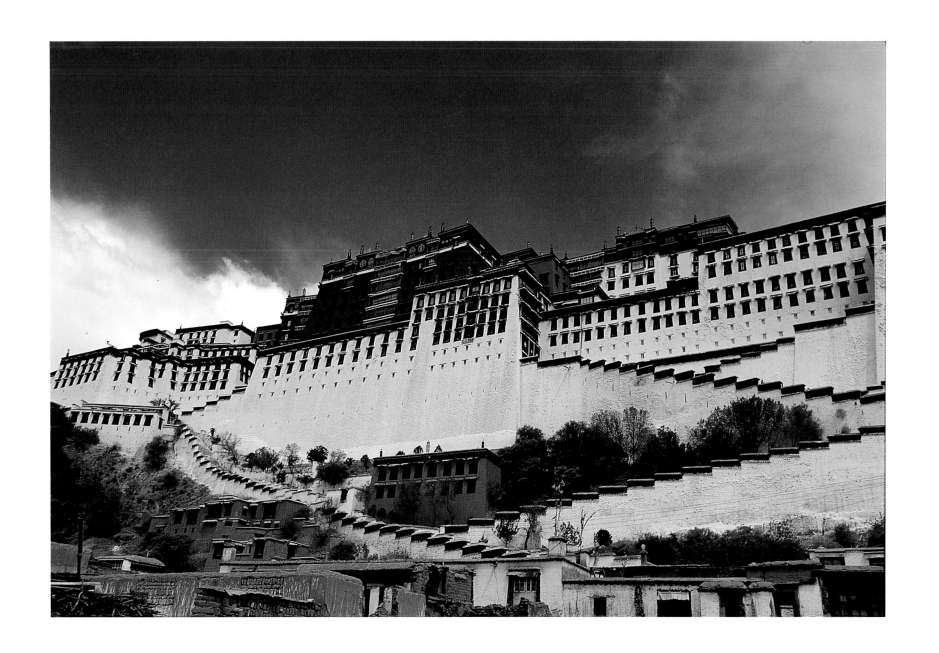

Potala Palace in Lhasa has more than a thousand rooms. It was the winter home of the
dalai lamas and the traditional seat of Tibet's government.

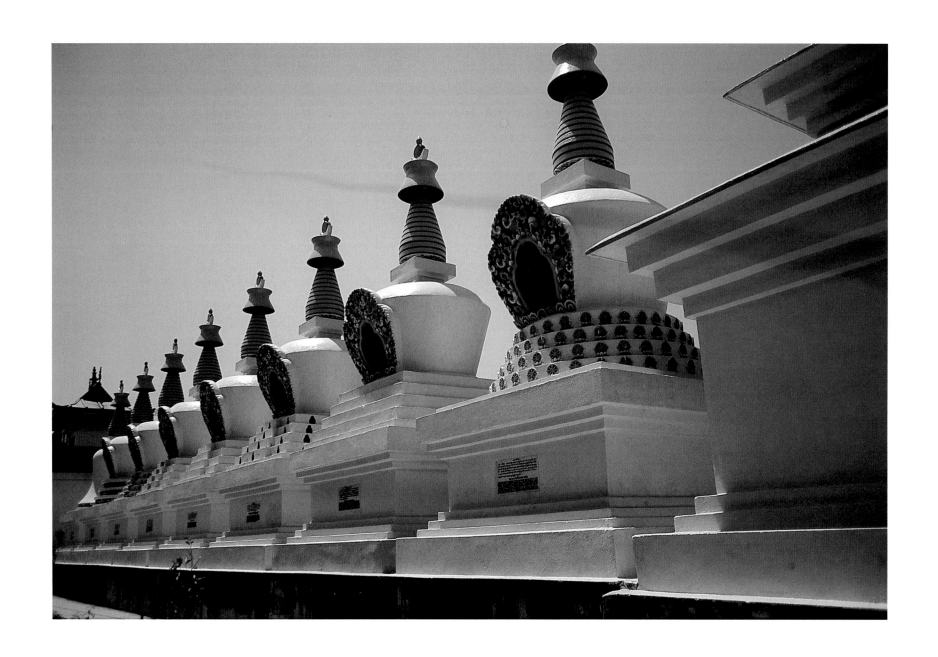

Shechen Tennyi Dargyeling monastery in Kathmandu, Nepal. Each stupa
commemorates an important event in the life of the Buddha.

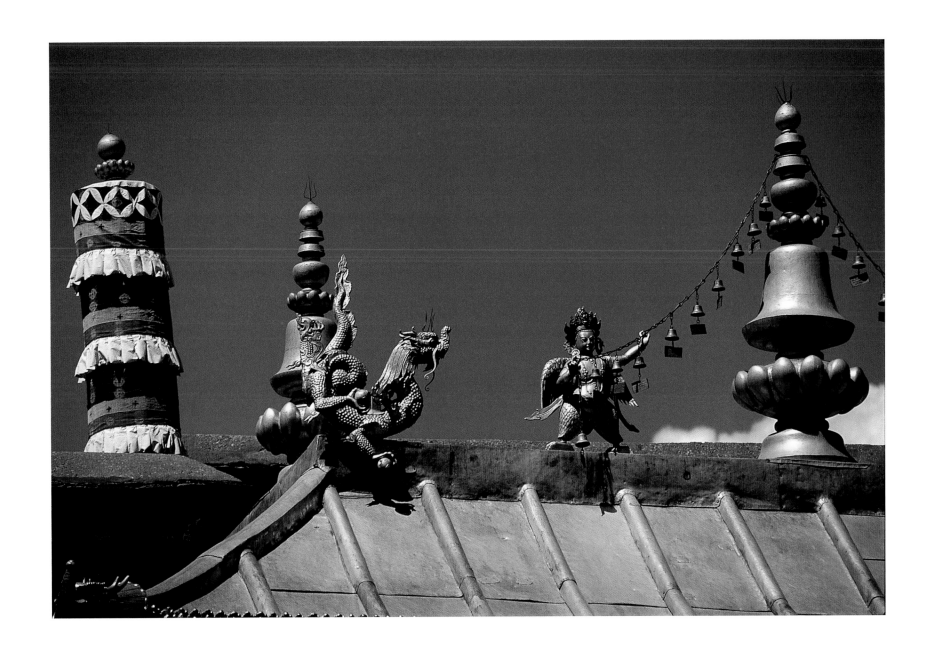

Jokhang Temple, Lhasa.

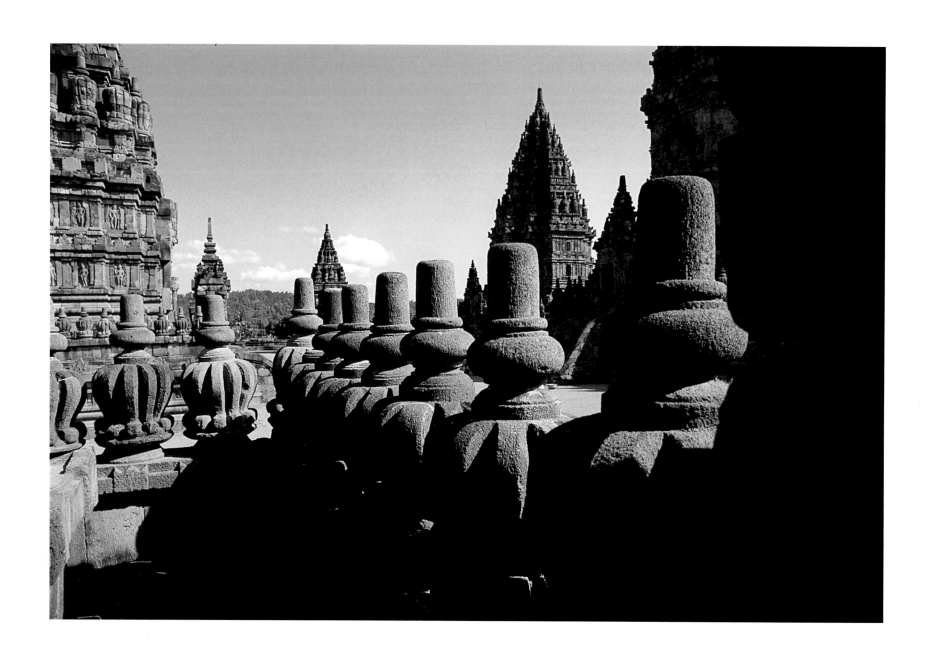

Loro Jonggrang, Java. A ninth-century Hindu shrine near Borobudur, where Hinduism and Buddhism coexist.

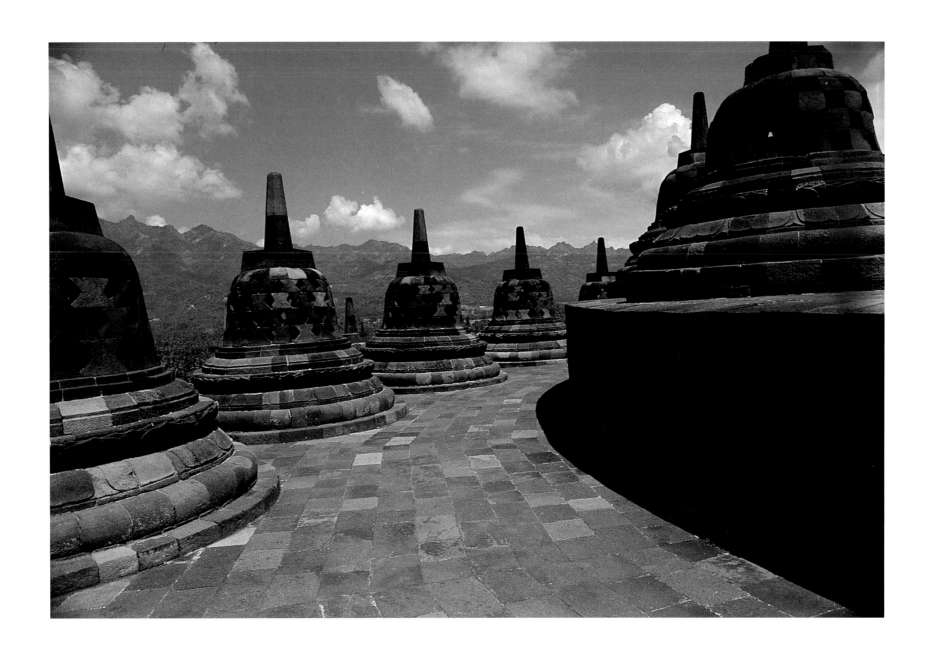

A detail of the Borobudur Stupa, the largest Buddhist monument in the world.

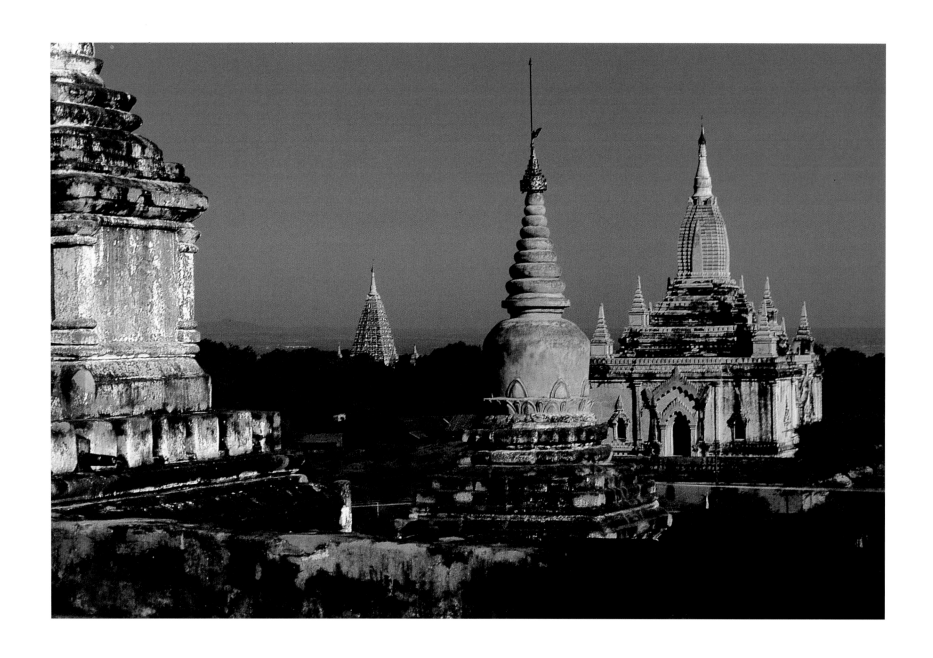

Most of the pagodas at Pagan, Myanmar, were constructed between the eleventh and thirteenth centuries.

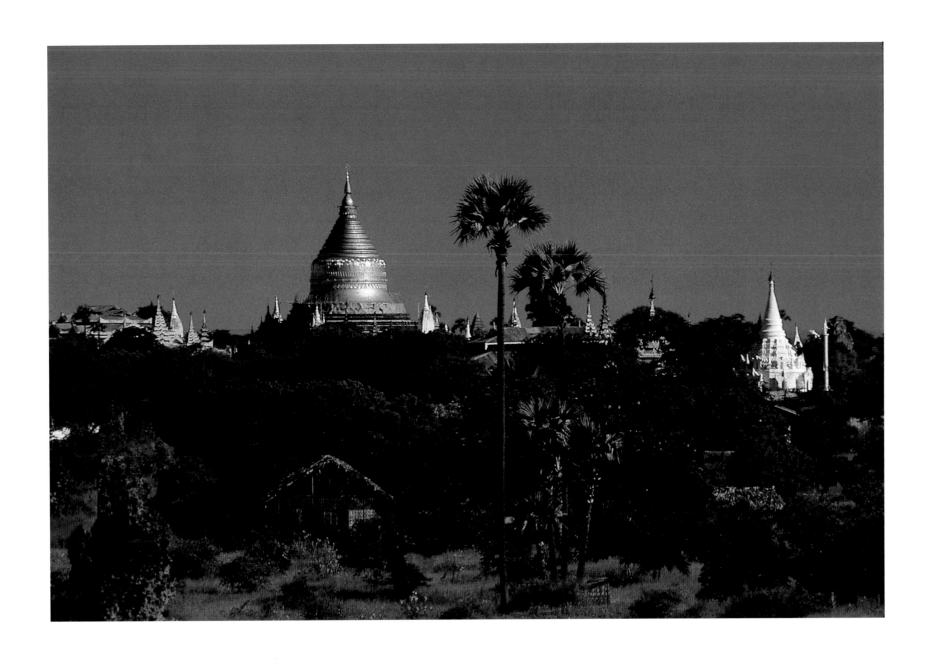

Shwezigon Pagoda in Pagan.

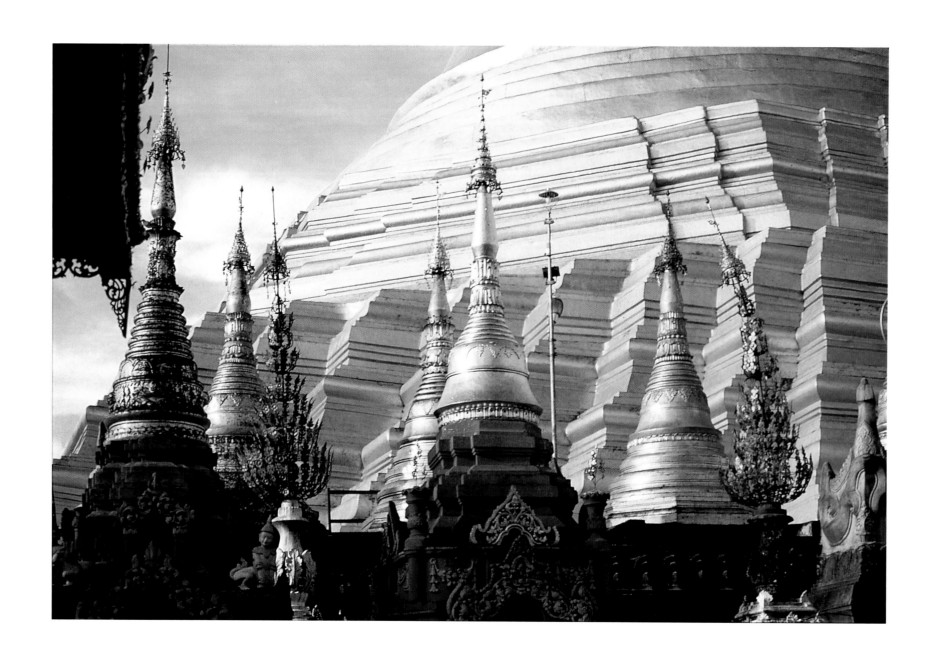

Shwedagon Pagoda, Rangoon. Sixty-four shrines encircle the base of this 1,500-year-old pagoda.

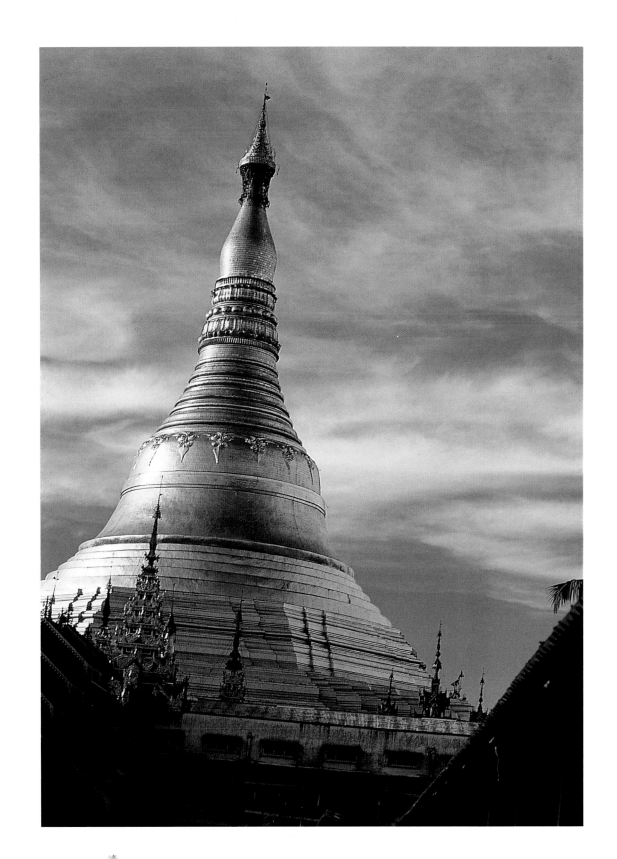

The Shwedagon Pagoda is 326 feet high.
It is the spiritual heart of Myanmar.

Pagan at dusk.

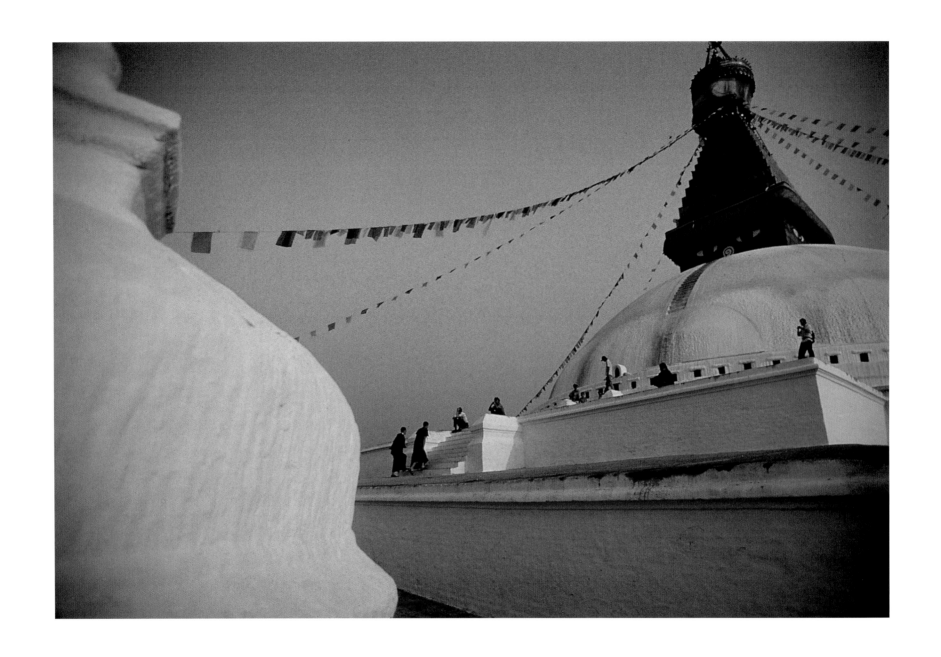

Boudhanath Stupa in Kathmandu, Nepal.

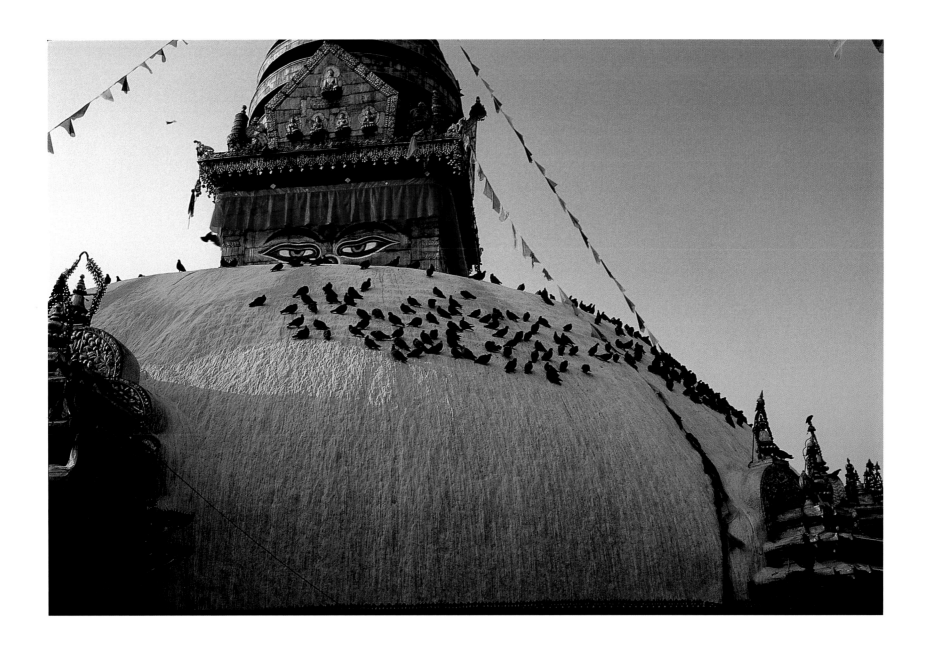

Swayambhunath Stupa, in Kathmandu.

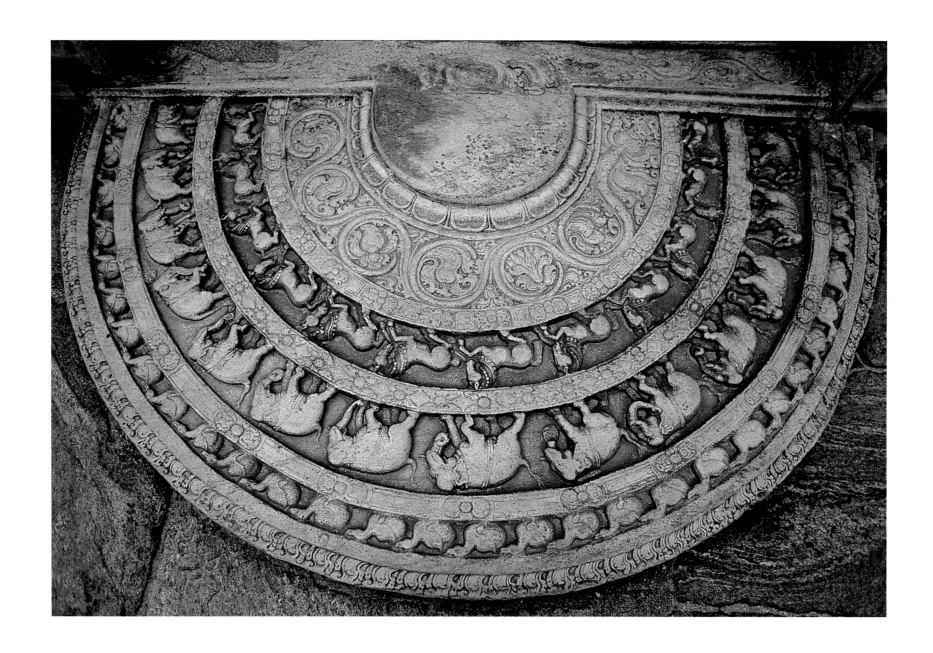

The traditional emblem of Sri Lanka appears on a moonstone step in a temple in the Polonnaruwa complex.

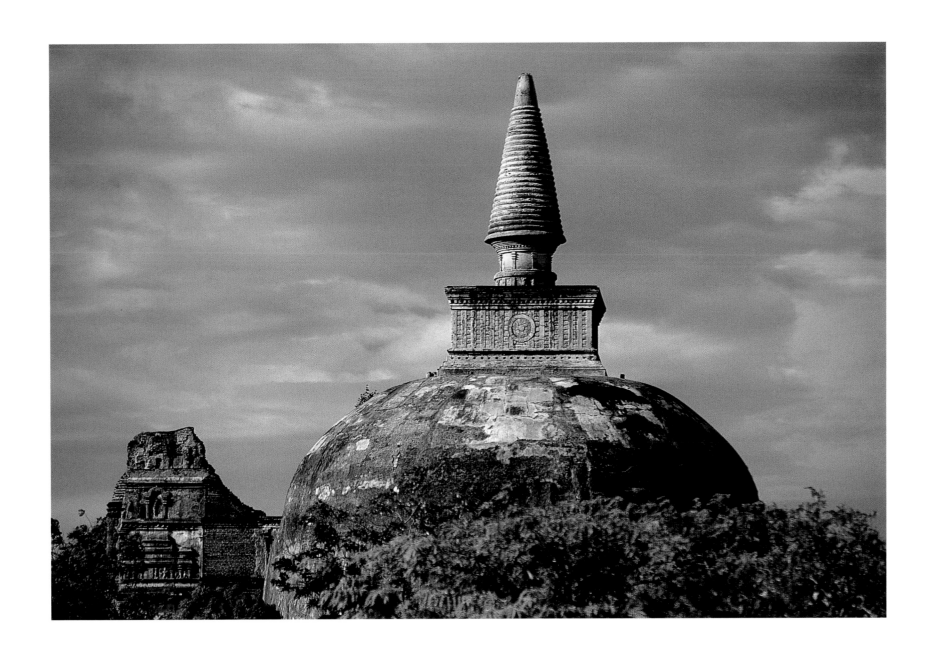

Kiri Vehera Stupa, Polonnaruwa, Sri Lanka.

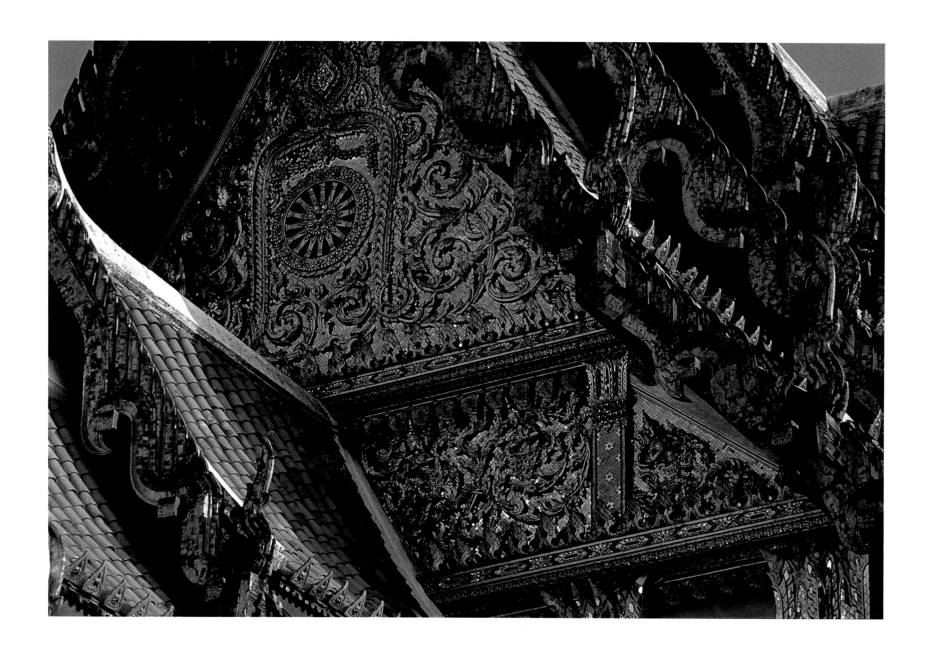

Decorative roof on a temple in Chiang Mai, in northern Thailand.

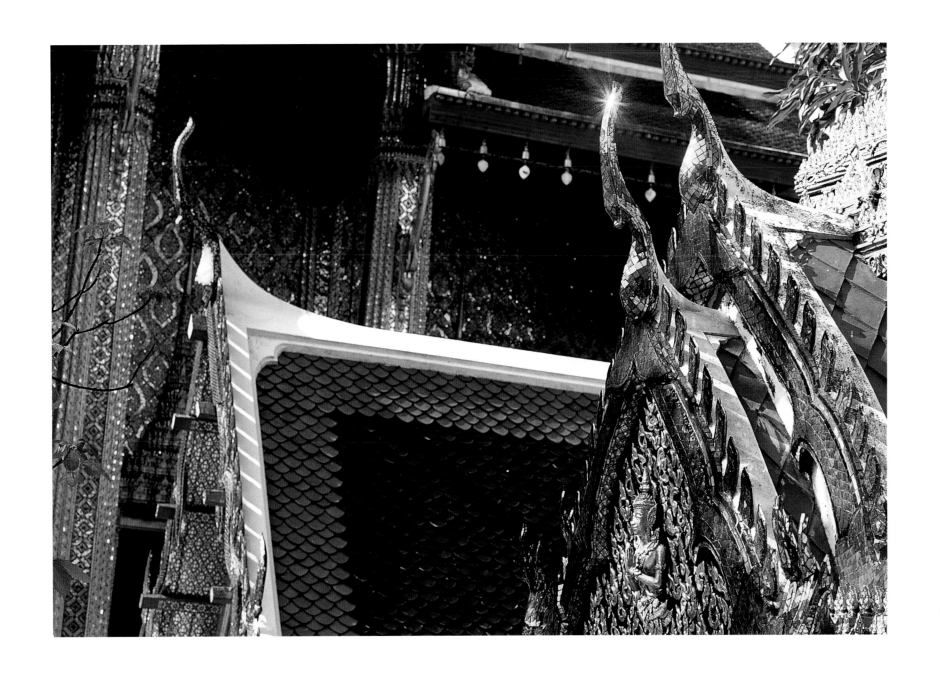

Gold leaf, mirrors, and bells decorate a temple in Bangkok.

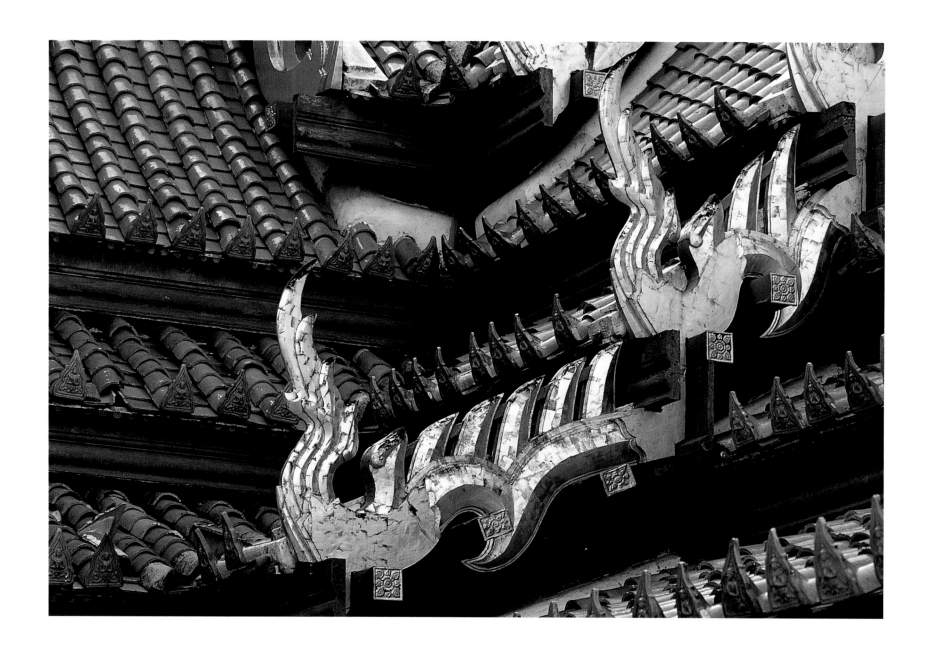

A small figure of Buddha appears in the end tiles of the roof on a temple in Chiang Mai.

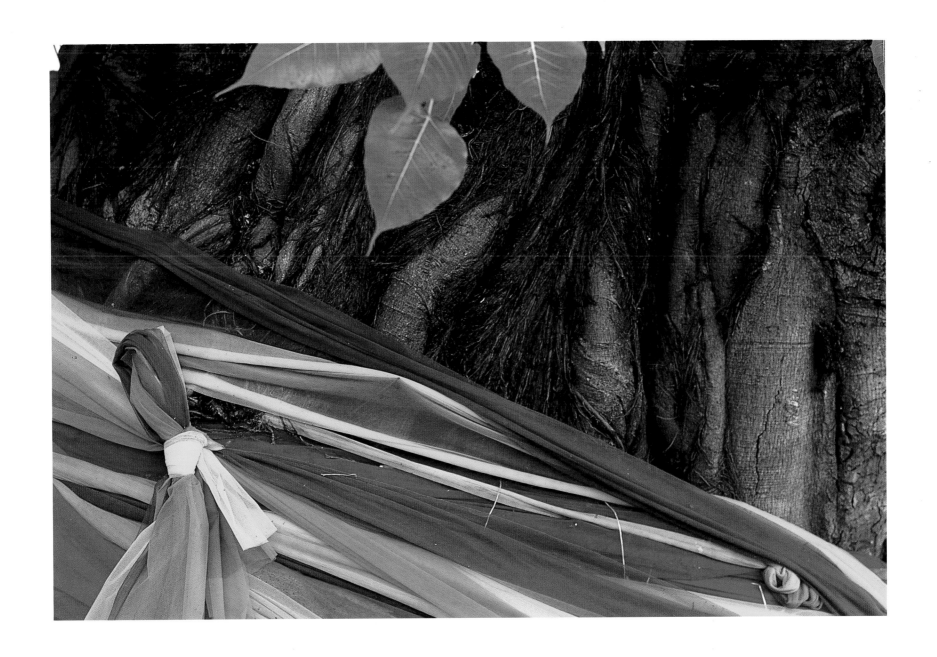

Colored scarves decorate a sacred tree in Bangkok. Buddha was sheltered by a fig tree when he found enlightenment.

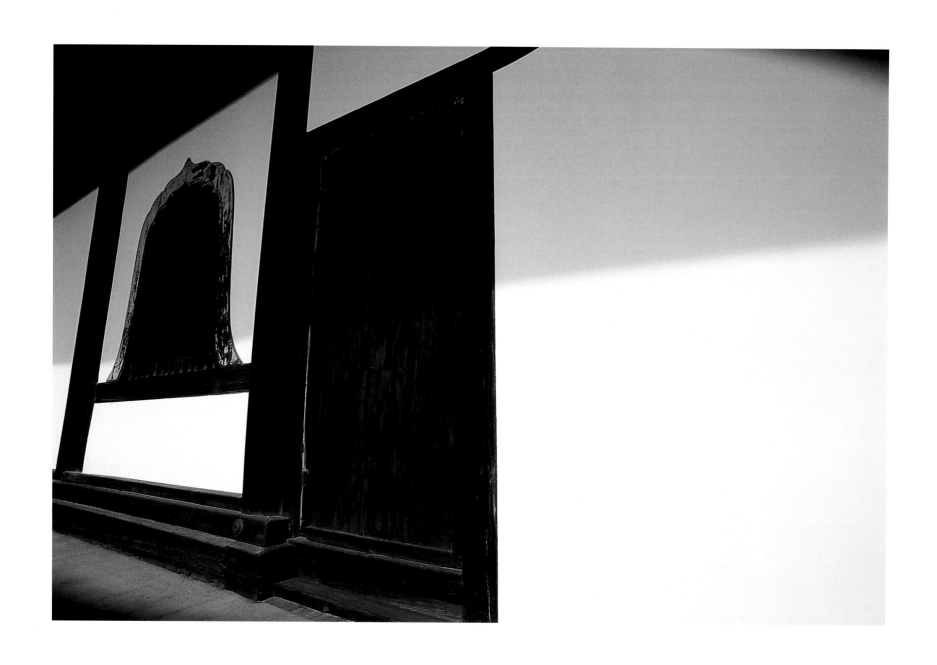

A Buddhist temple in Kyoto, Japan.

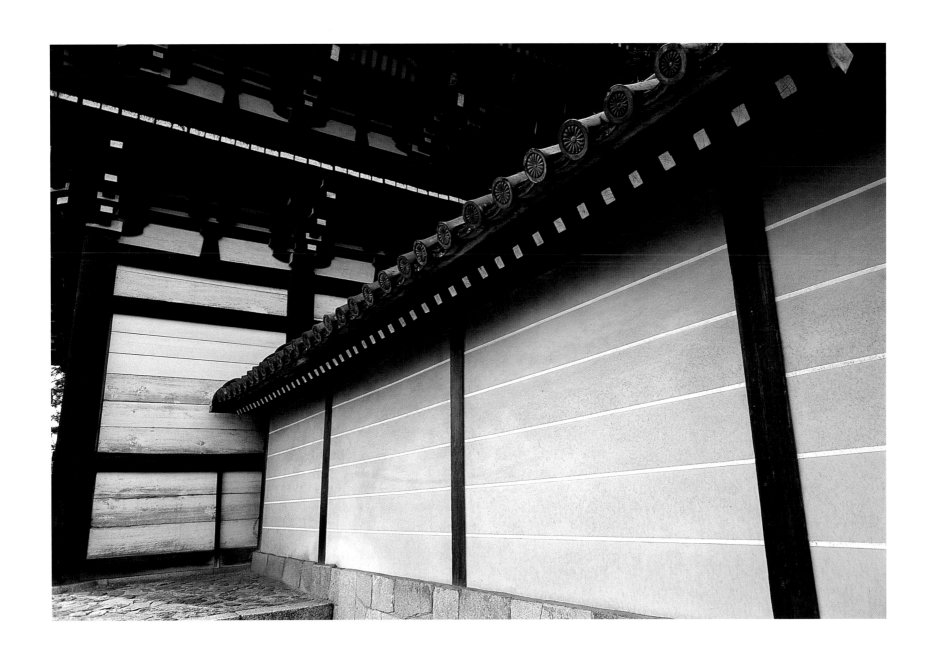

Kyoto.

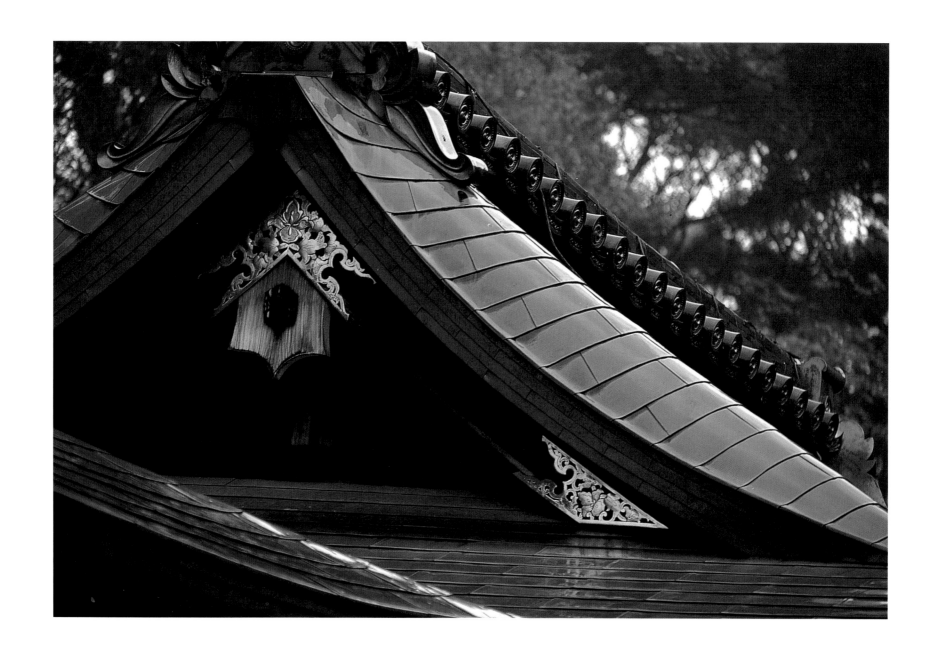

The roof of a Buddhist shrine in Kyoto.

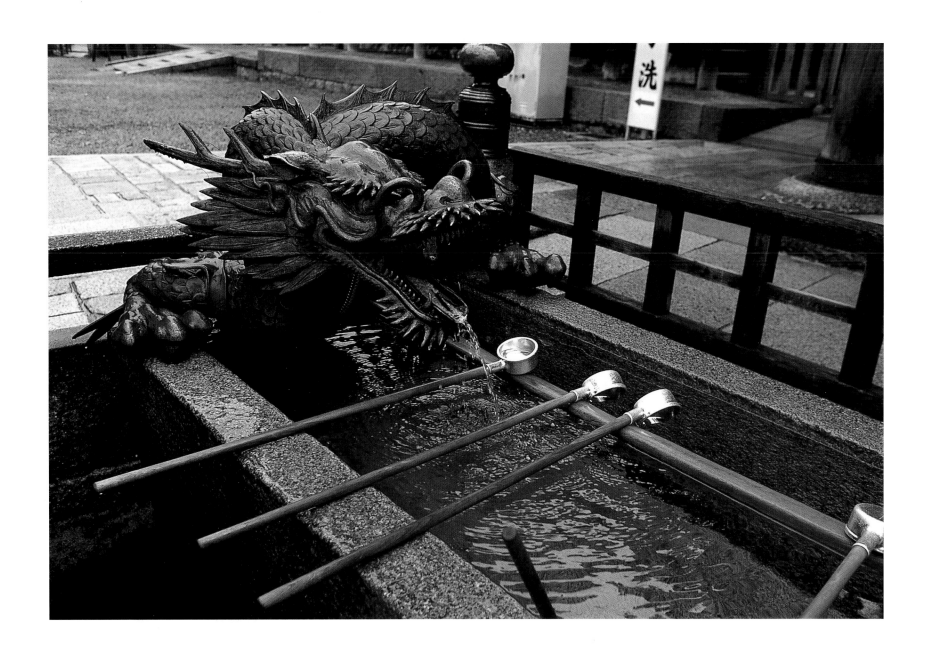

Long-handled ladles provide water for ritual purification at the Kiyomizu Temple in Kyoto.

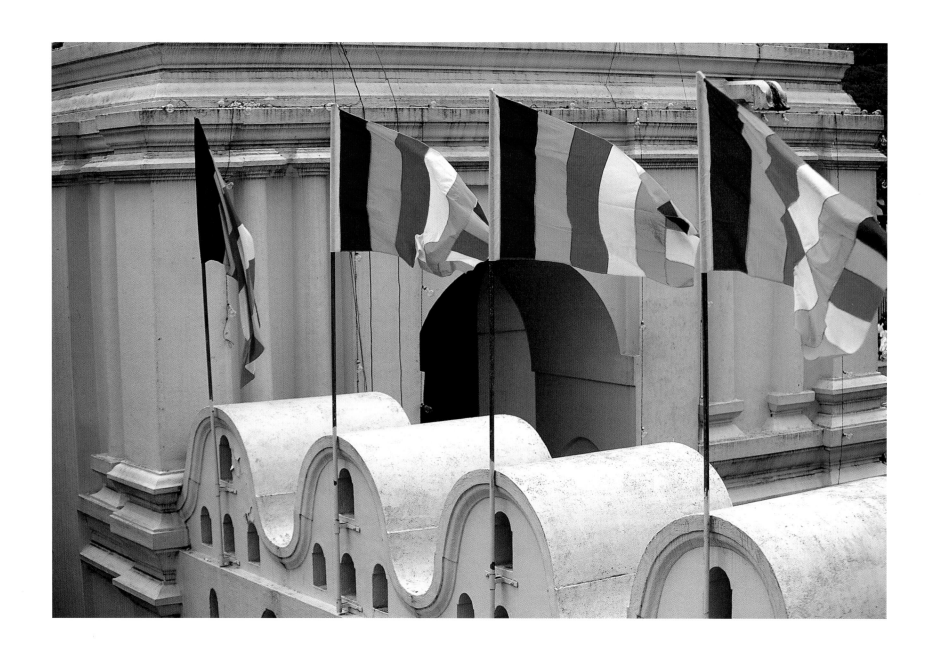

Buddhist flags at the Temple of the Tooth in Kandy, Sri Lanka.

The Temple of the Tooth enshrines a tooth relic from Shakyamuni Buddha.

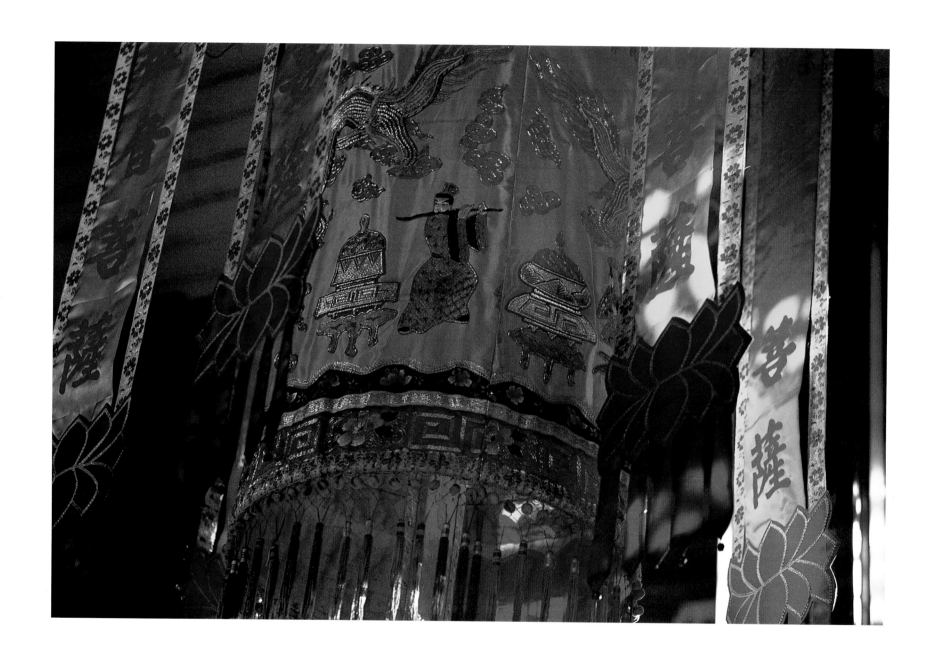

Silk and satin embroidered hangings in a temple in Bangkok.

Decorative silk hangings in the Potala Palace, Lhasa, Tibet.

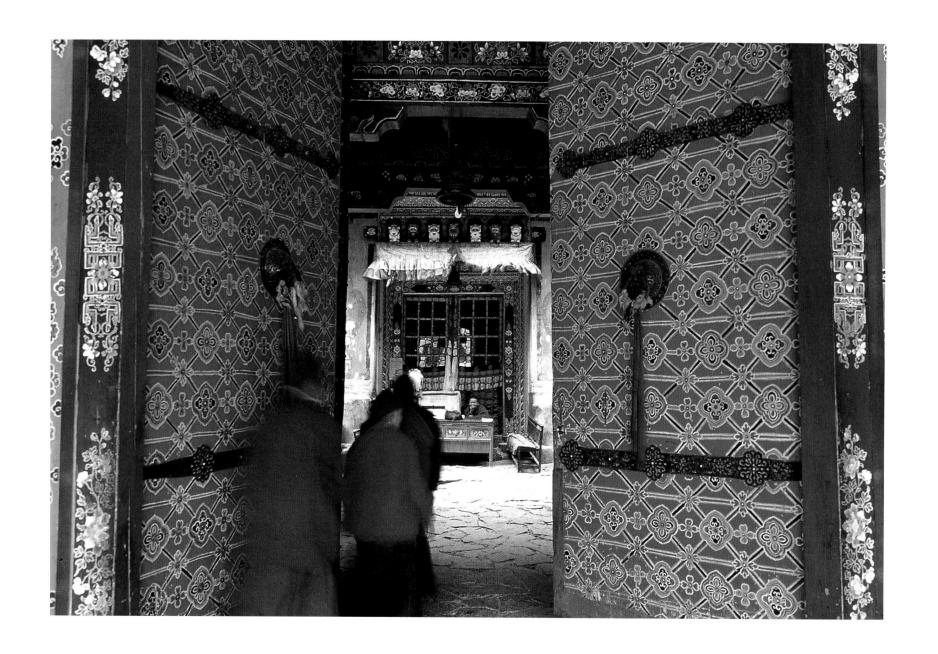

Huge painted doors frame the entryway into Samye monastery in Tibet.

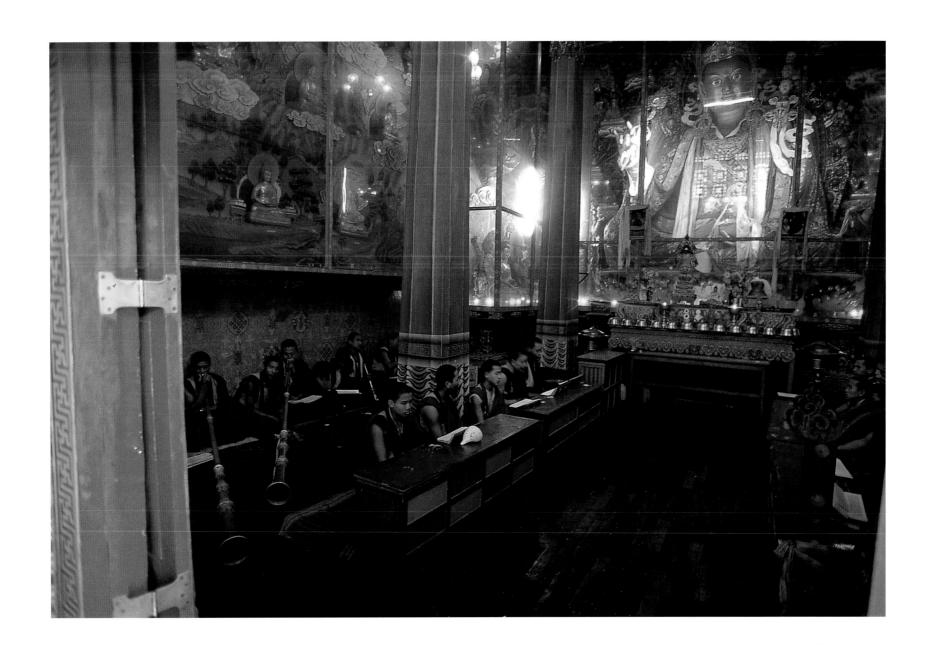

Monks in the Shechen Tennyi Dargyeling monastery in Kathmandu.

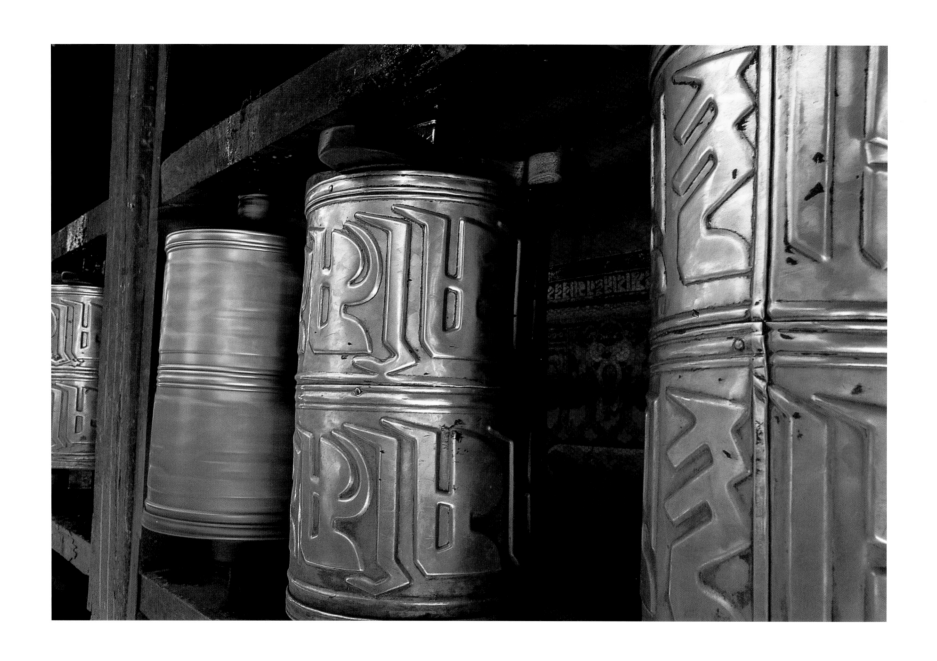

Metal prayer wheels in a temple in Tibet.

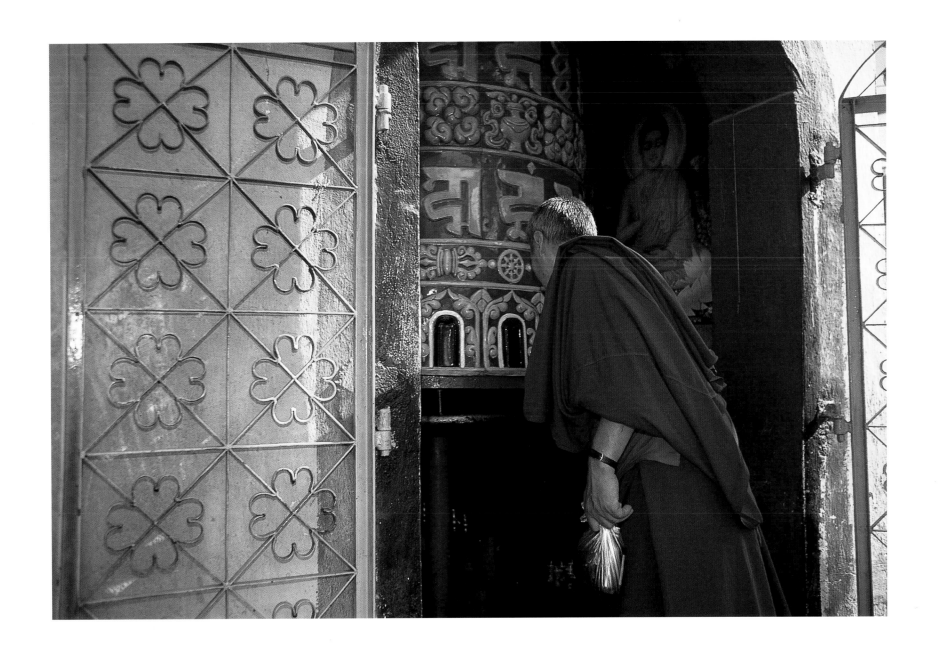

A monk turns a prayer wheel at Swayambhunath Temple in Kathmandu.

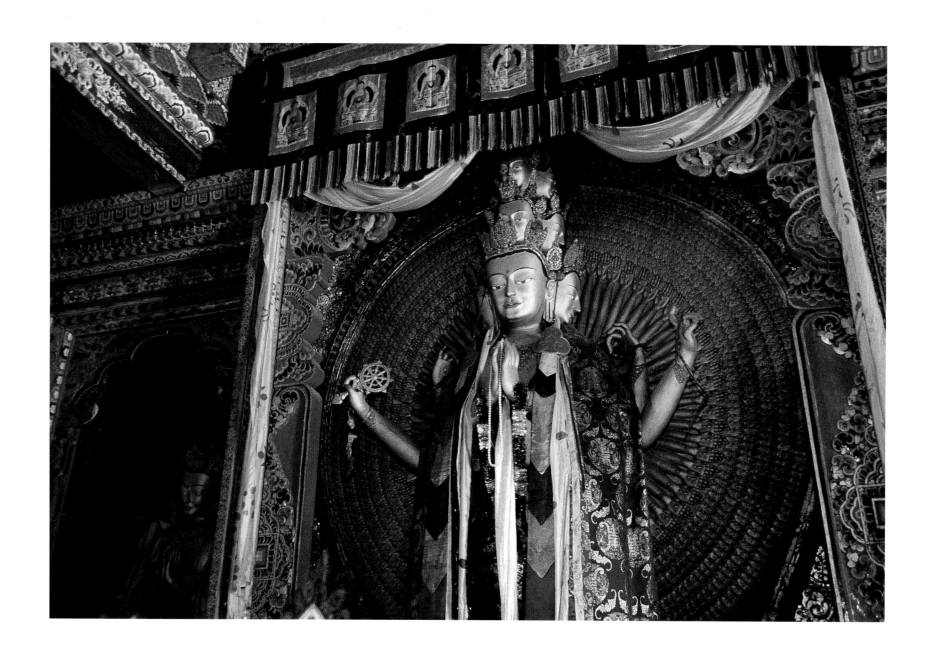

The eleven-headed, thousand-armed Chenrezi Bodhisattva at Gantey Gompa in Bhutan.

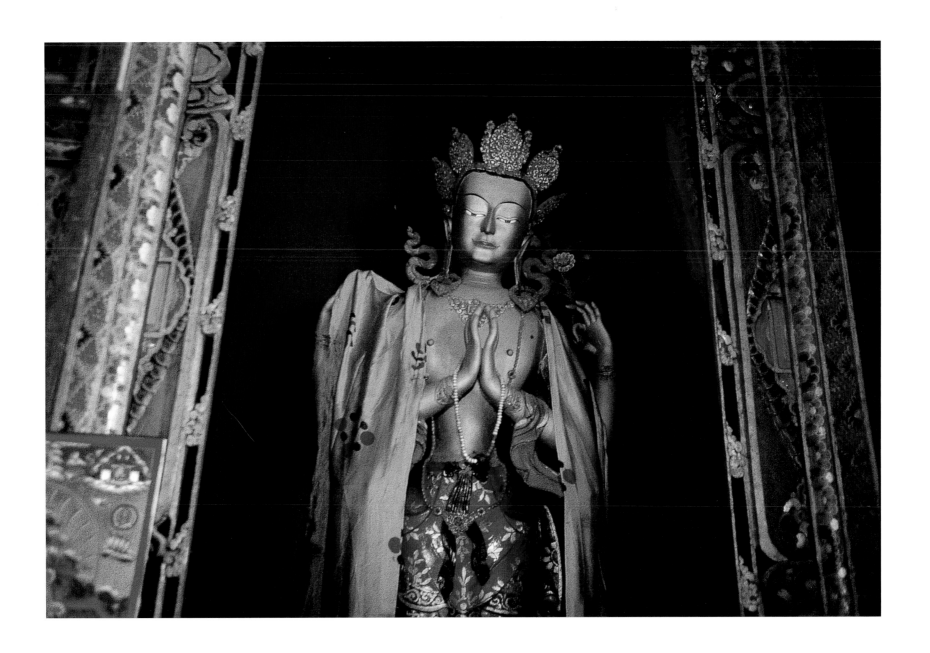

Bodhisattvas have attained enlightenment but remain on earth to teach.

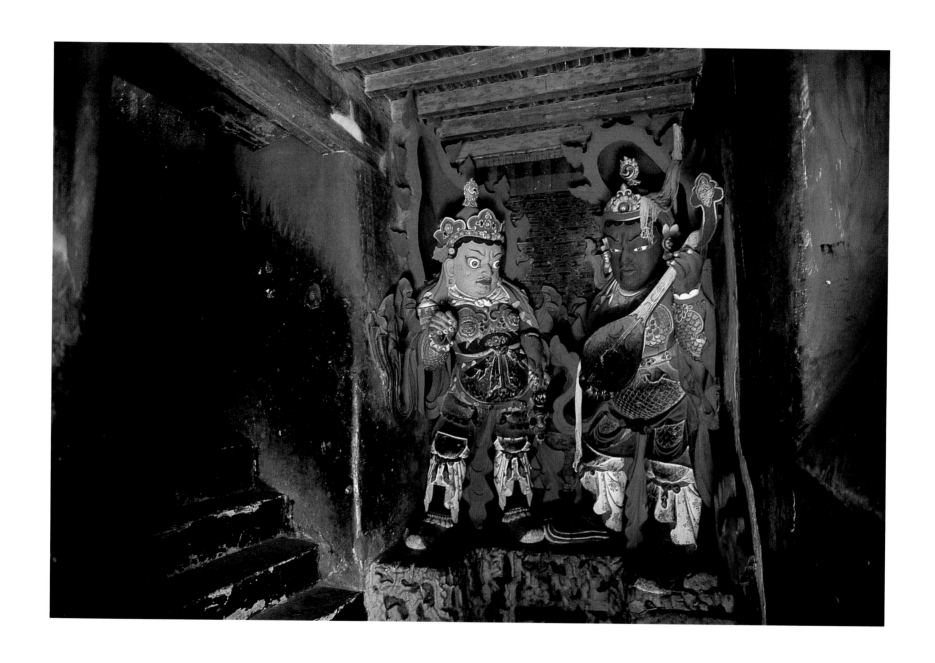

The Kumbum *chorten* in Gyantse, Tibet, was built in the fifteenth century.

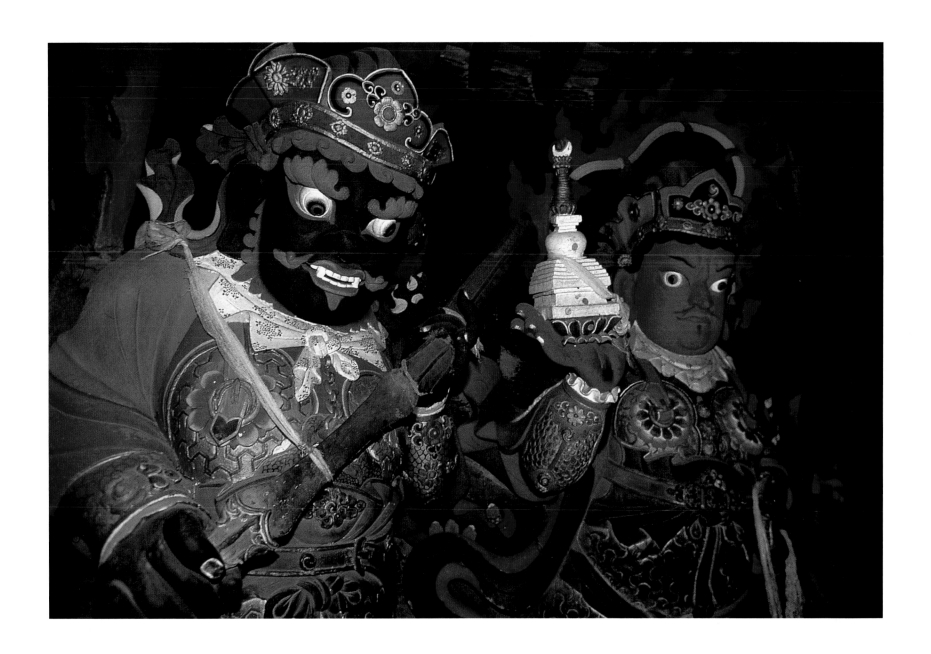

Protective deities in the Kumbum *chorten*.

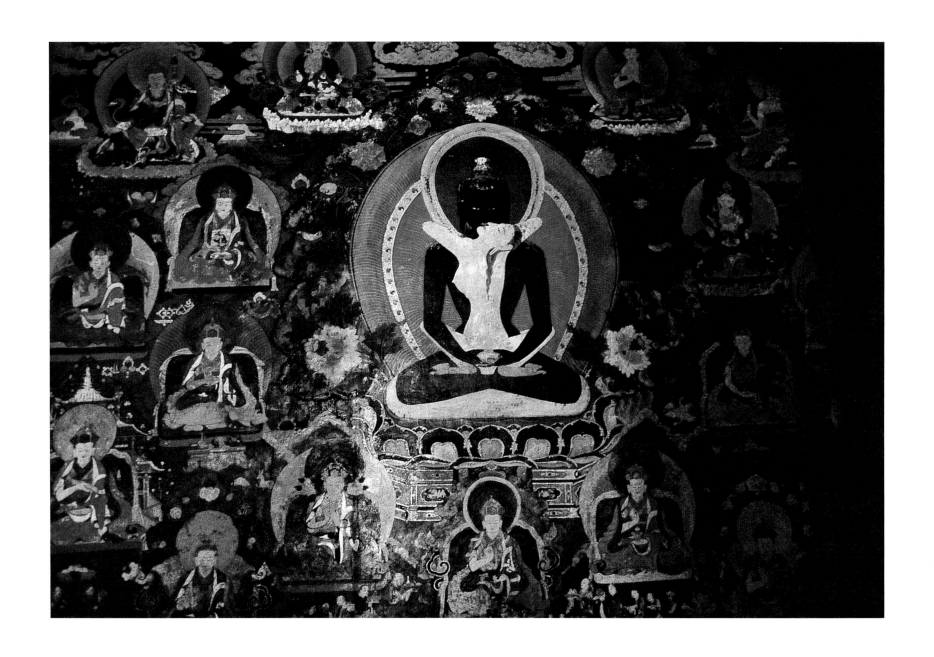

Potala Palace, Lhasa. Samantabhadra, the primordial Buddha, with his consort.

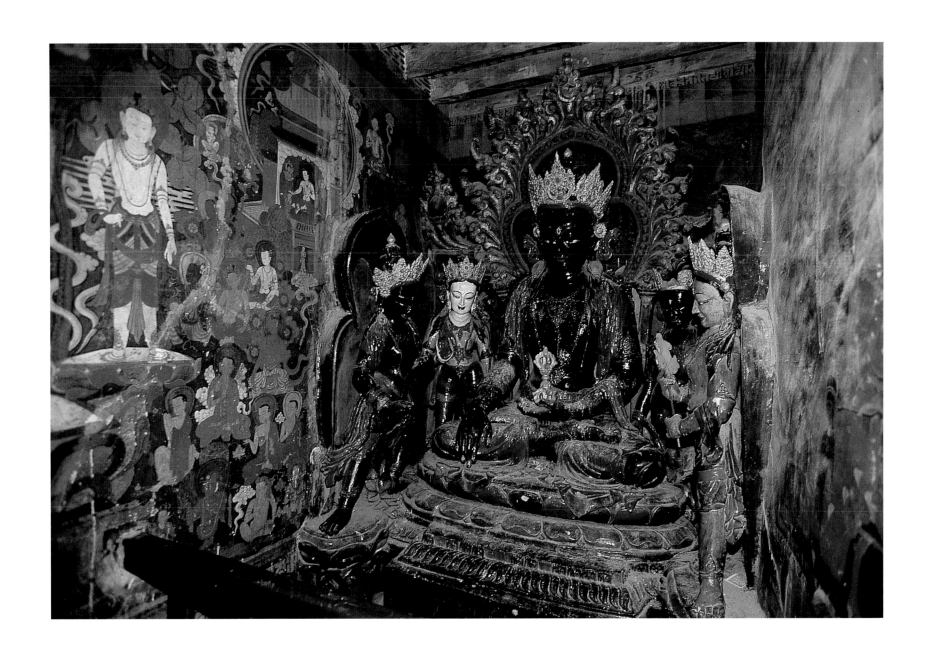

Potala Palace, Lhasa. The statue represents a Tantric form of Lord Buddha.

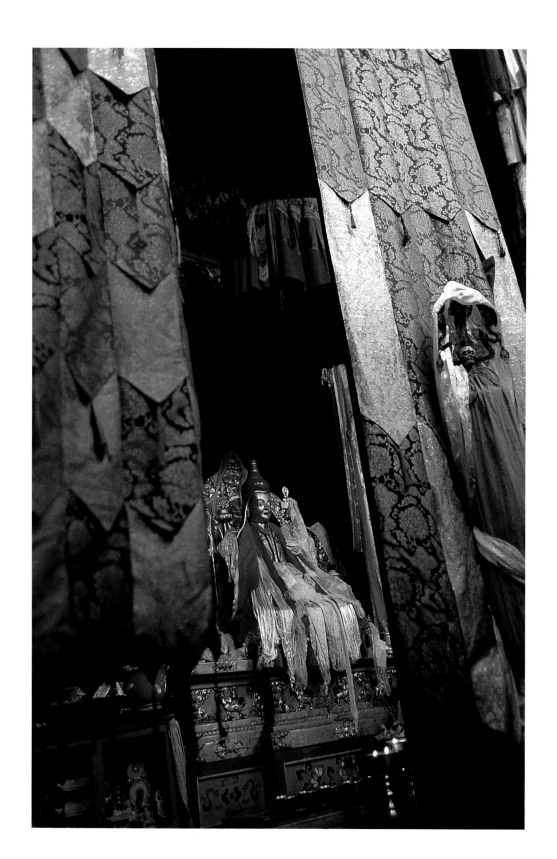

White silk *kata* scarves are draped on a figure
representing a Dalai Lama in Potala Palace.

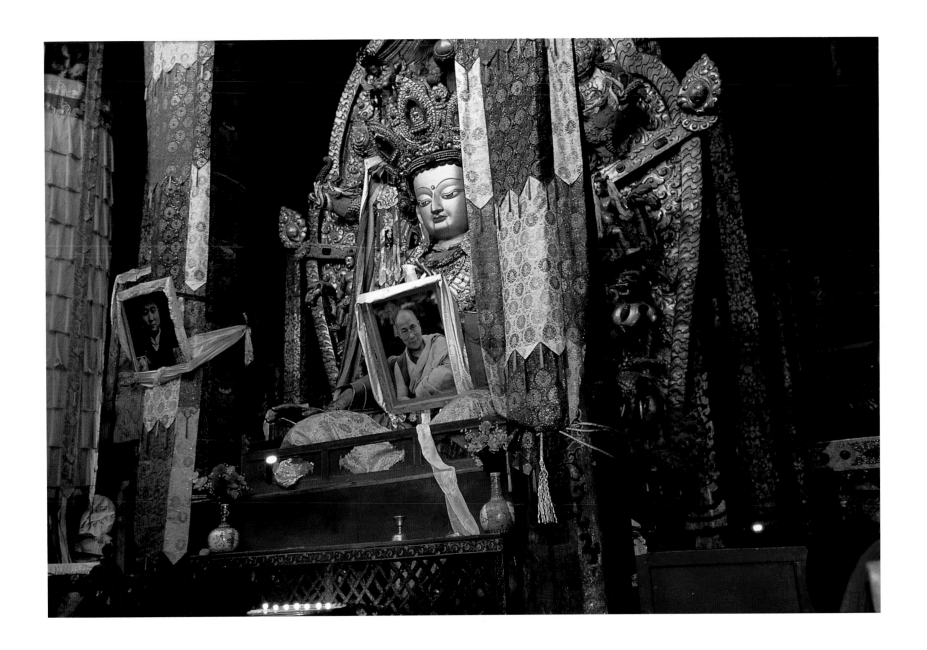

Shakyamuni Buddha with a photograph of His Holiness, the fourteenth Dalai Lama, in Potala Palace.
Photographs of the Dalai Lama have since been prohibited in the Potala and throughout Tibet.

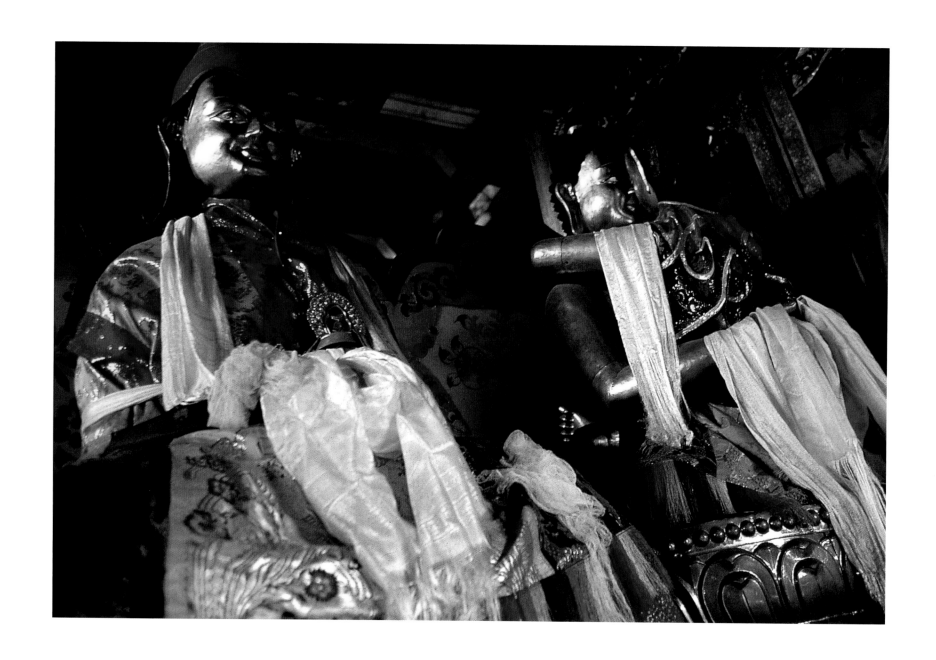

Buddhas in a temple in Tibet.

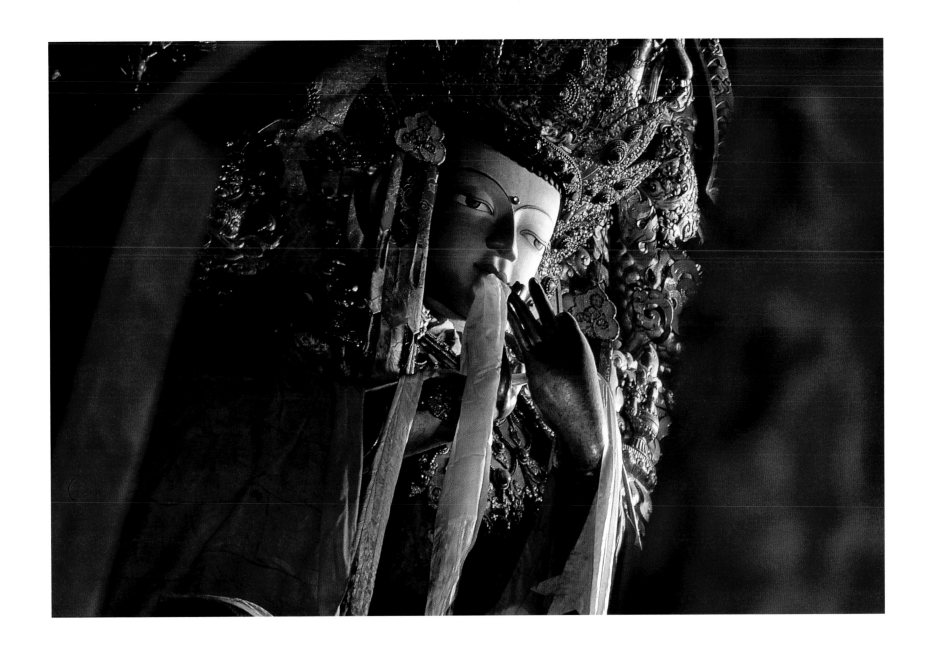

Maitreya Buddha in Shigatse, Tibet.

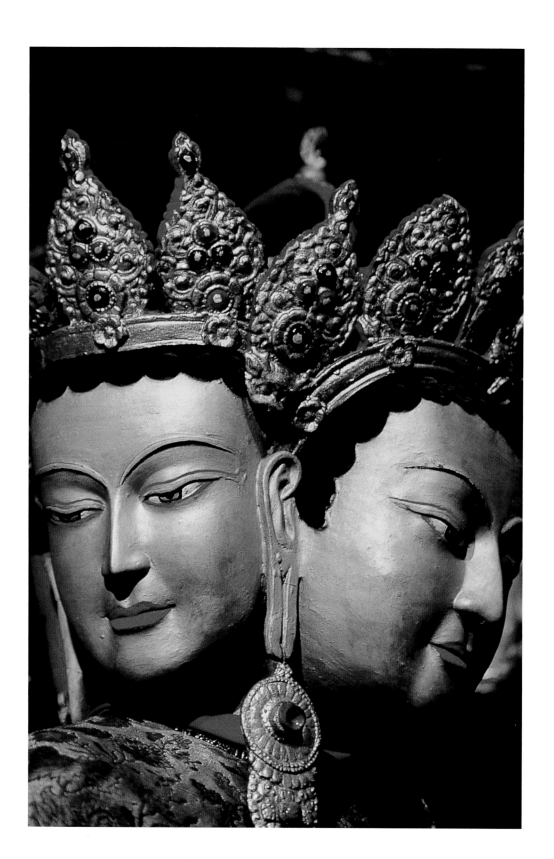

Jokhang Temple, Lhasa. Maitreya Buddha,
the Buddha of the Future, who will be the fifth
and final earthly buddha.

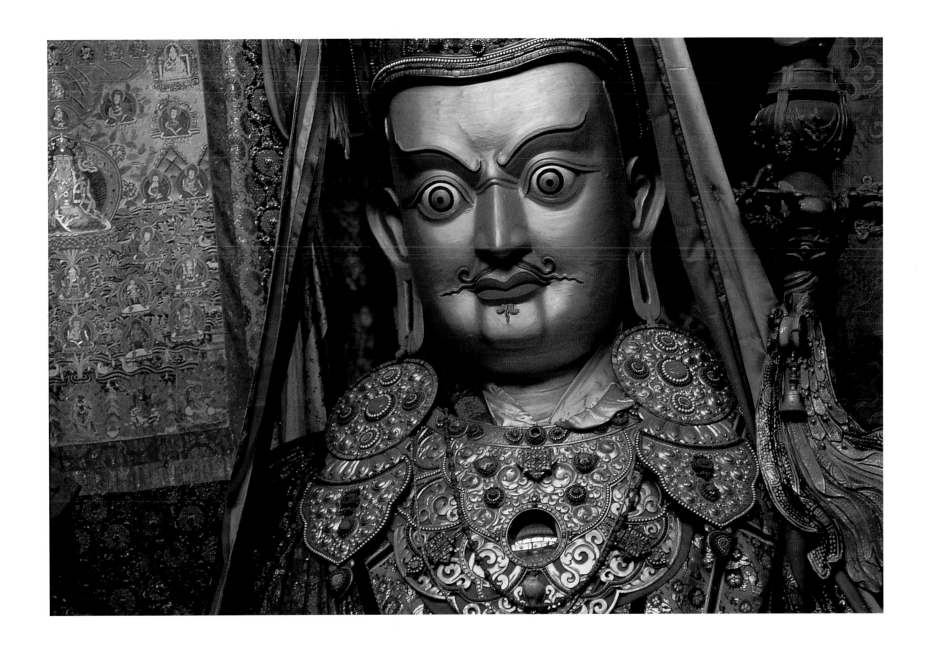

Jokhang Temple, Lhasa. Padmasambhava, or Guru Rinpoche, who brought Buddhism to
Tibet in the eighth century, is venerated as the second buddha.

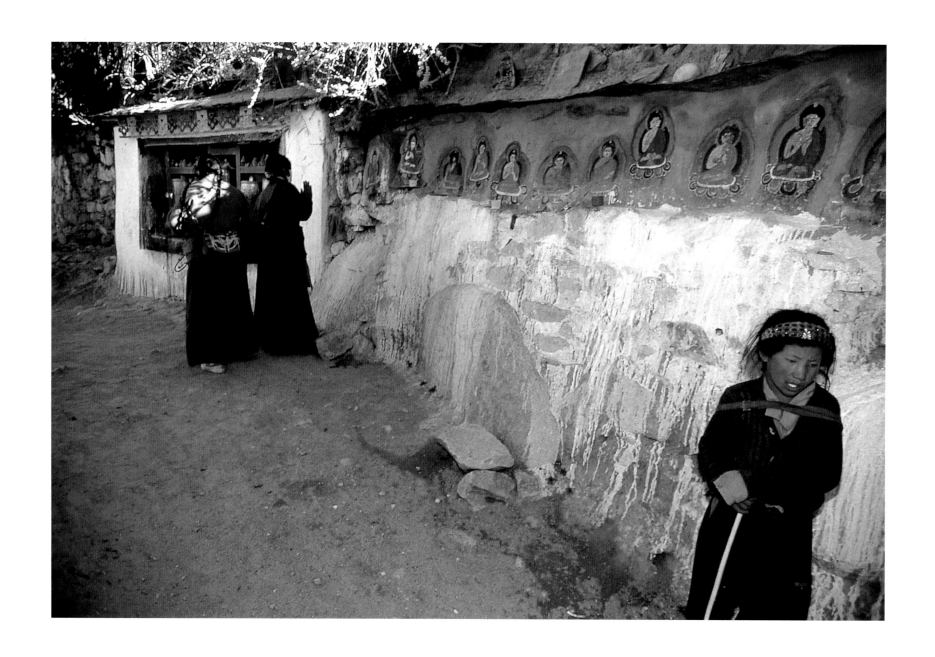

Images of Buddha are painted on rock walls along the path to the Drepung monastery in Lhasa.

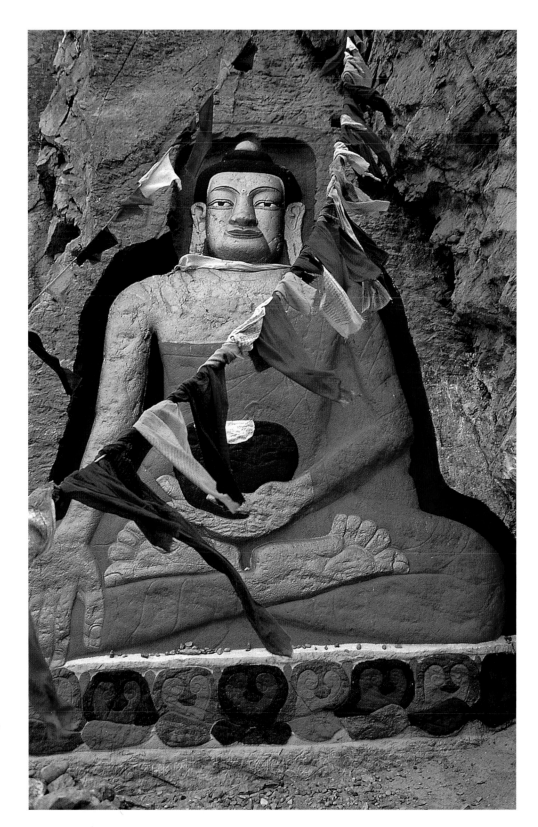

An Indian Buddhist master in the eleventh century, Atisha,
carved this Buddha on a cliff outside Lhasa.

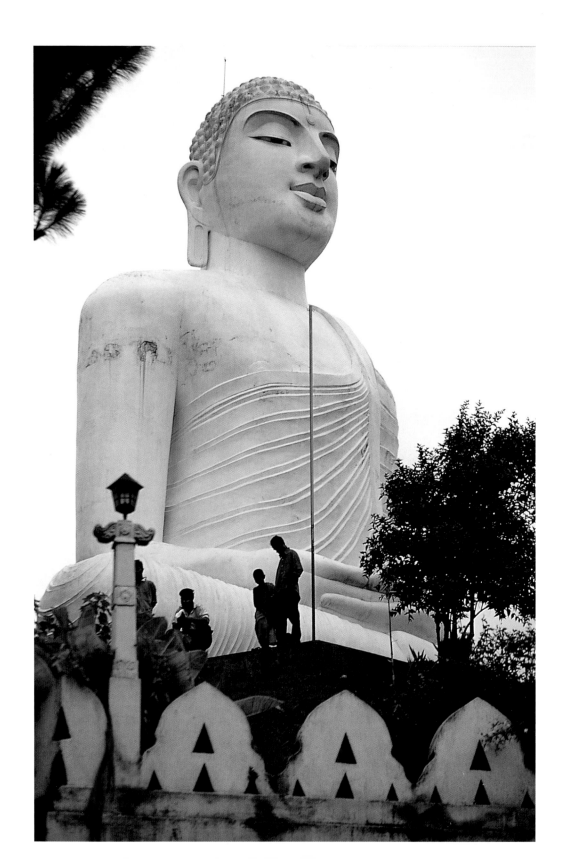

A twentieth-century Buddha overlooking
Kandy in Sri Lanka.

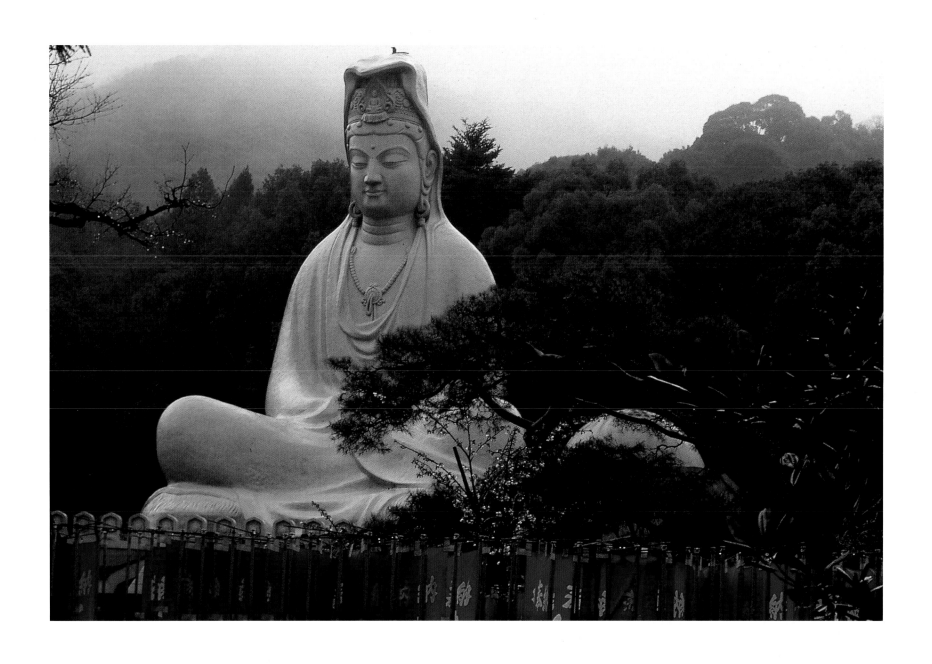

In Kyoto, a huge statue of Ryozen Kwanon, the Bodhisattva of Compassion, memorializes those who died in World War II.

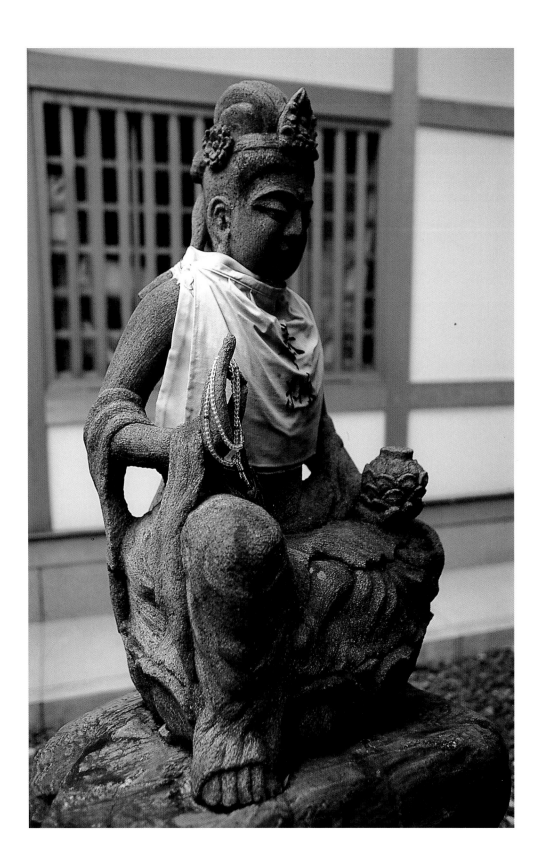

A statue near the Sanjusangendo Temple in Kyoto
makes the teaching gesture.

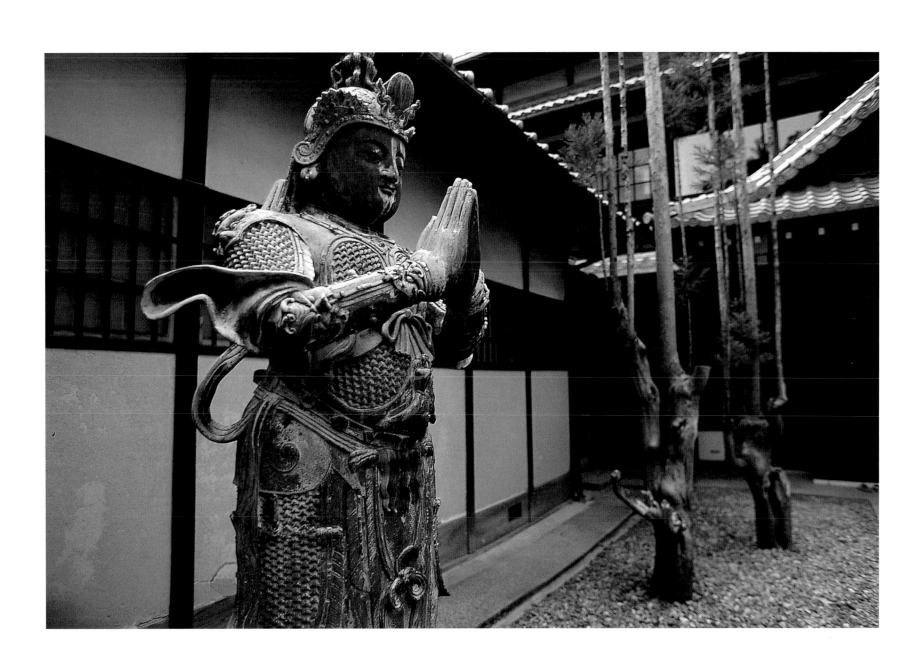

A figure guarding the Sanjusangendo Temple gestures in greeting.

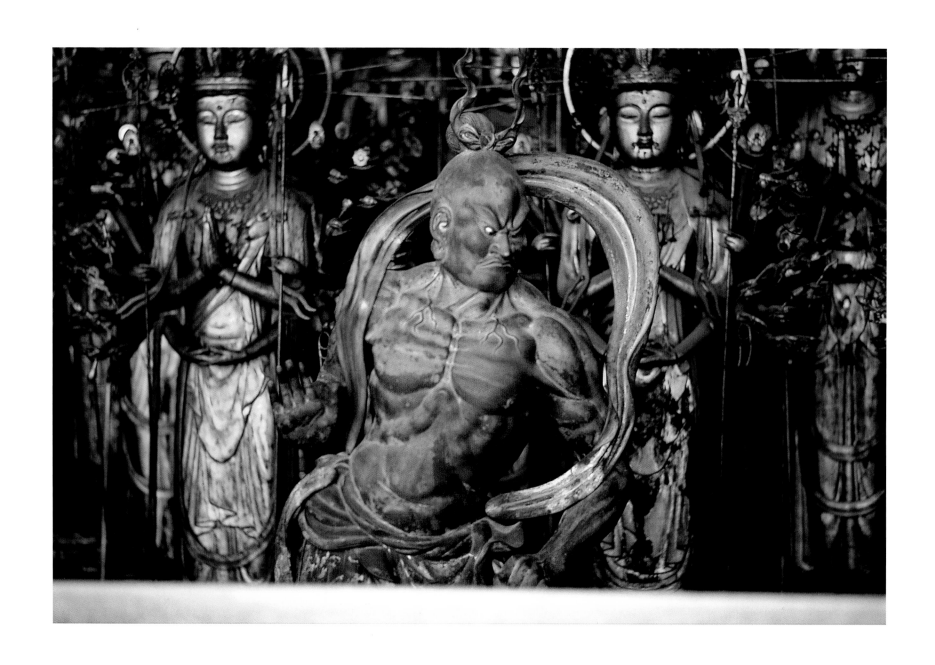

A wrathful guardian of the Thousand Bodhisattvas in the Sanjusangendo Temple.

A shrine in the Ryoanji Temple, Arashiyama Park, Kyoto.

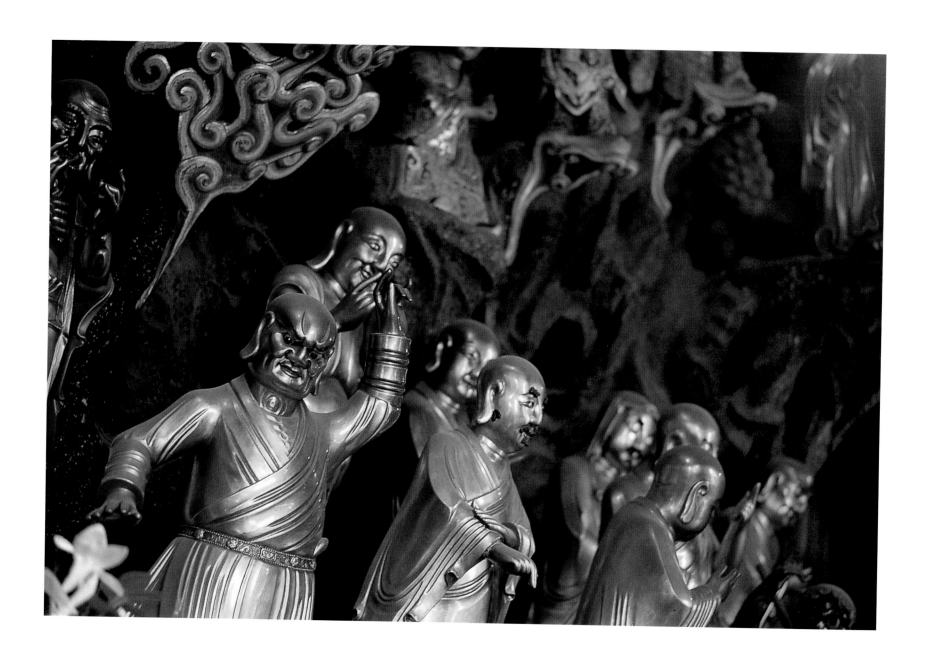

Gilded figures in a Chinese temple.

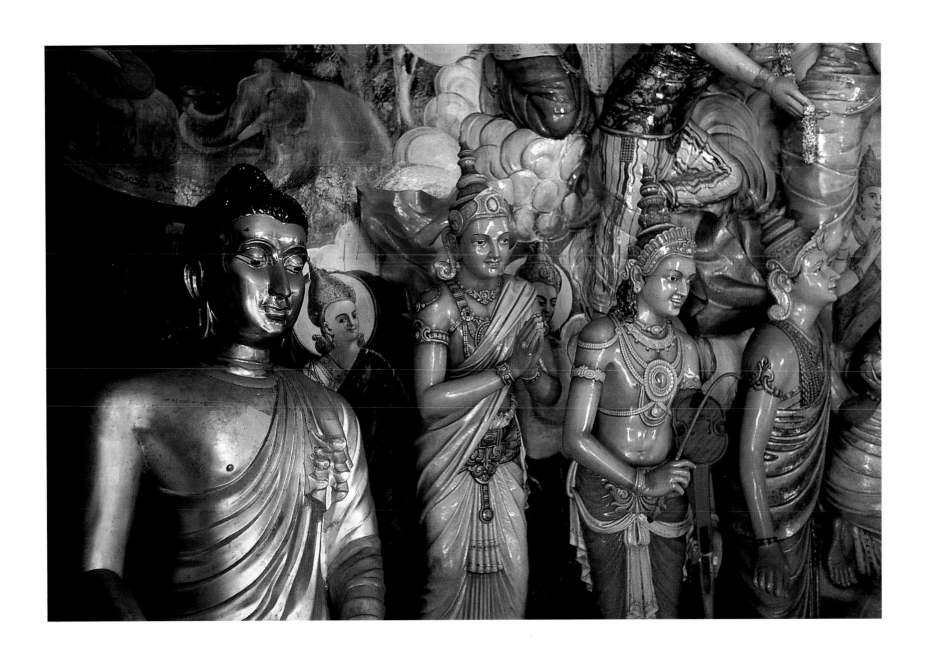

Shakyamuni Buddha and attendant figures in the monastery of Gangarama Vihara, Colombo, Sri Lanka.

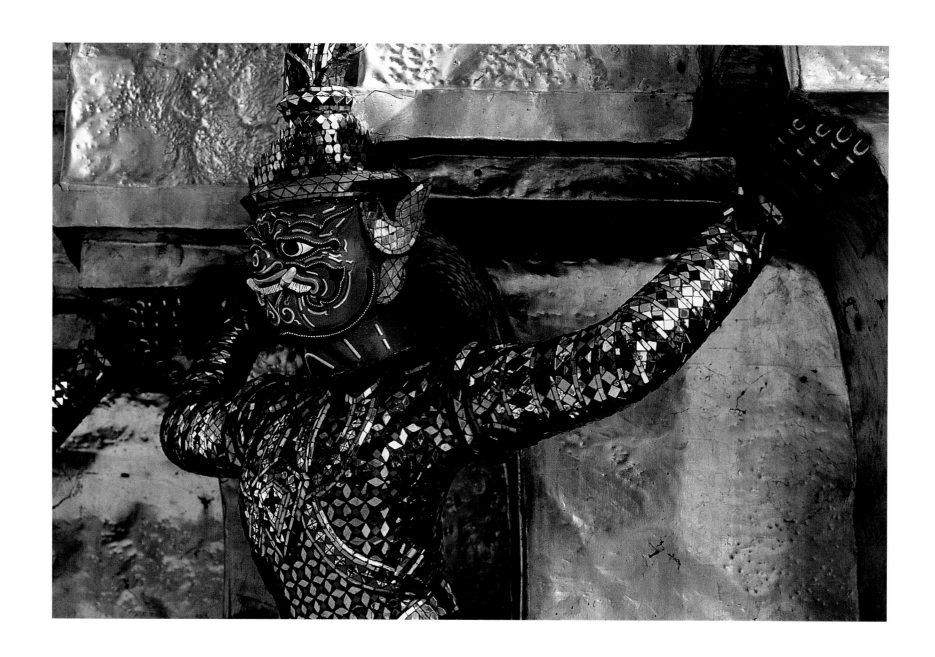

Mirrored tiles cover a figure that appears to be holding up a temple in Bangkok.

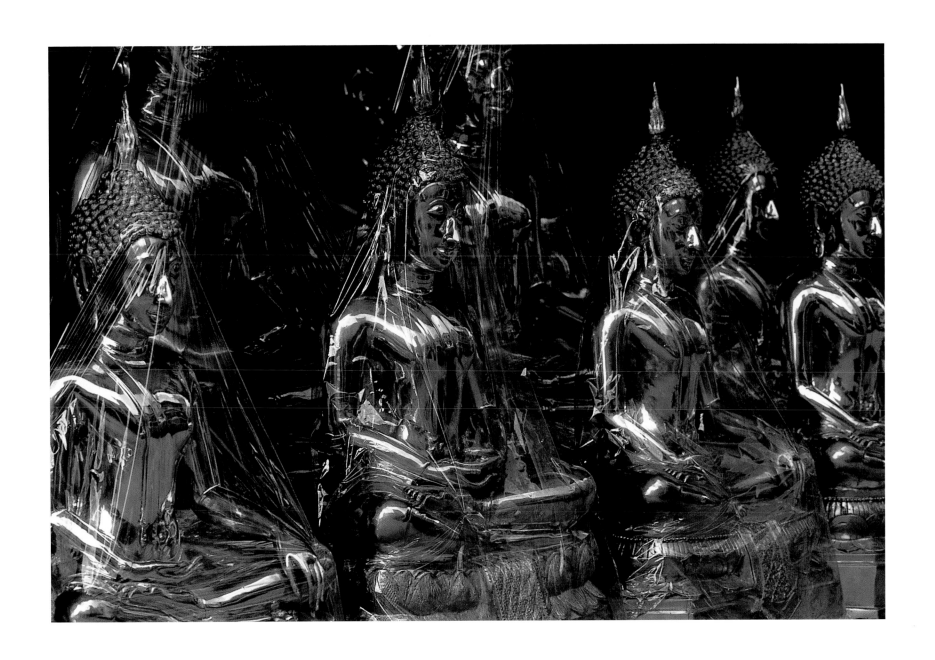

Cellophane-covered Buddhas for sale in a shop in Bangkok.

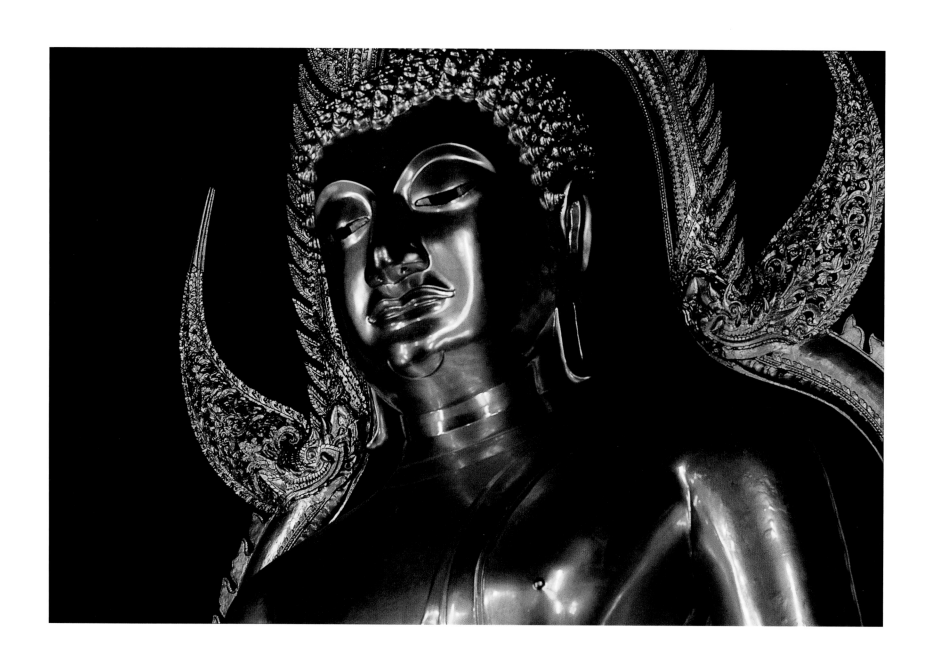

Bronze Buddha in Bangkok.

Buddha statue for sale, Bangkok.

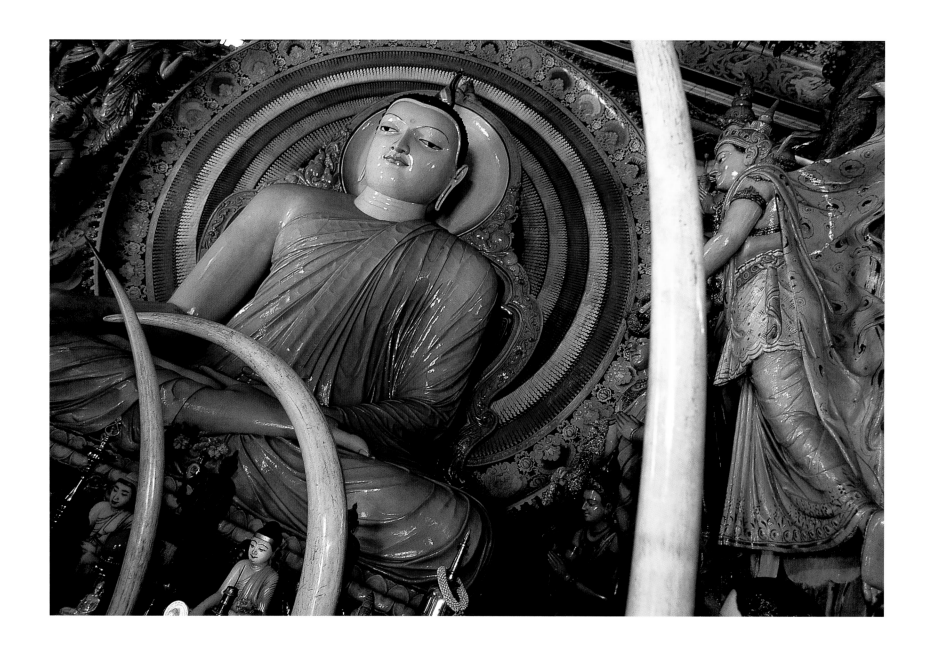

Elephant tusks surround a Buddha in the Gangarama Vihara monastery in Sri Lanka.

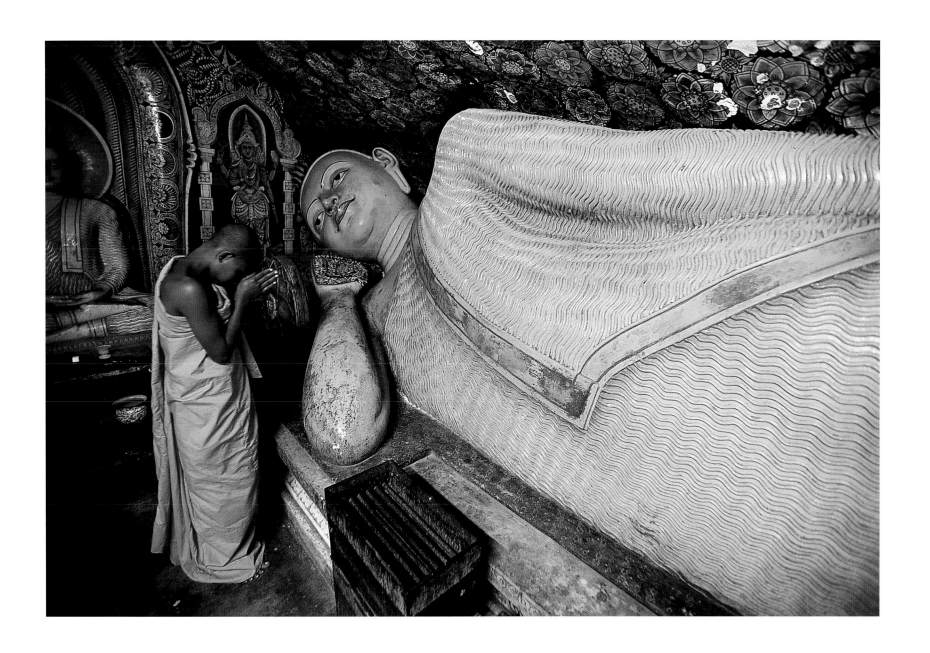

A painted stone Buddha in Isurumuniya, Anuradhapura, Sri Lanka. The death of the Buddha is traditionally represented with this pose.

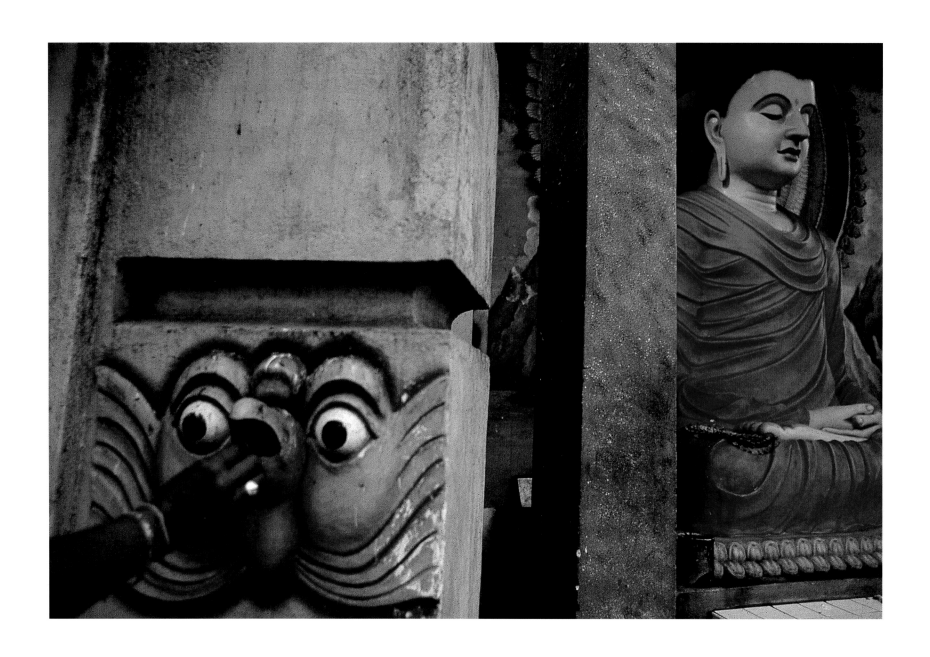

Depositing an offering at a roadside shrine in Kandy, Sri Lanka.

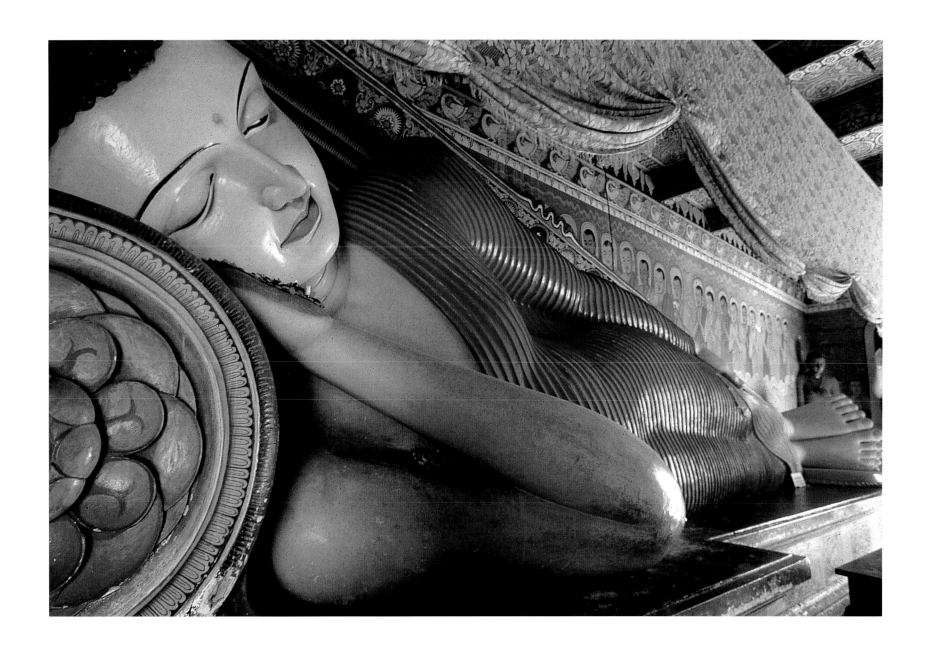

The Buddha in death, reclining on a lotus-blossom pillow. Isurumuniya, Anuradhapura, Sri Lanka.

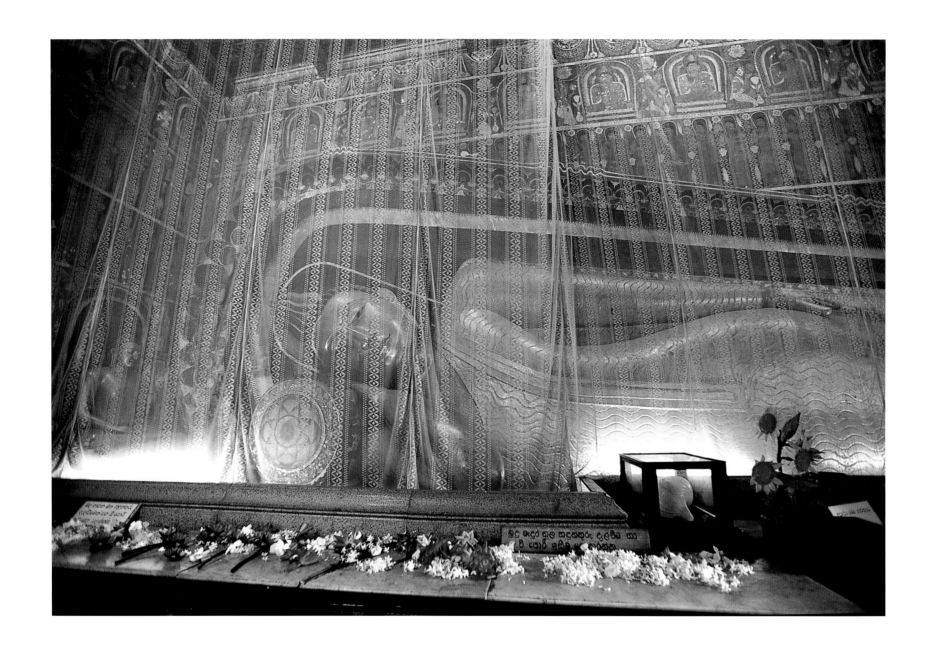

A conch shell, one of the Eight Auspicious Symbols, is displayed in front of a
Buddha at the Rajamaha Vihara Buddhist Center in Sri Lanka.

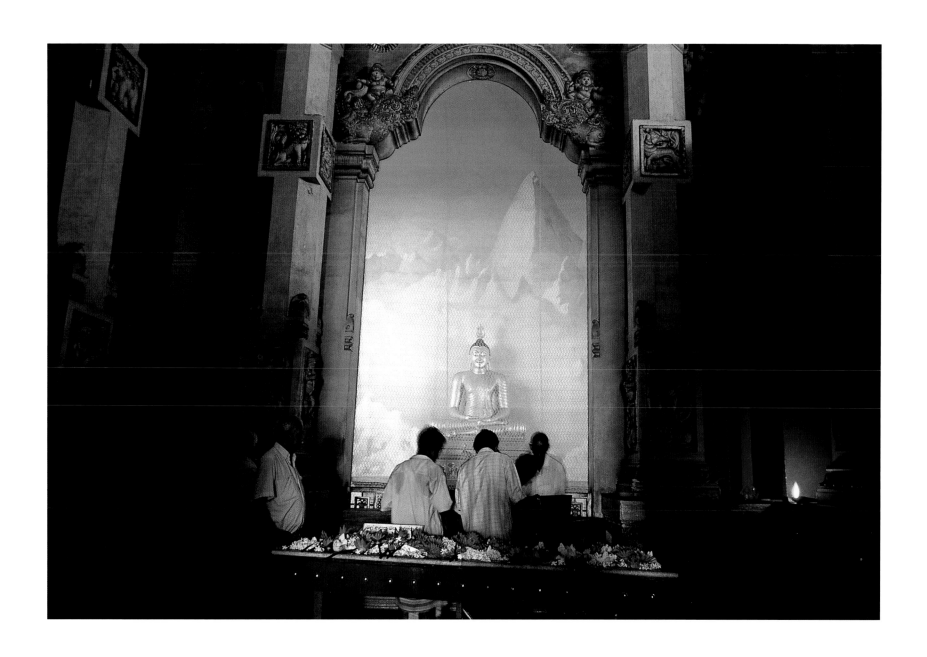

A mural of the Himalaya Mountains provides the backdrop for a Buddha at the Rajamaha Vihara Buddhist Center.

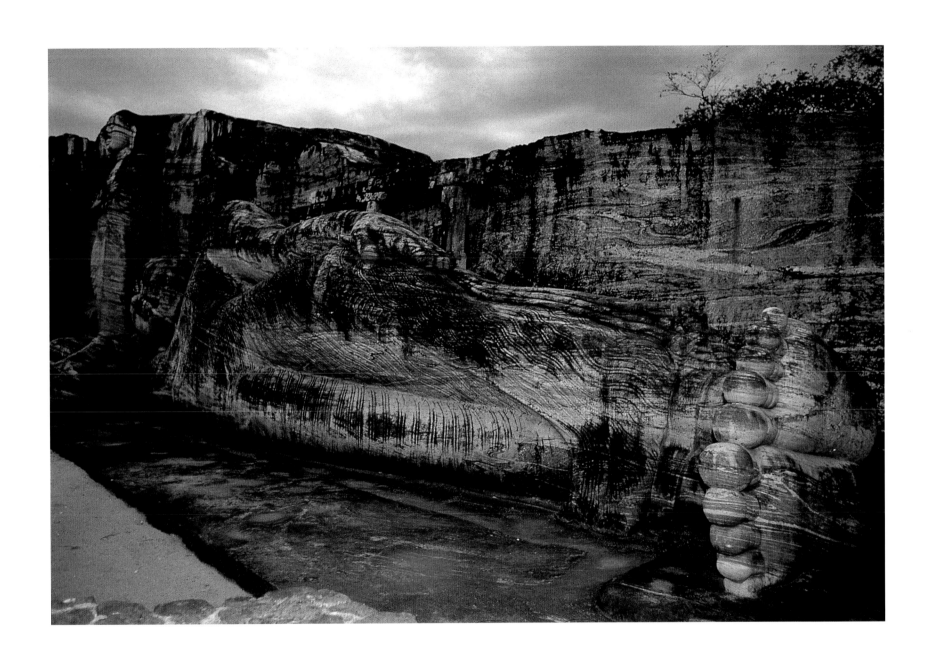

A carved granite Buddha from the twelfth century reclines at Gal Vihara, Polonnaruwa, in Sri Lanka.

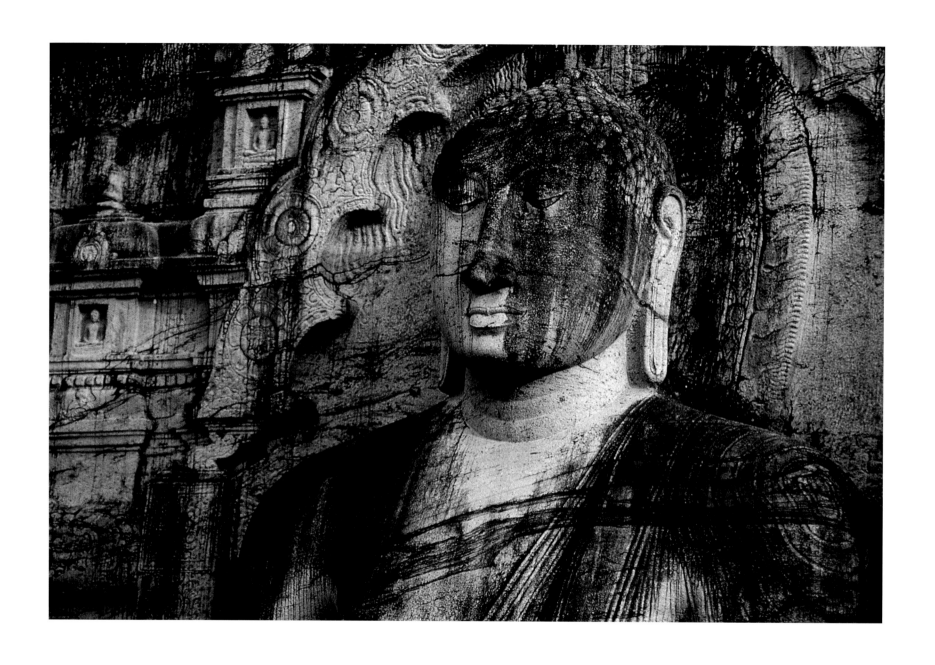

Gal Vihara, Polonnaruwa, Sri Lanka.

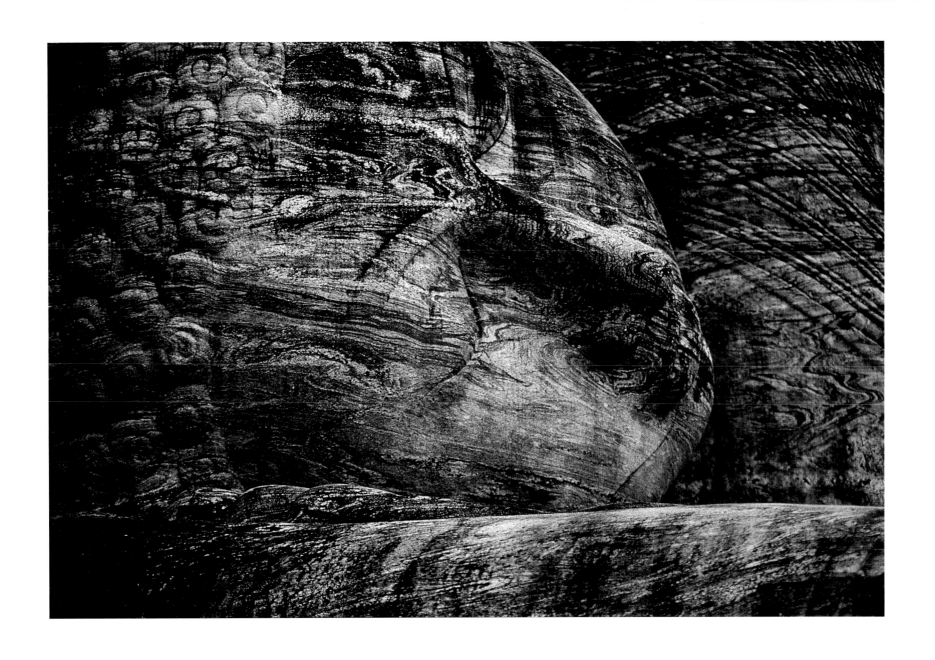

Gal Vihara, Polonnaruwa, Sri Lanka.

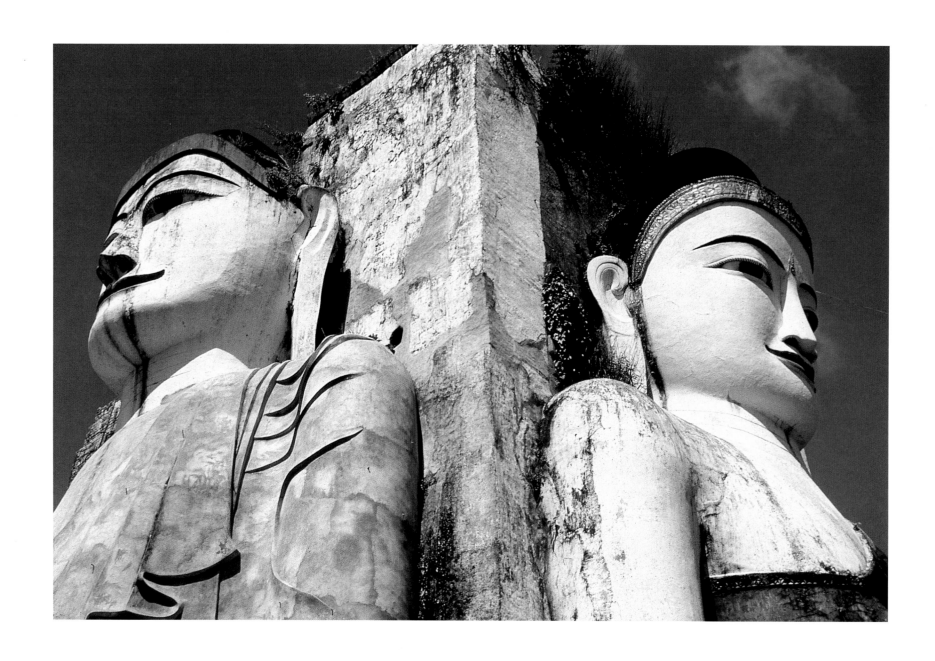

Two of four standing Buddhas that face the cardinal points, in Bago, north of Rangoon.

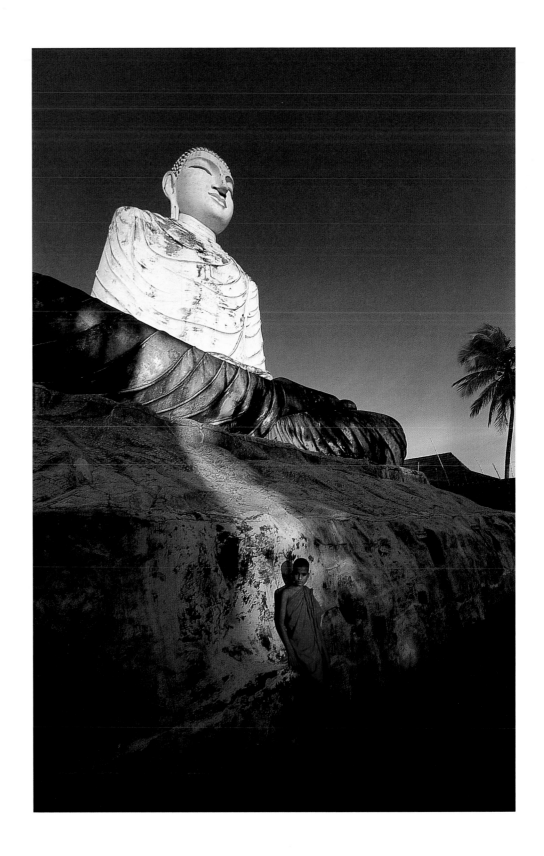

Sri Sarananda, Anuradhapura, Sri Lanka.

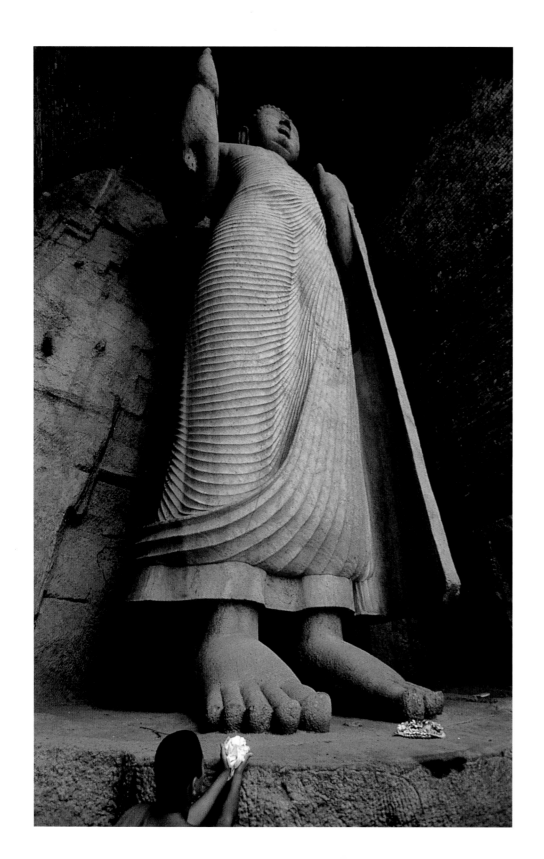

A ninth-century Buddha in Aukana, Sri Lanka.

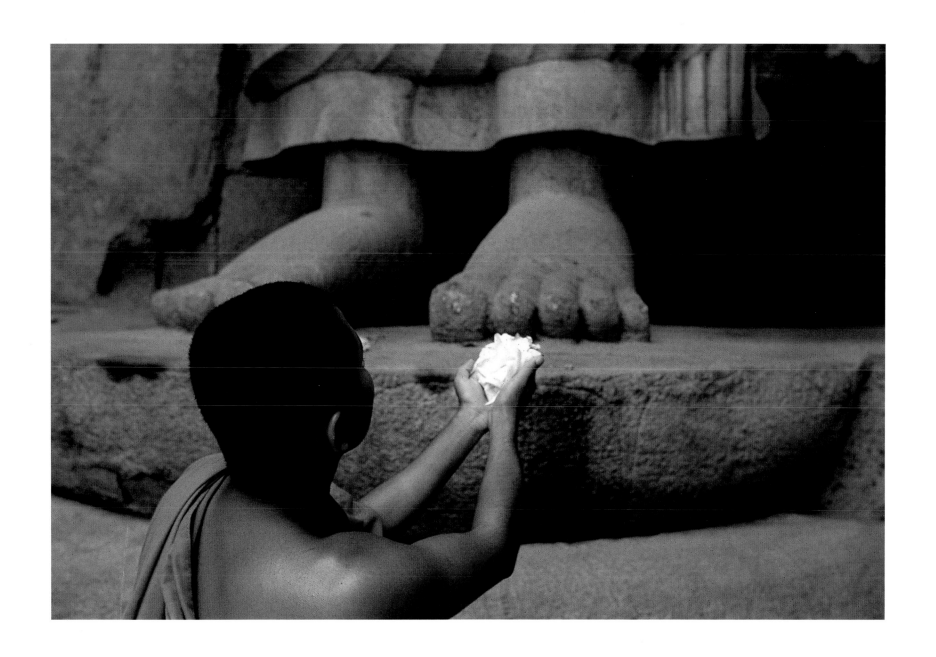

A young monk offers lotus petals to the Buddha.

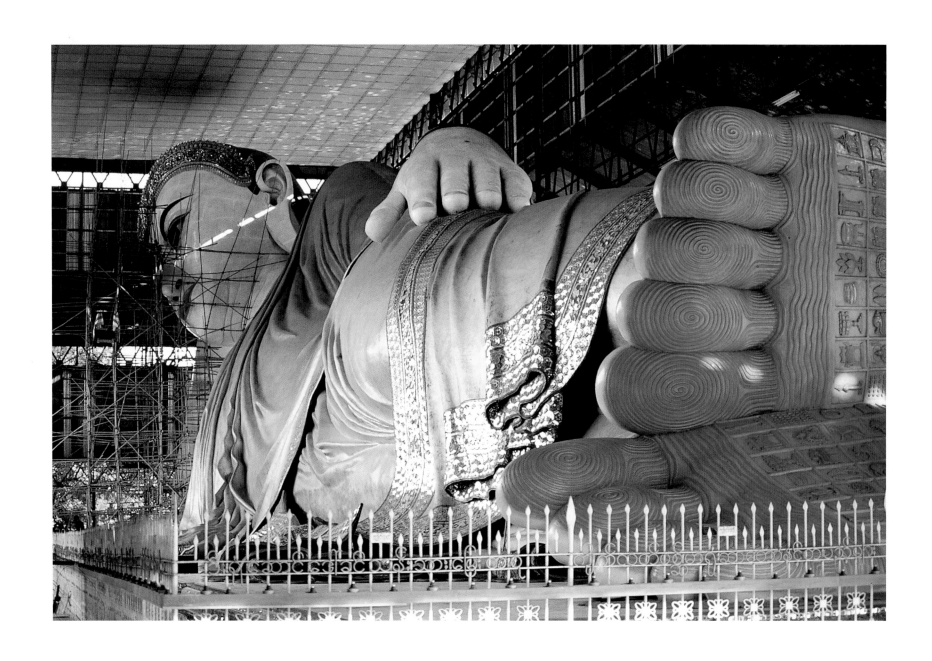

Reclining Buddha in Shwethalyang, Pegu, Myanmar.

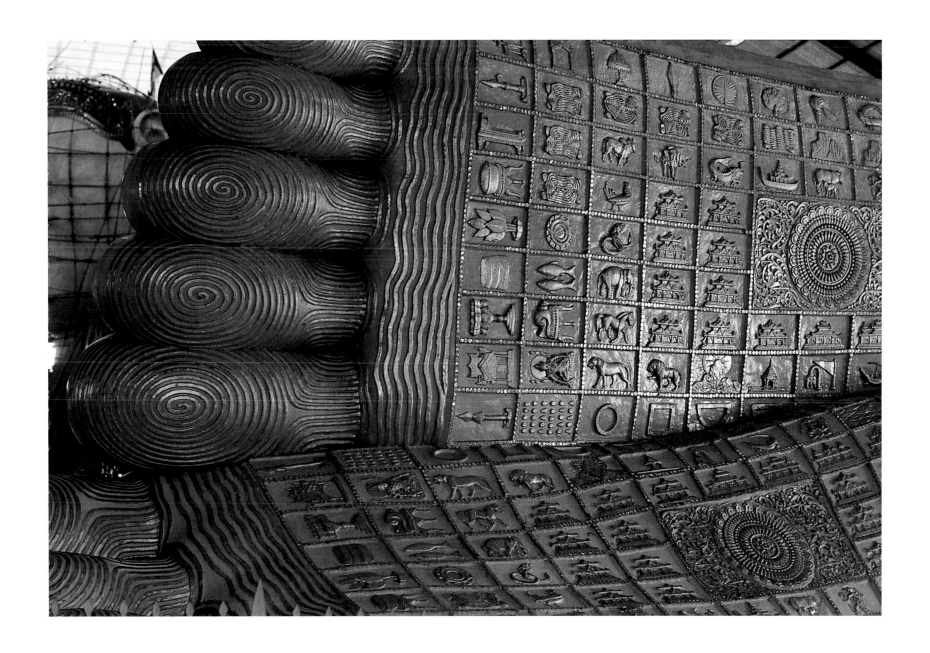

The Buddha's feet repainted. There are one hundred eight Auspicious Signs on his soles.

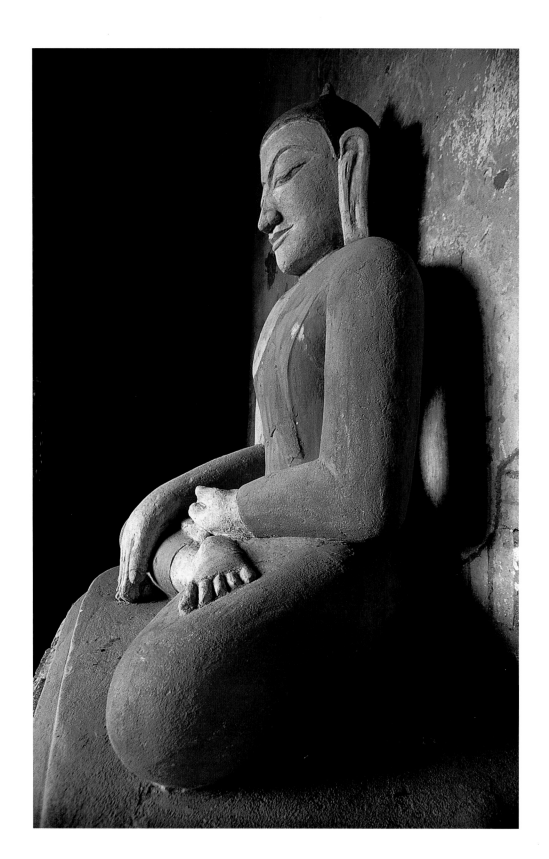

Hitlminlo Temple, Pagan, Myanmar.

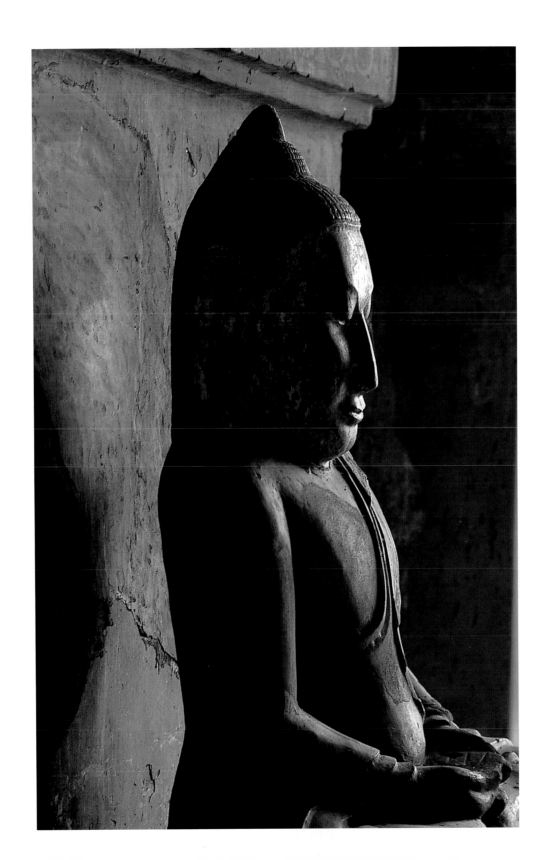

Hitlminlo Temple, Pagan.

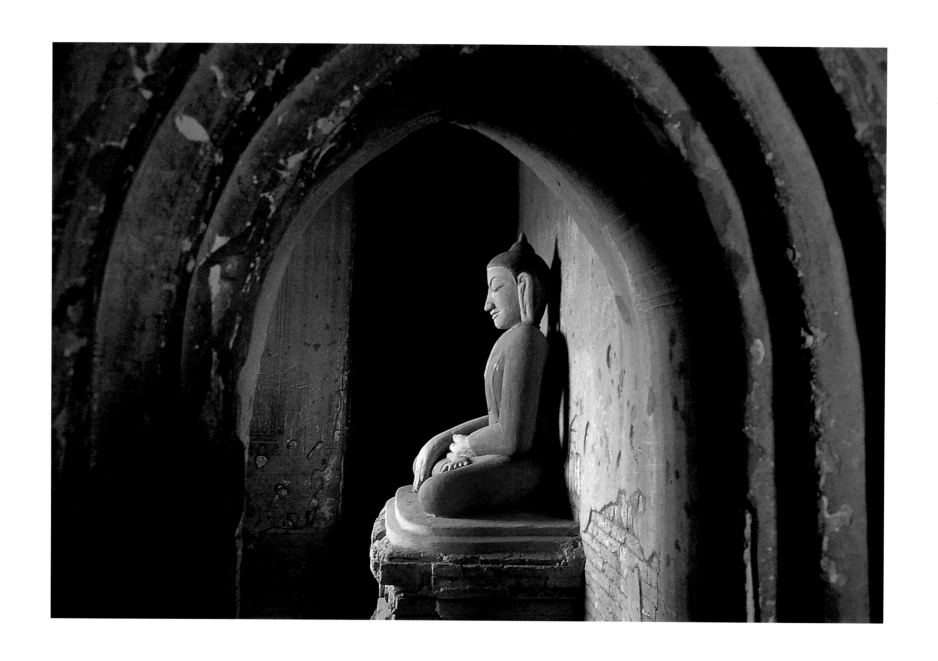

Hitlminlo Temple, Pagan.

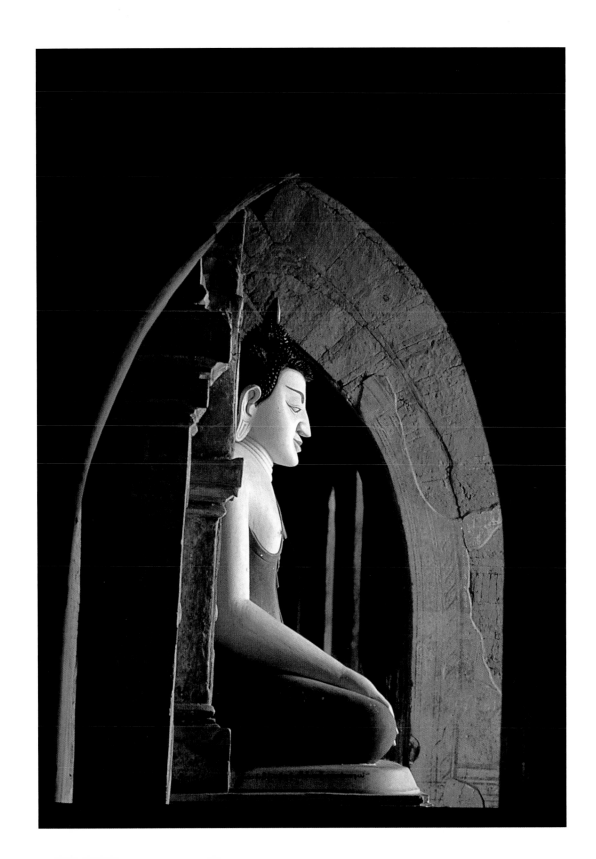

Hitlminlo Temple, Pagan.

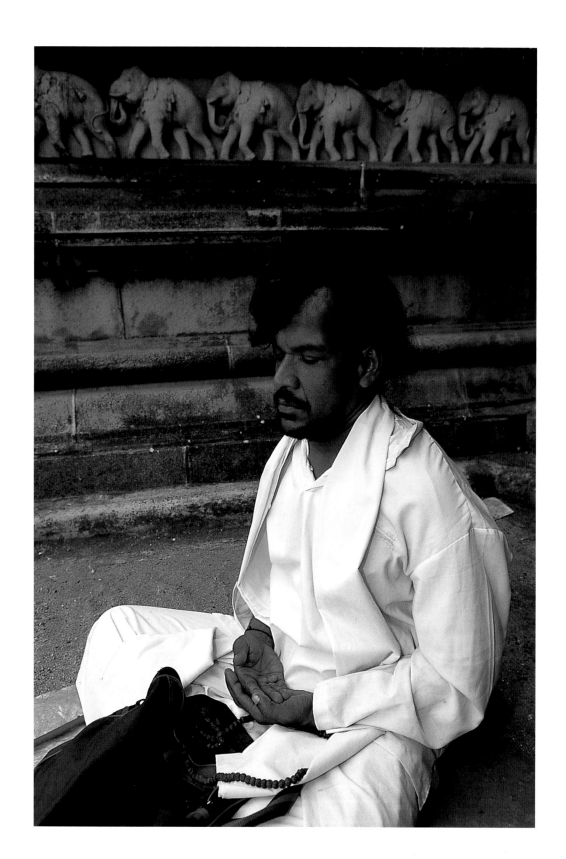

Rajamaha Vihara, in the Kelaniya District,
near Colombo, Sri Lanka.

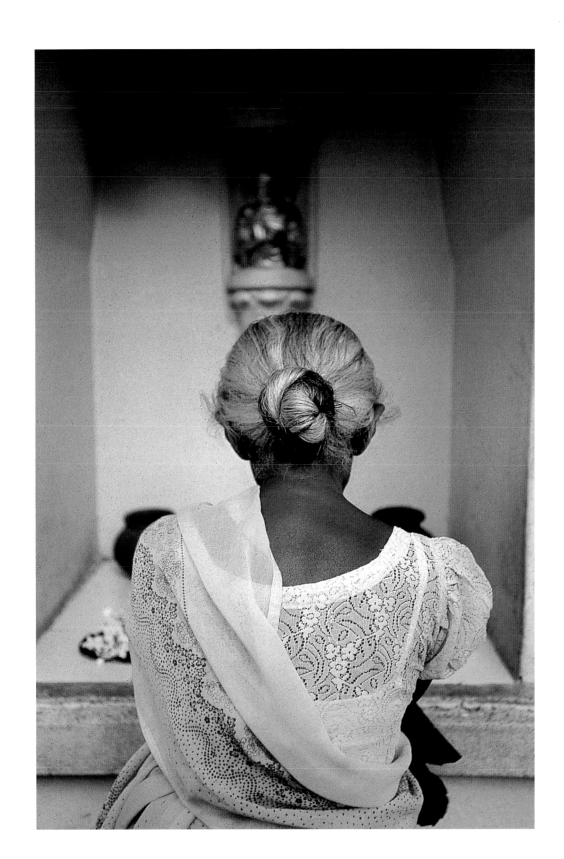

Gatambe Temple, near Colombo, Sri Lanka.

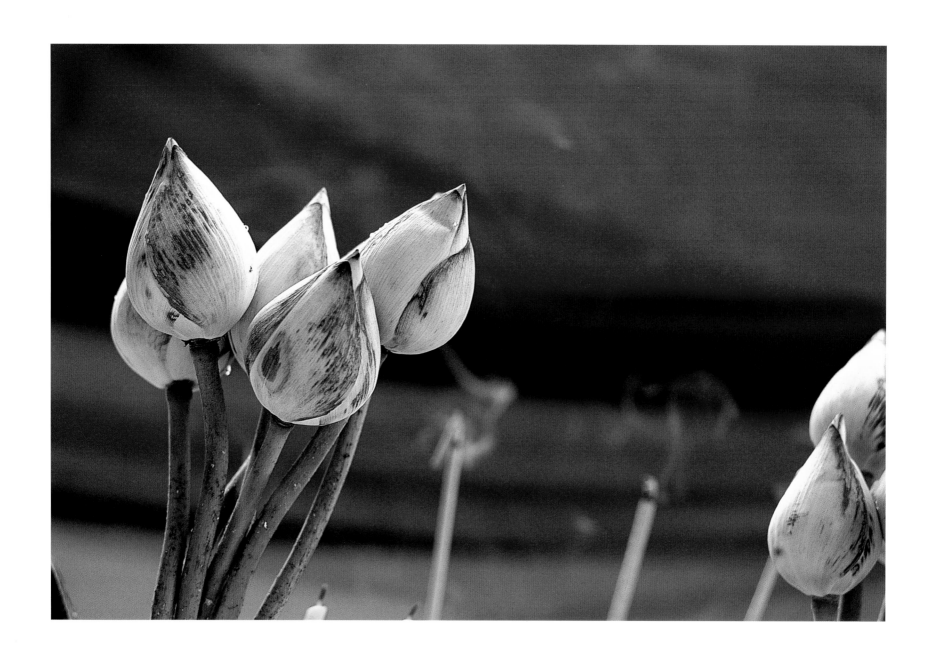

Lotus buds, Bangkok.

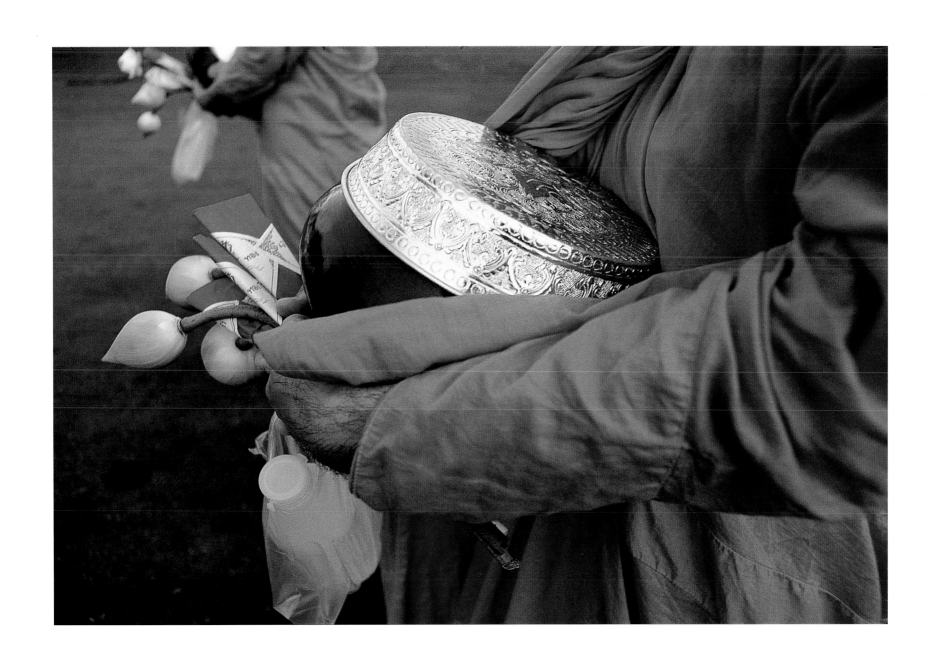

Monk with a food bowl, Bangkok.

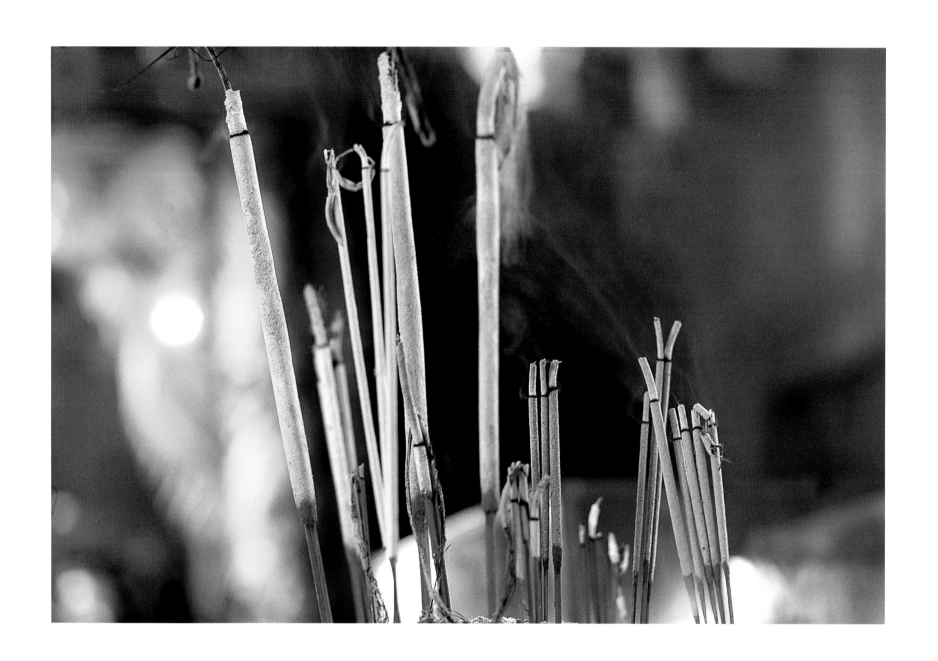

Incense sticks, Bangkok.

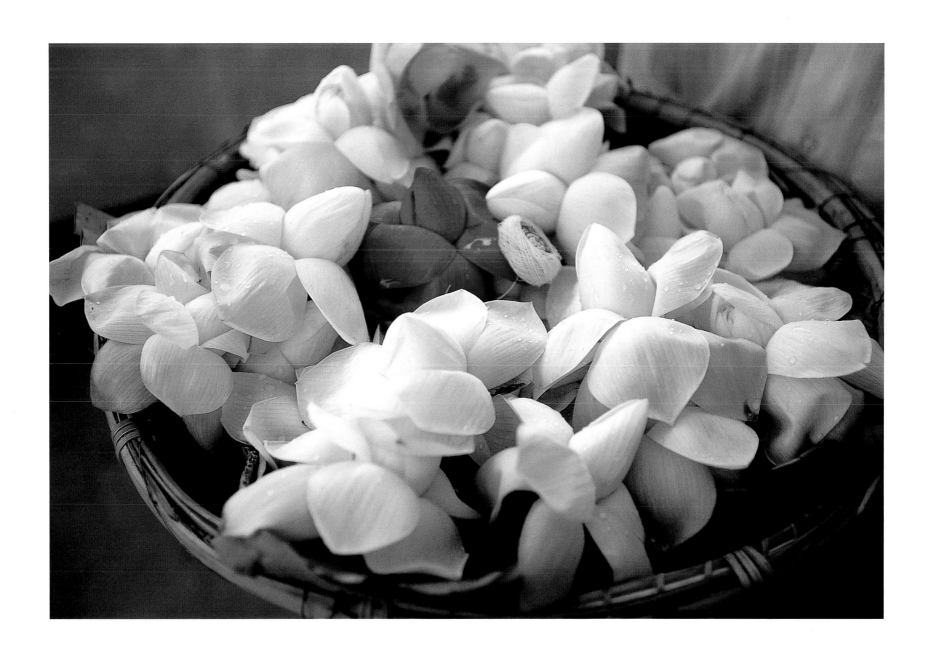

Lotus flowers are a symbol of the purity of the enlightened mind.

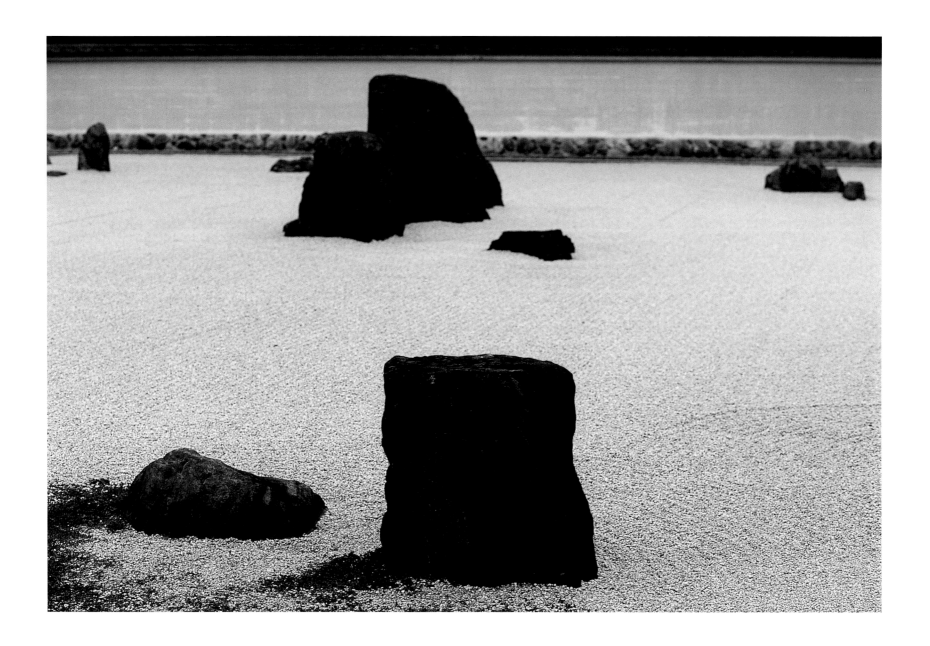

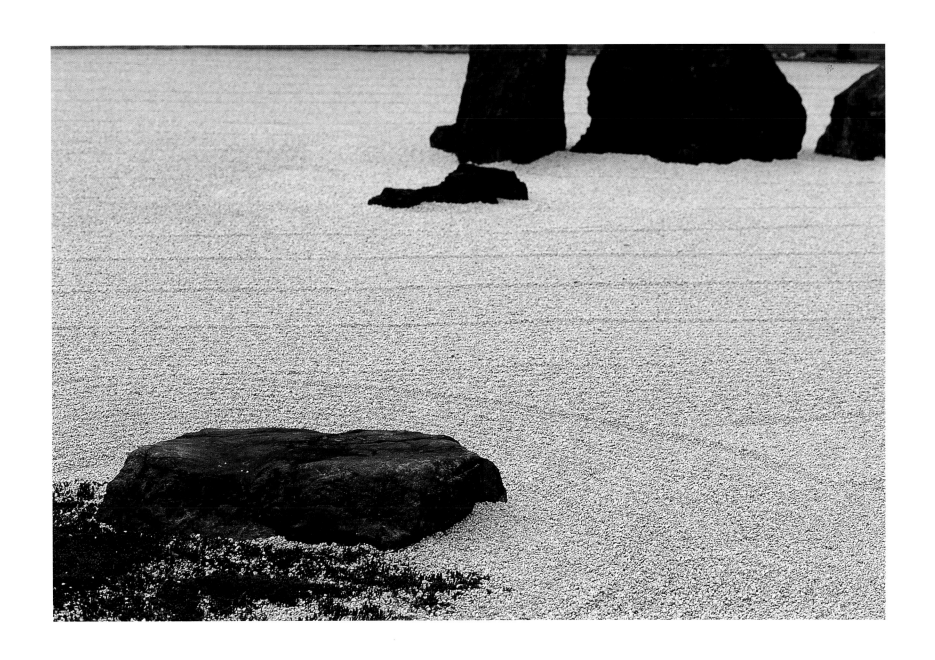

Meditation garden in the Ryoanji Temple, Arashiyama Park, near Kyoto.

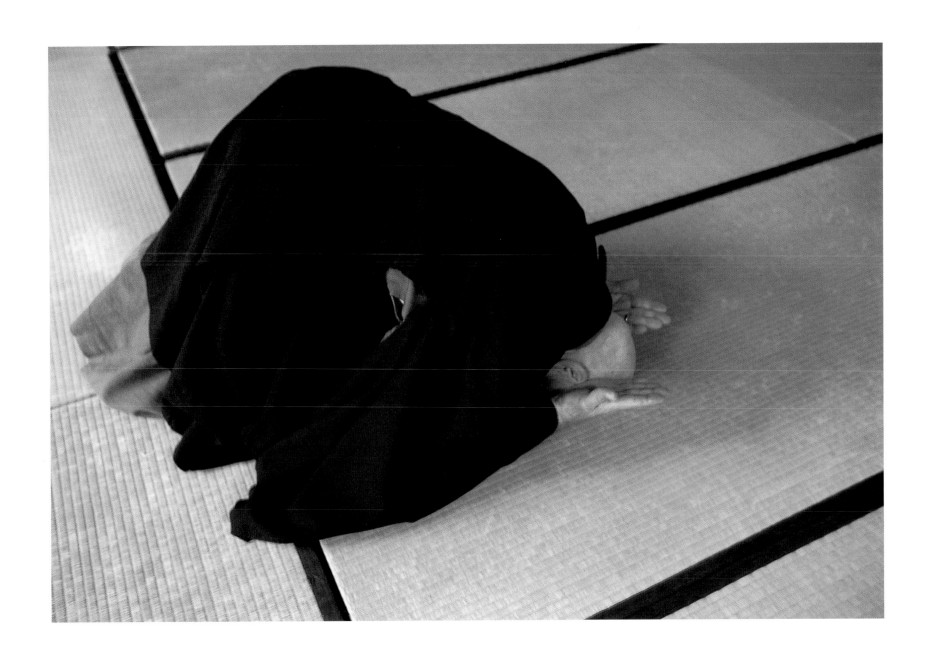

San Francisco Zen Center, California.

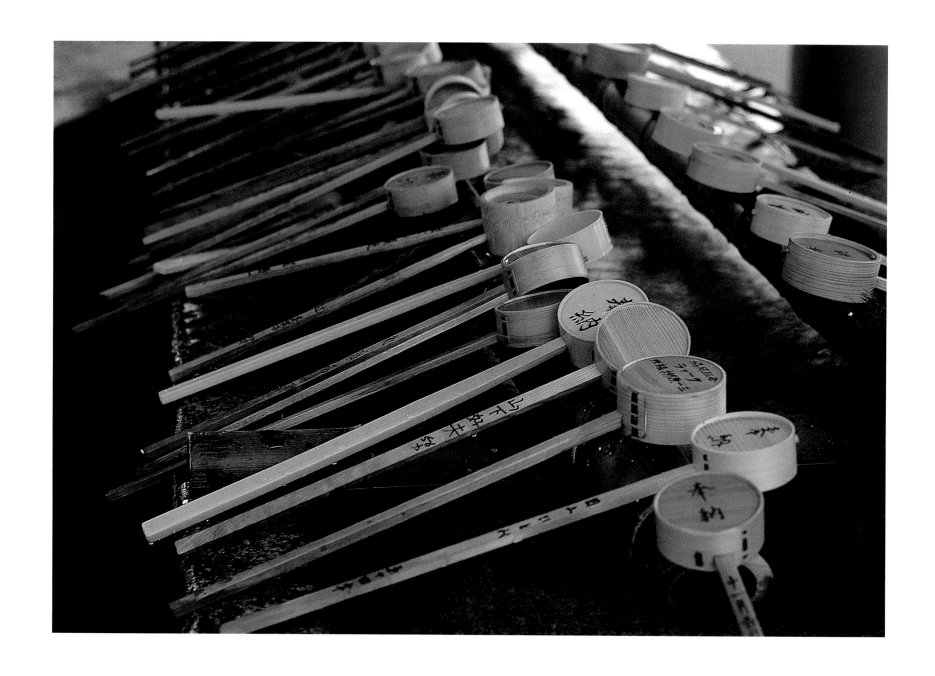

Water ladles in the Kiyomizu Temple, near Kyoto.

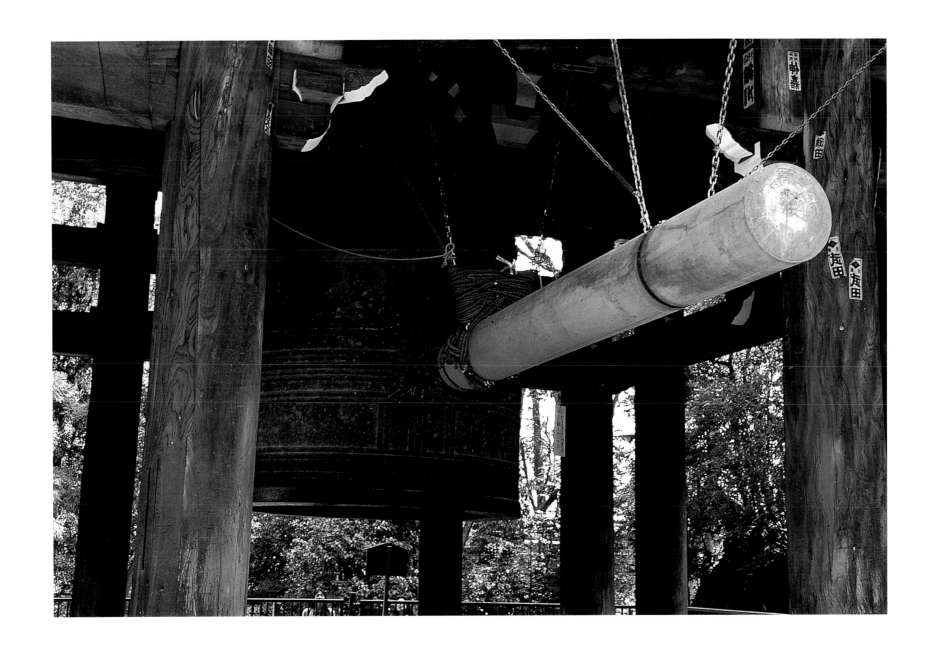

Temple bell, Kyoto.

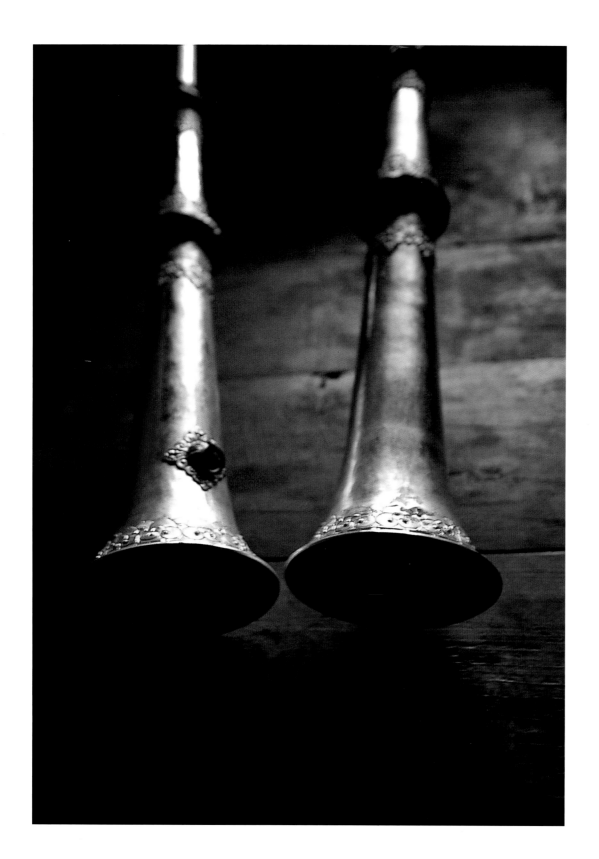

Long horns, *tungs,* in Jakar,
Bumthang Valley, Bhutan.

A monk reads a sacred text and beats a drum in a room dimly lit by yak-butter lamps in the Drepung monastery, Lhasa, Tibet.

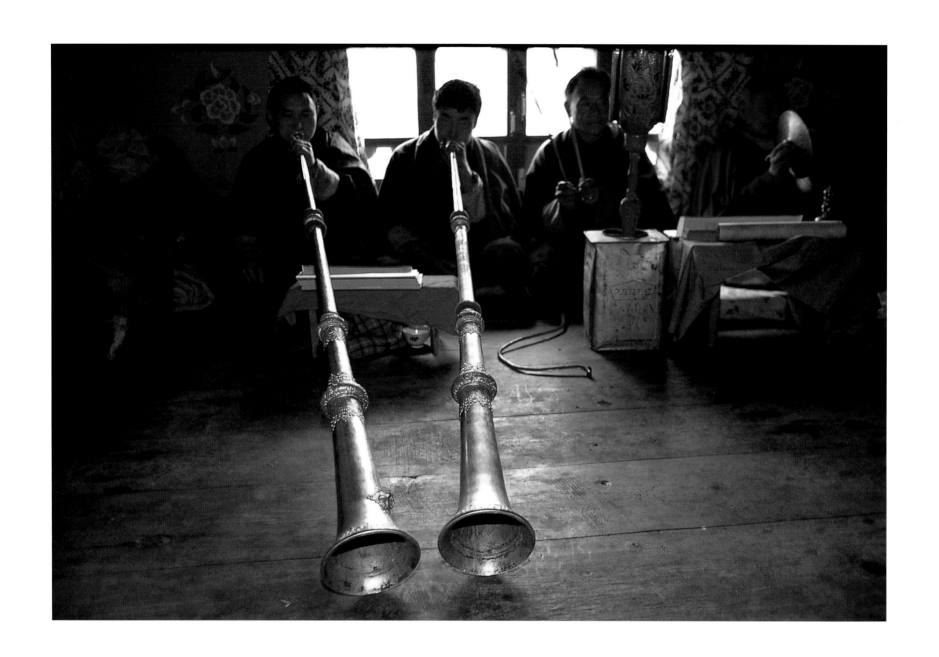

A ceremony in a house in Jakar, Bhutan.

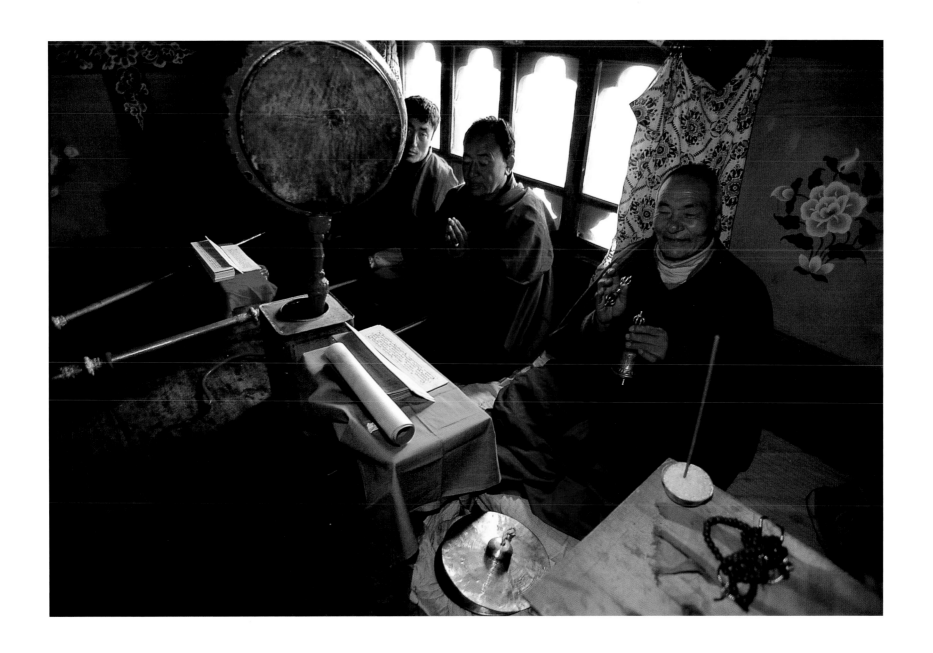

A man holds the ritual *vajra* (lightning-bolt scepter) and rings the *ghanta* (bell) in Jakar, Bhutan.

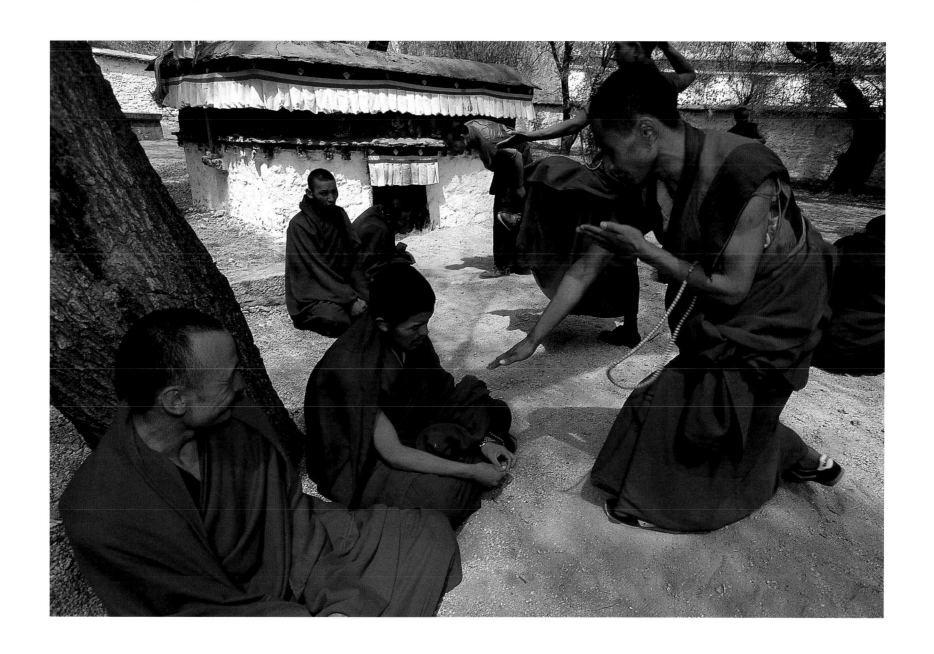

Young monks practice debating as a learning discipline at the Sera monastery, Lhasa.

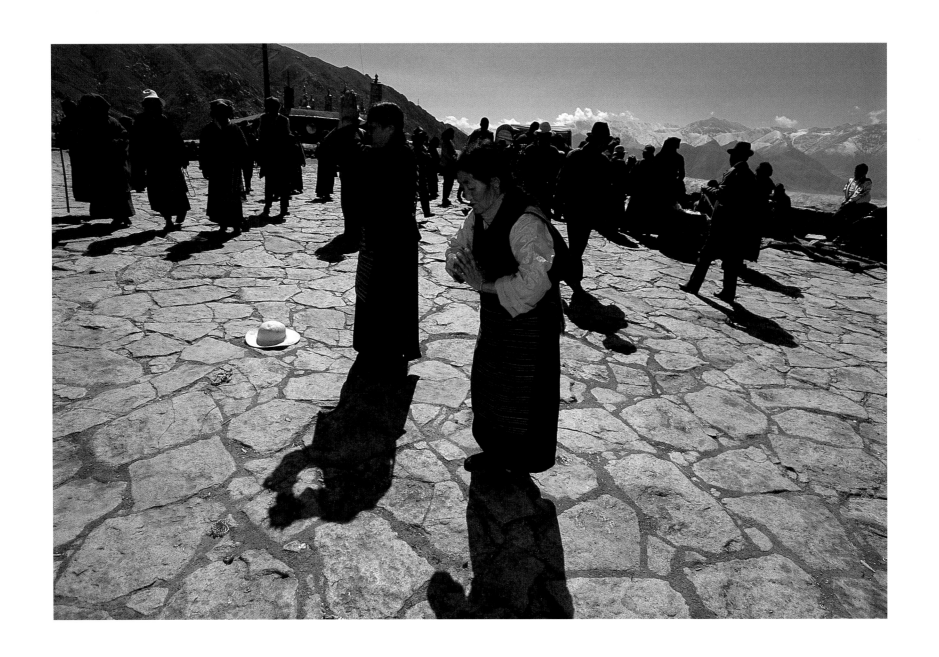

Pilgrims at the Drepung monastery, Lhasa.

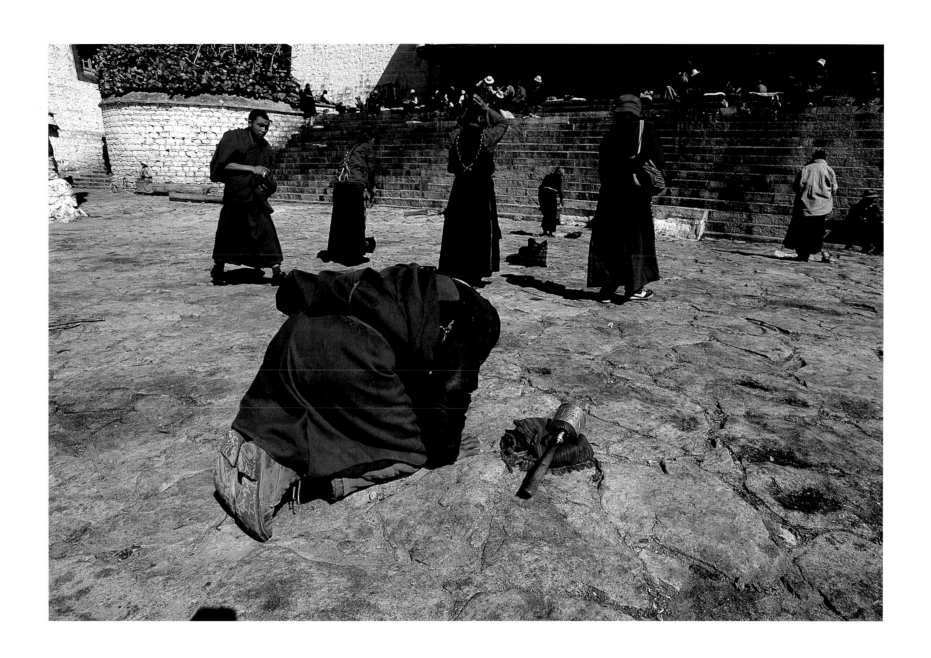

A worshiper prostrates himself next to a handheld prayer wheel in the Drepung monastery, Lhasa.

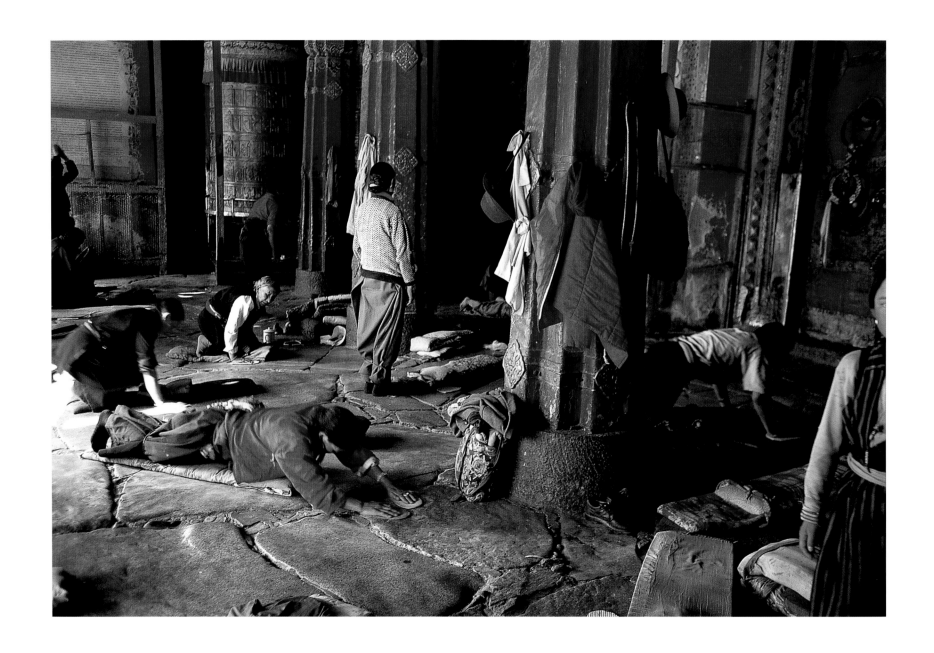

Jokhang Temple, Lhasa.

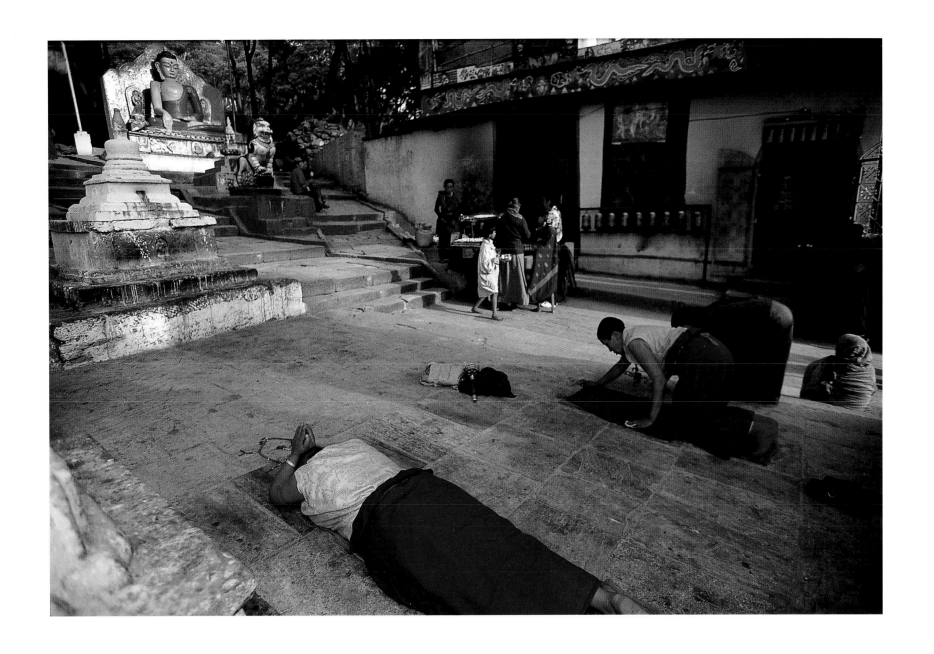

Swayambhunath Stupa, Kathmandu, Nepal.

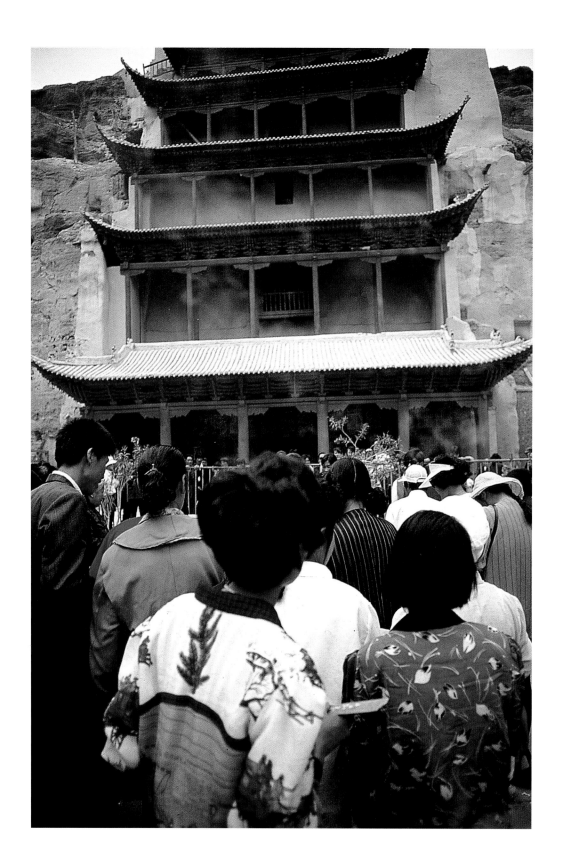

Celebrating Buddha's birthday, Magao Caves,
Dunhuang Province, China.

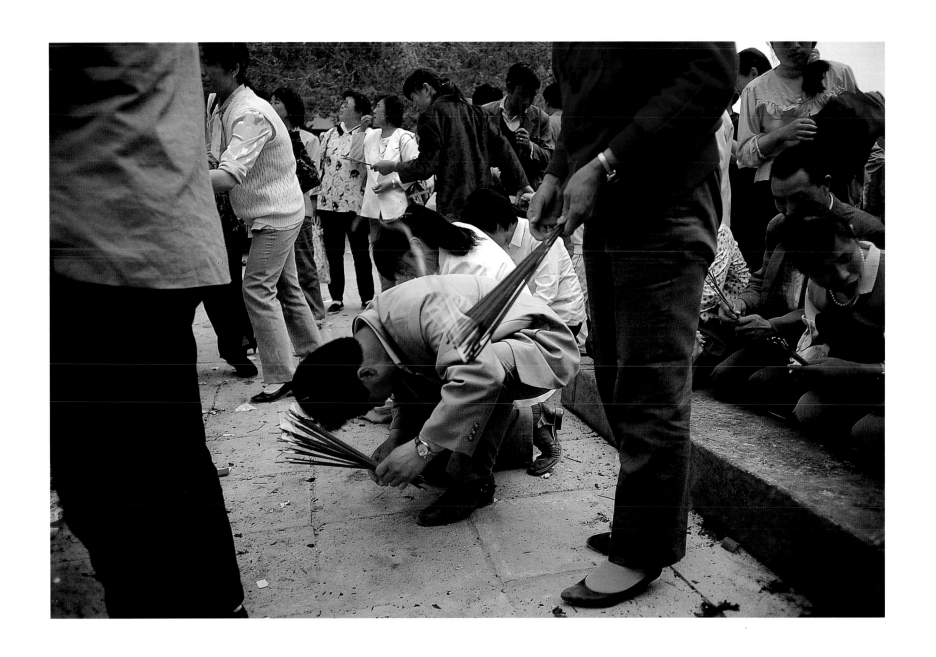

Magao Caves, Dunhuang Province.

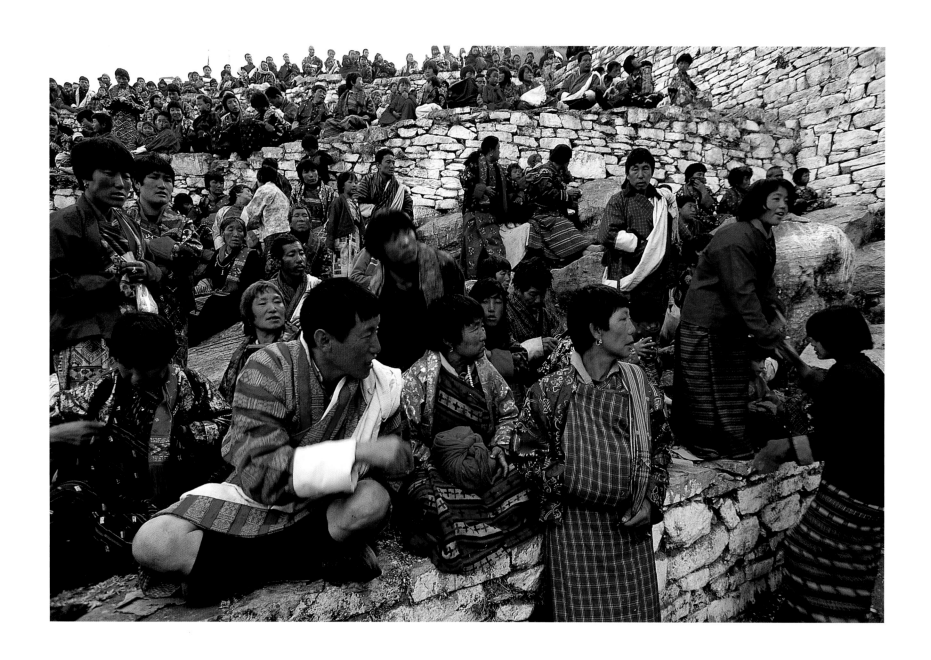

Celebrants gathering at the three-century-old Paro Festival in Bhutan.

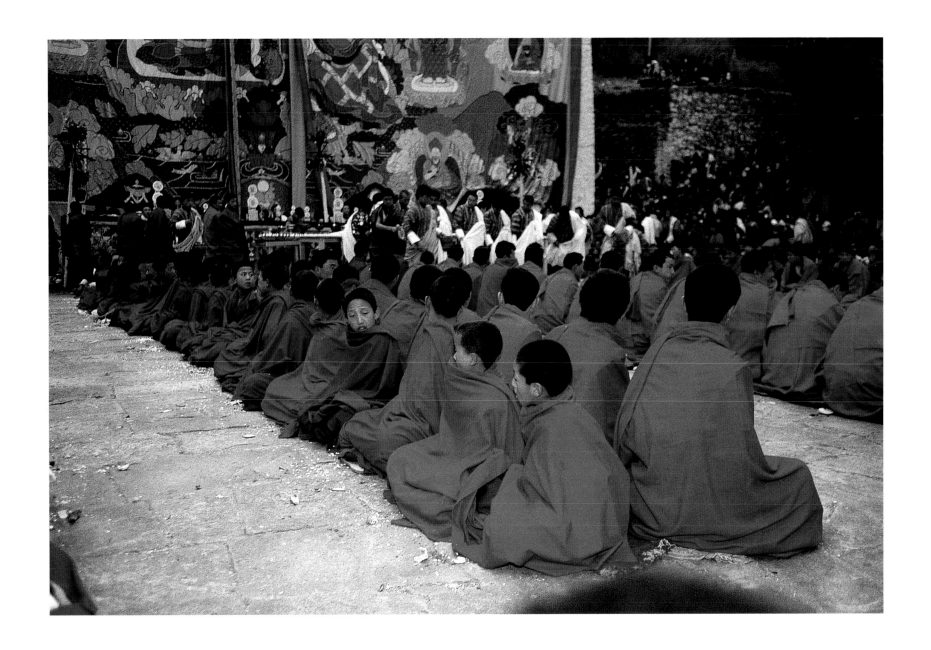

Novices in the courtyard of the Paro Dzong at dawn.

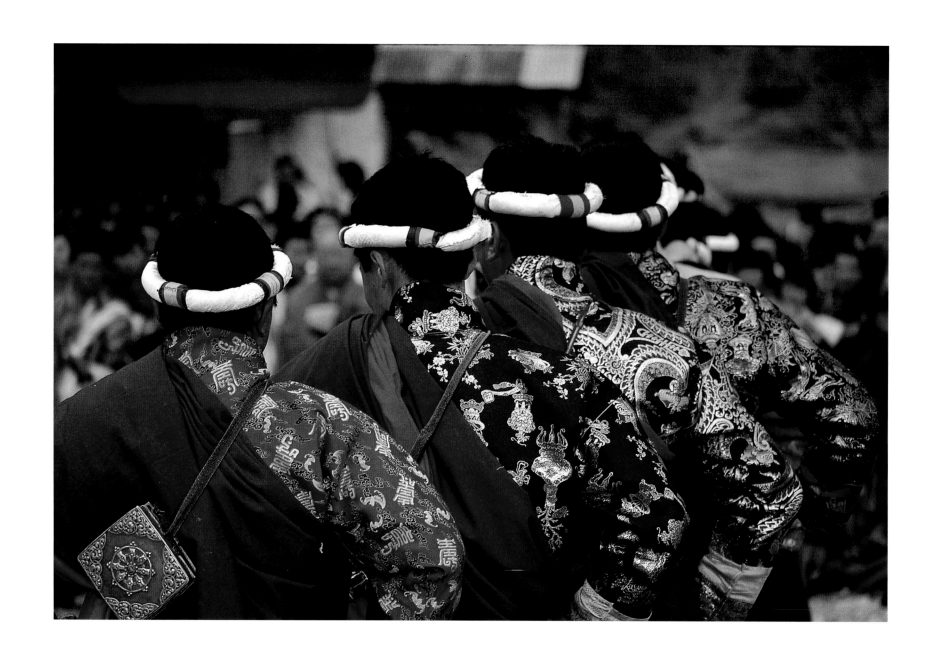

Dancers at the Paro Festival.

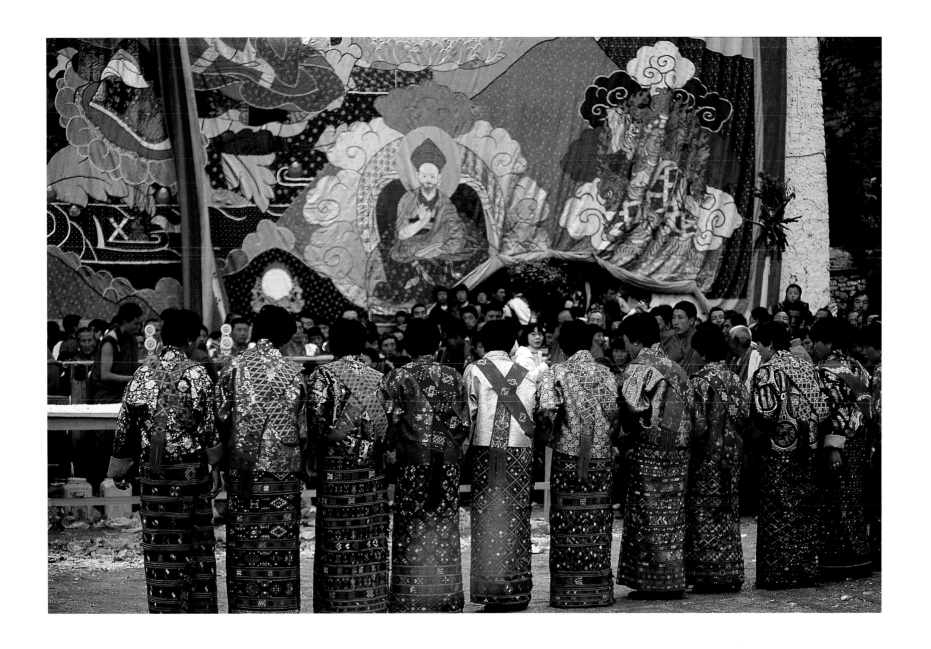

The embroidered *thangka* is unfurled once a year at the Paro Festival.

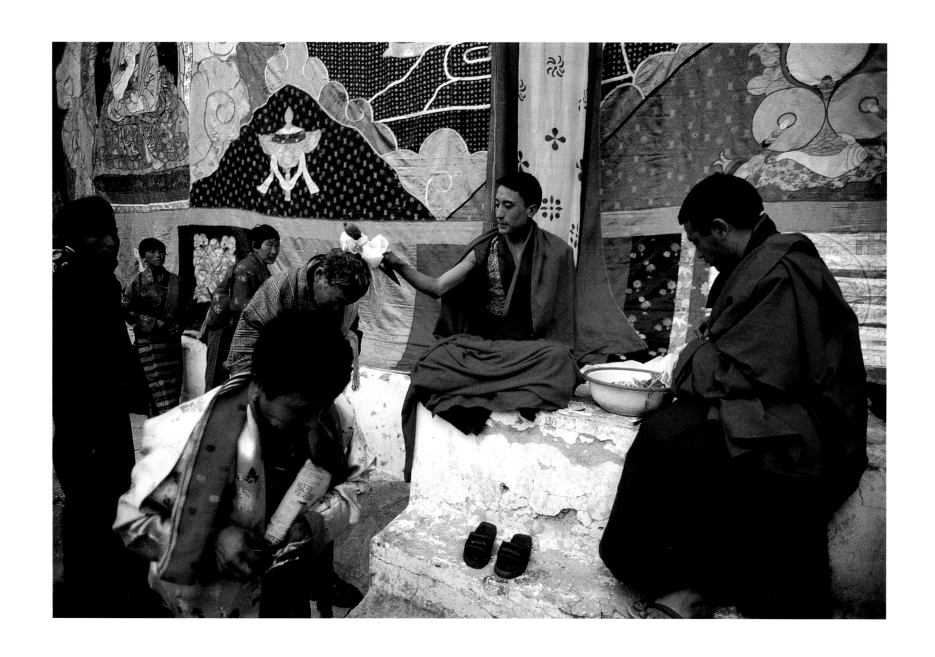

A senior monk dispenses blessings at the Paro Festival.

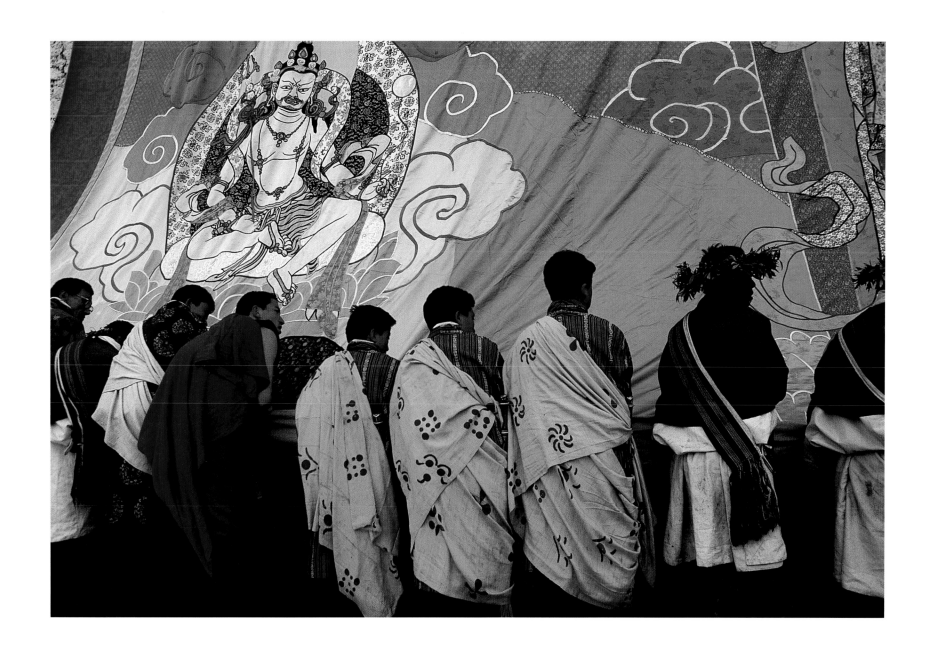

Rolling up the *thangka*.

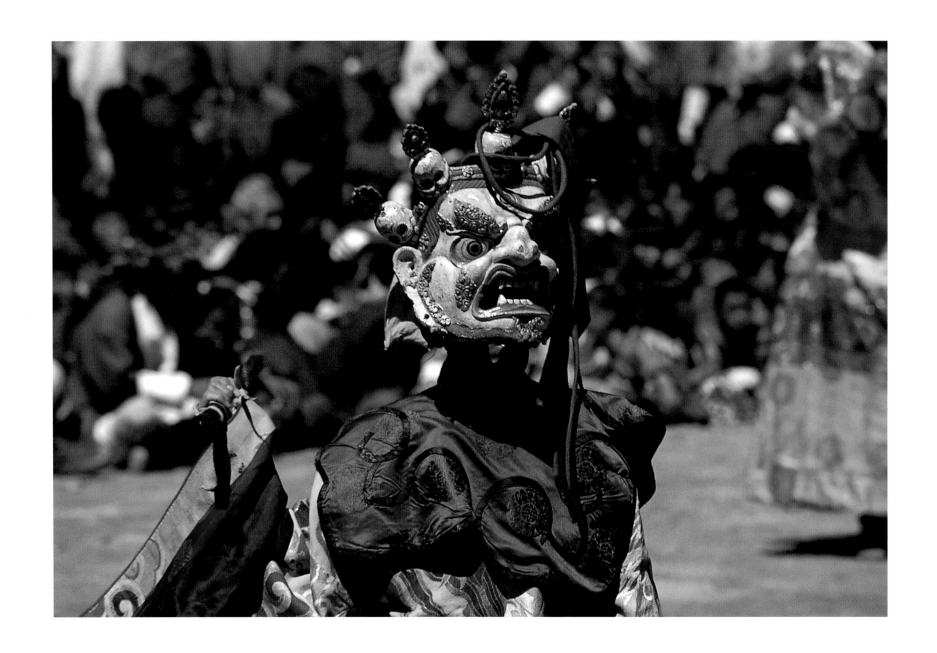

A mask of one of the *tsoling,* the Eight Protectors, at the Paro Festival.

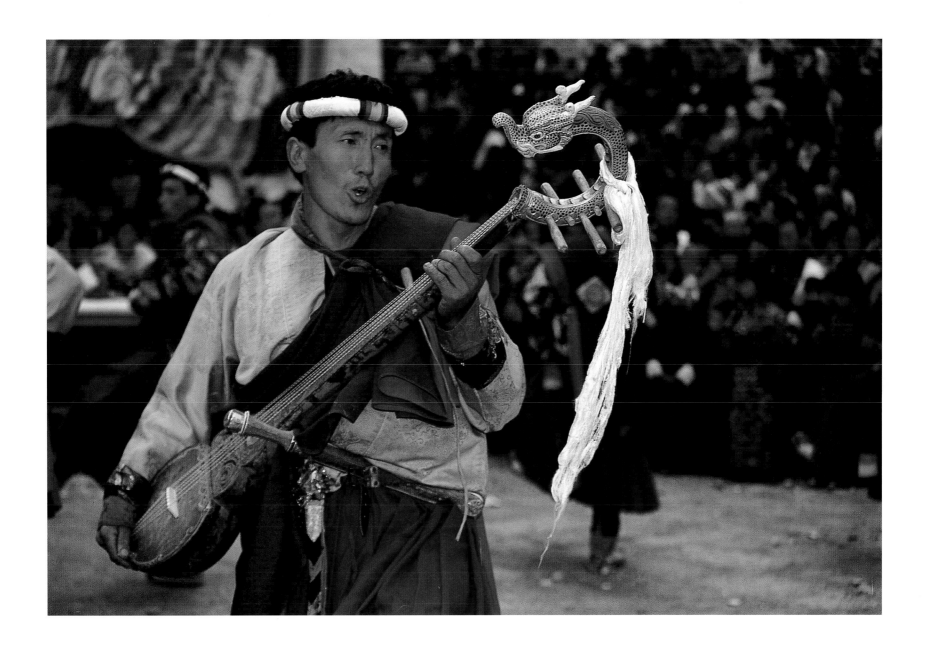

A minstrel with a *dranyen,* a stringed instrument, at the Paro Festival.

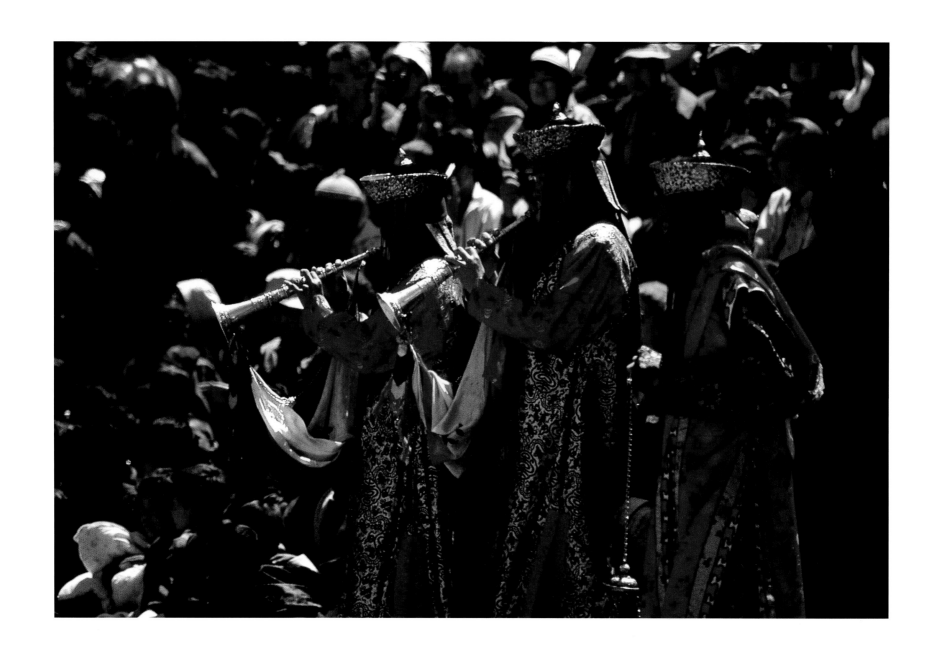

Heralds blowing their horns to purify the path, at the Paro Festival.

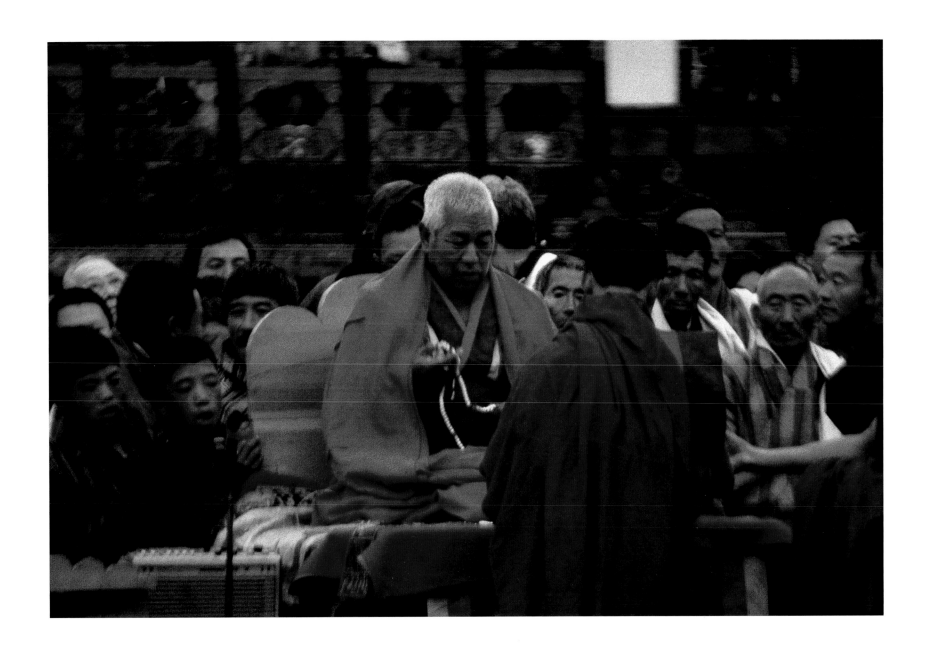

The Paro Dzong head abbot.

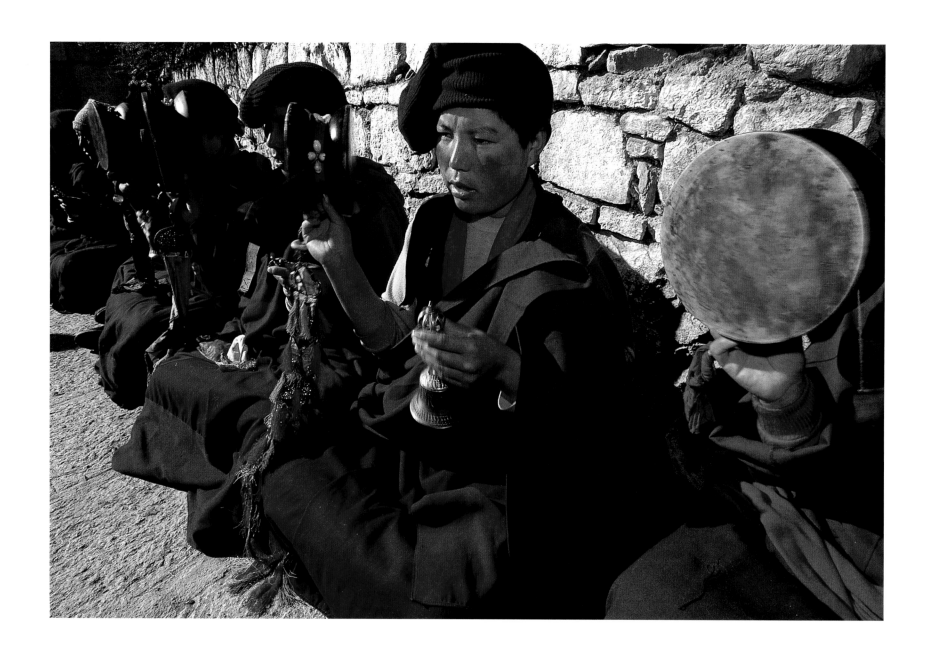

Nuns at the Drepung monastery, Lhasa.

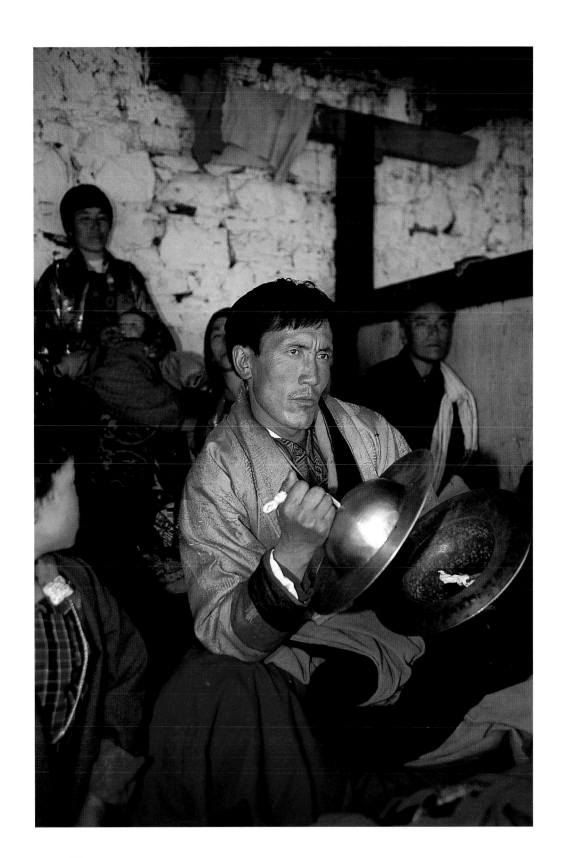

Paro Festival.

Paro Festival.

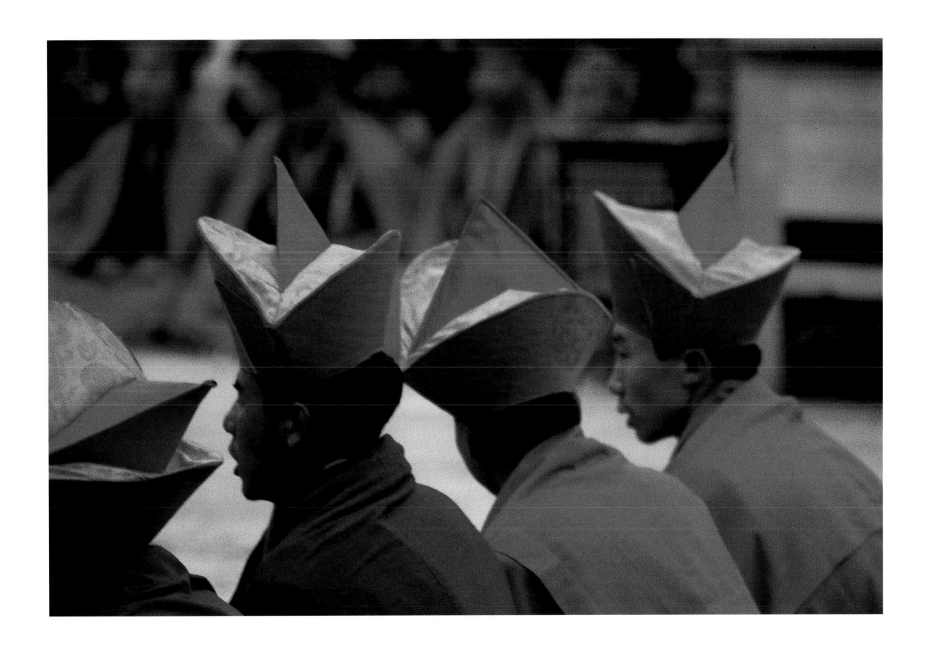

Paro Festival.

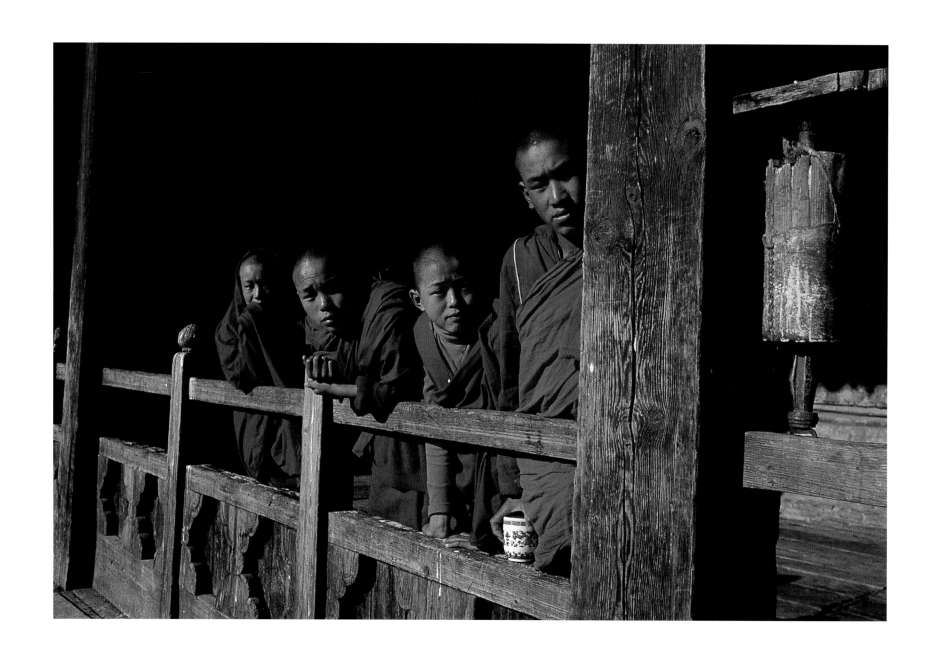

Novices at Gantey Gompa, Bhutan.

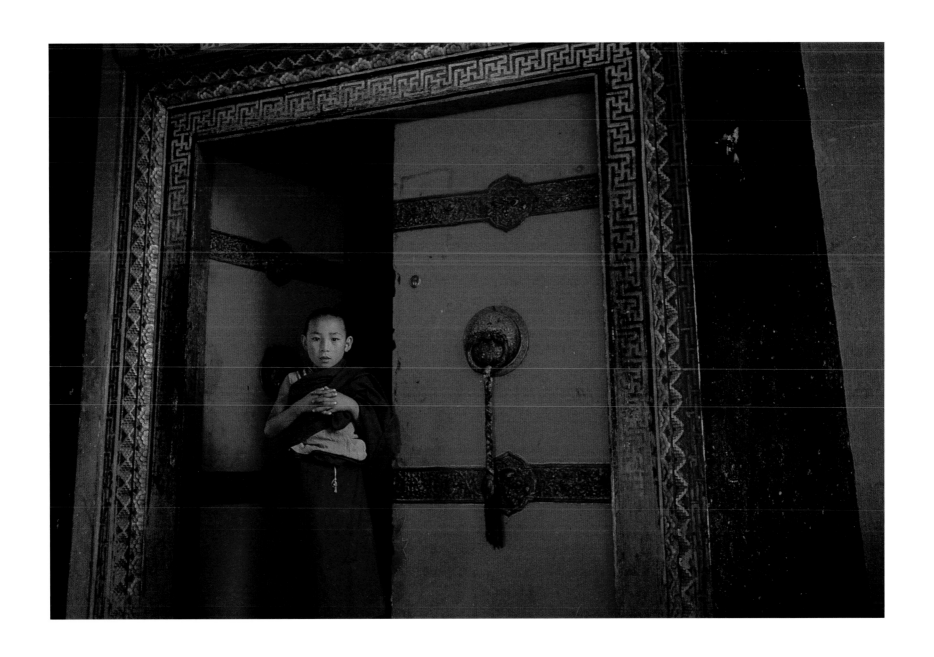

Shechen Tennyi Dargyeling monastery, Kathmandu.

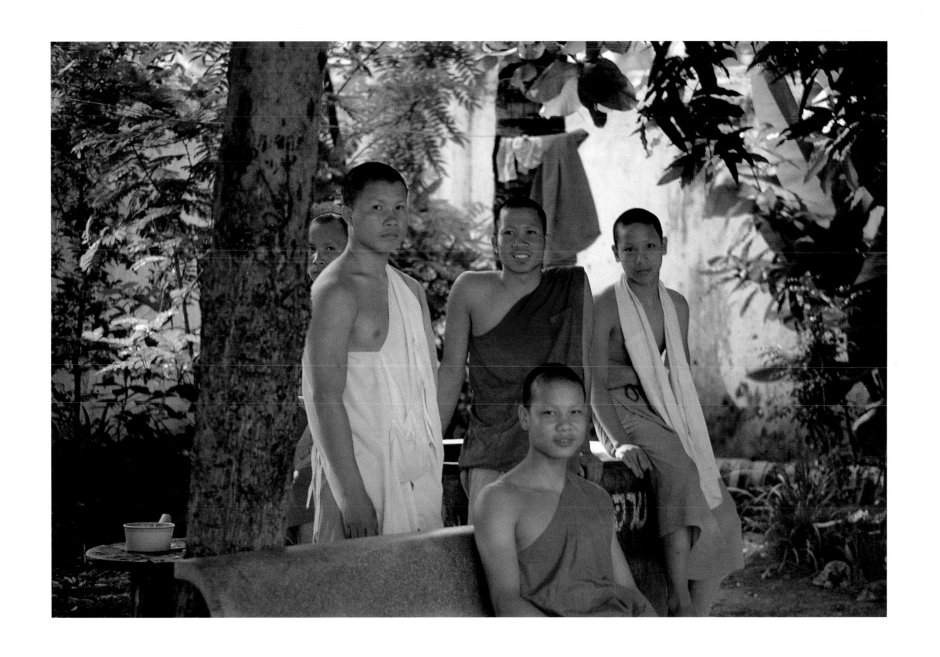

Monks near Chiang Mai, in Thailand.

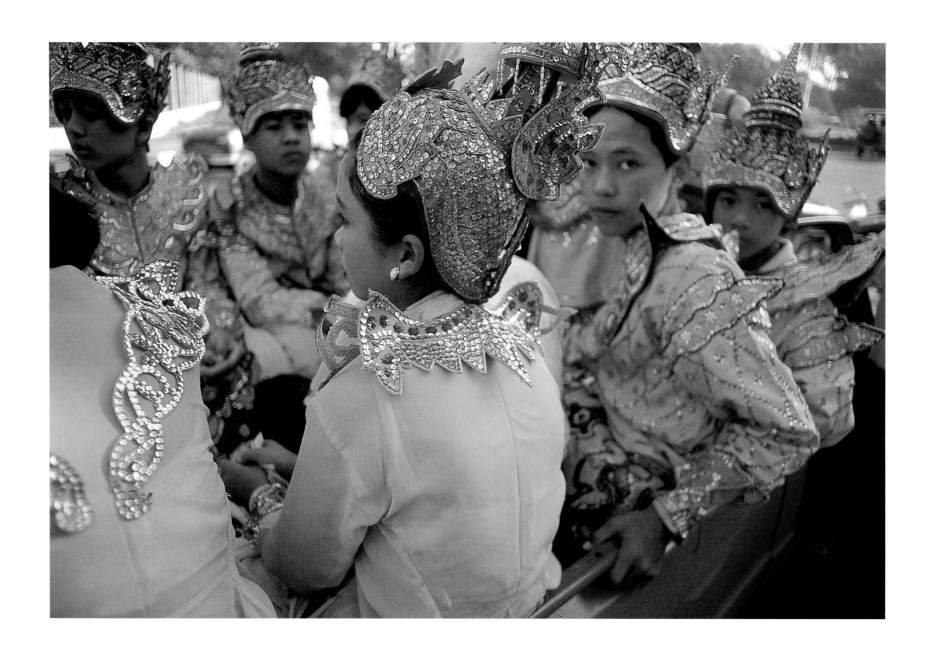

Girls on the way to a *nartha mingla,* ear-piercing ceremony, in Rangoon.

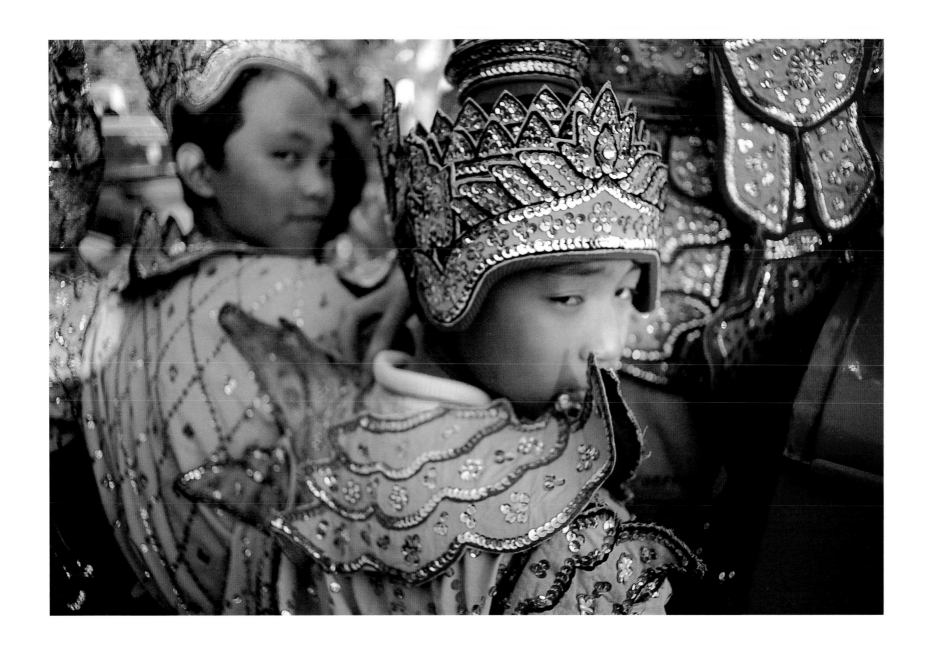

Boys on the way to a *shinbyu mingla*, in which they are admitted to a monastery.

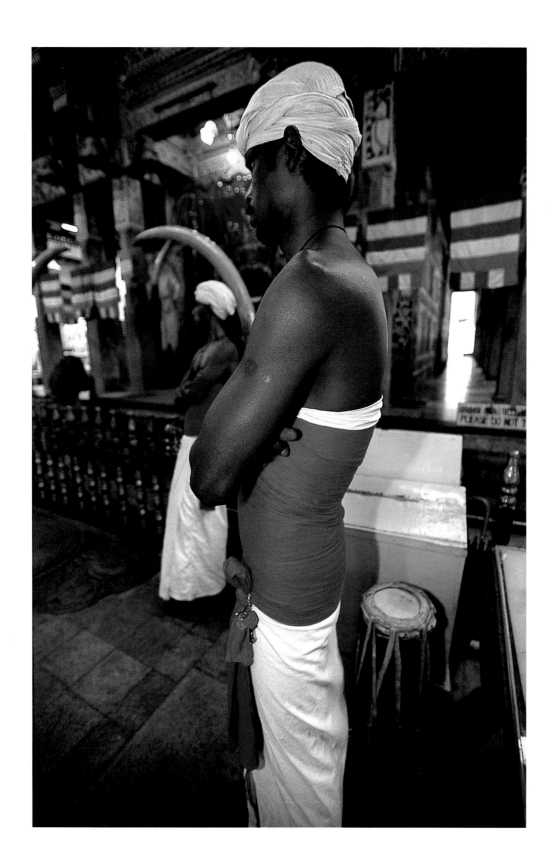

Temple of the Tooth, Kandy, Sri Lanka.

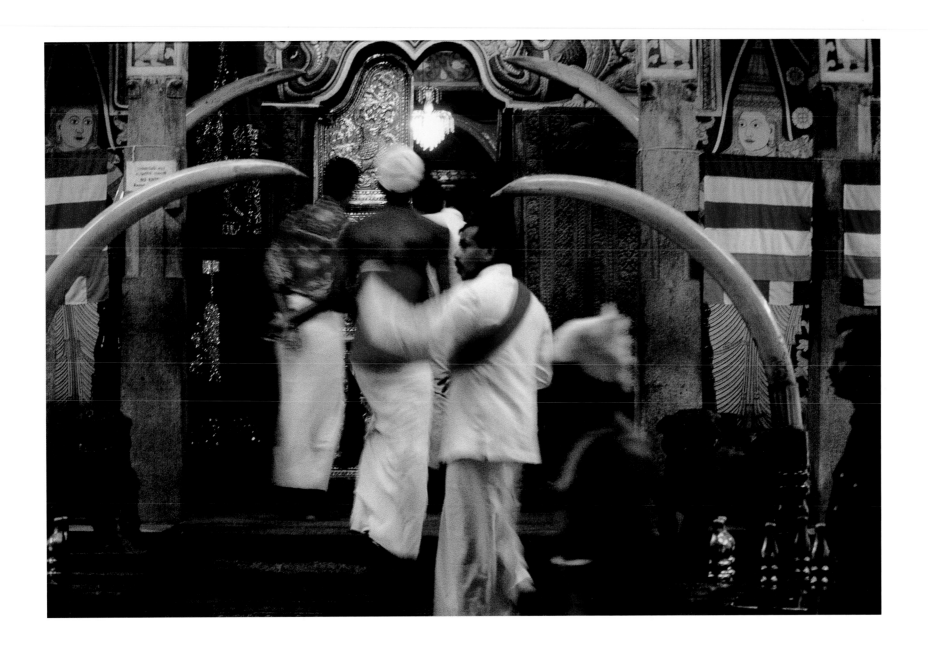

The silver doors lead to the room that houses the tooth relic.

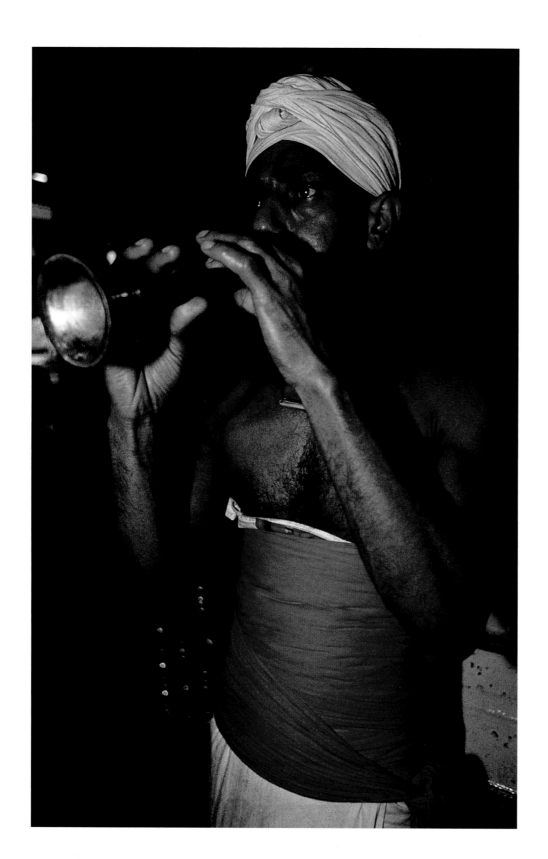

Temple of the Tooth, Kandy, Sri Lanka.

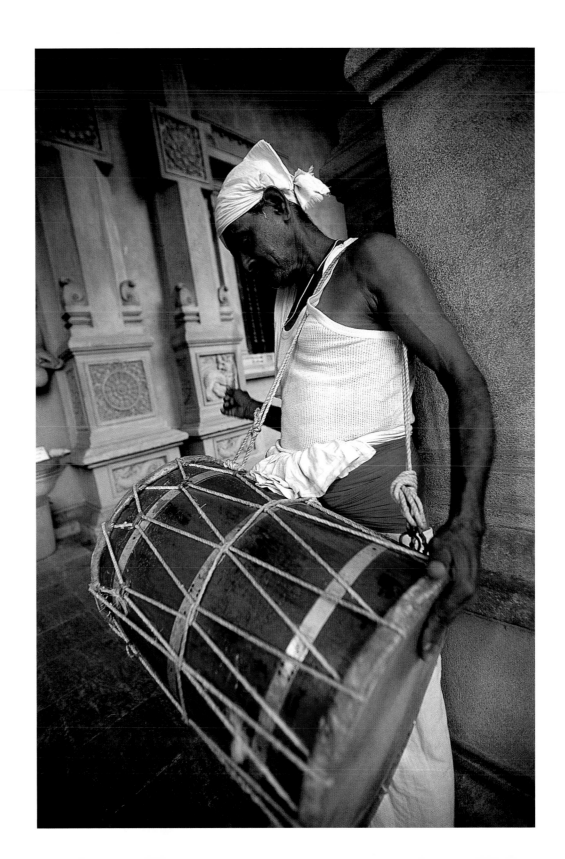

Rajamaha Vihara, in the Kelaniya District,
near Colombo, Sri Lanka.

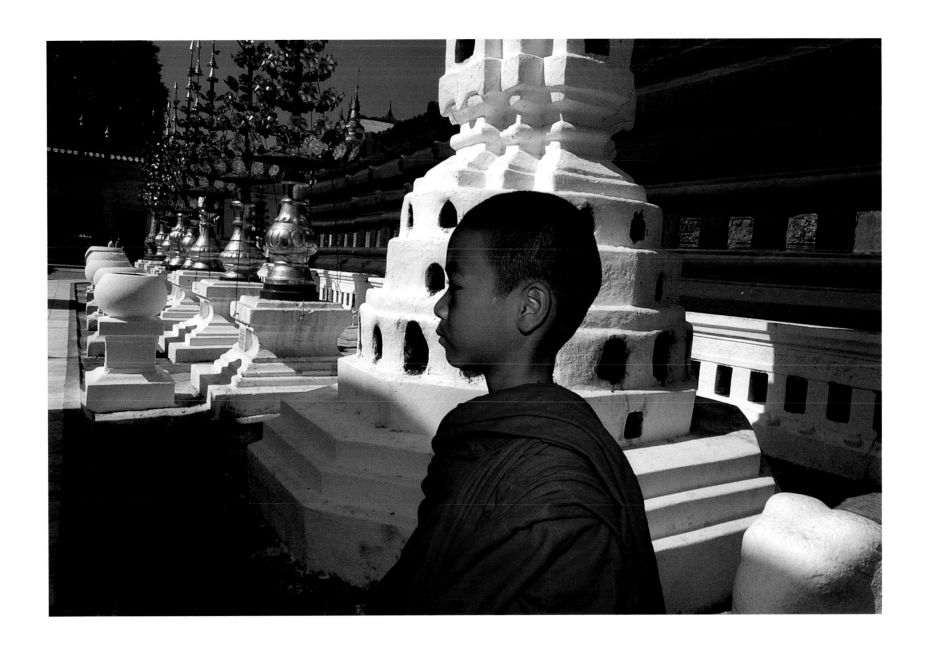

Novice at a shrine near the Irrawaddy River in Myanmar.

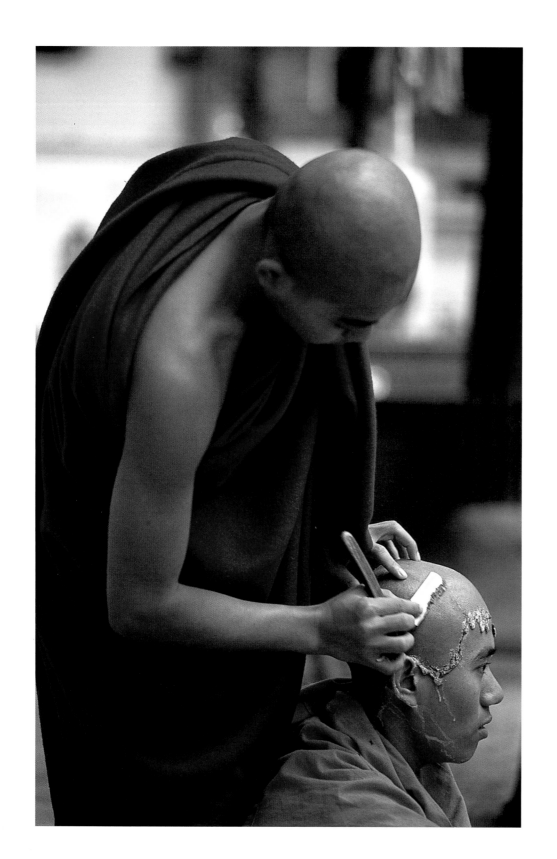

Head-shaving is an expression of humility and
detachment from the world.

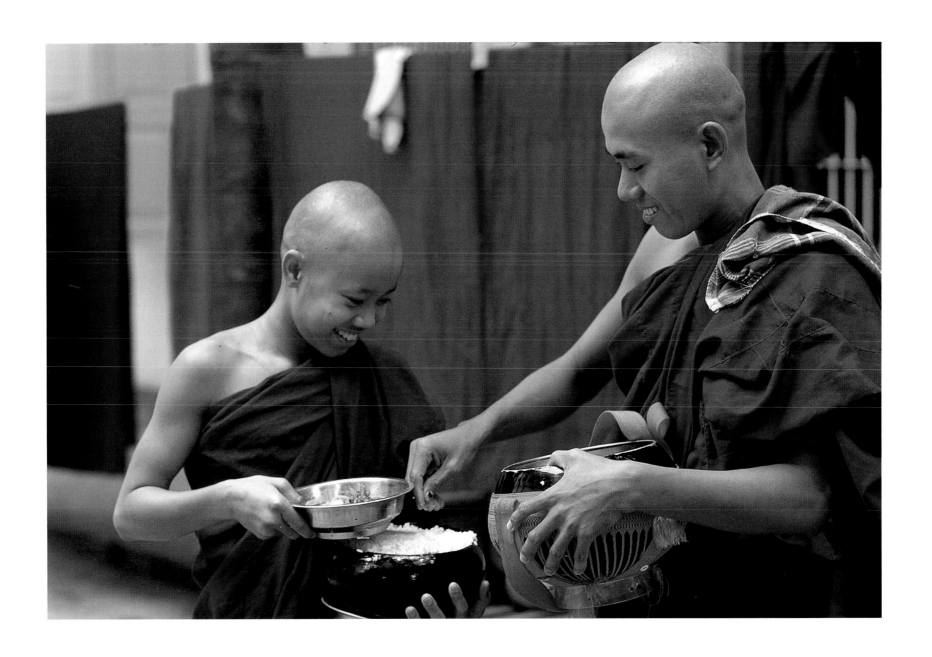

Monks sharing food in Rangoon.

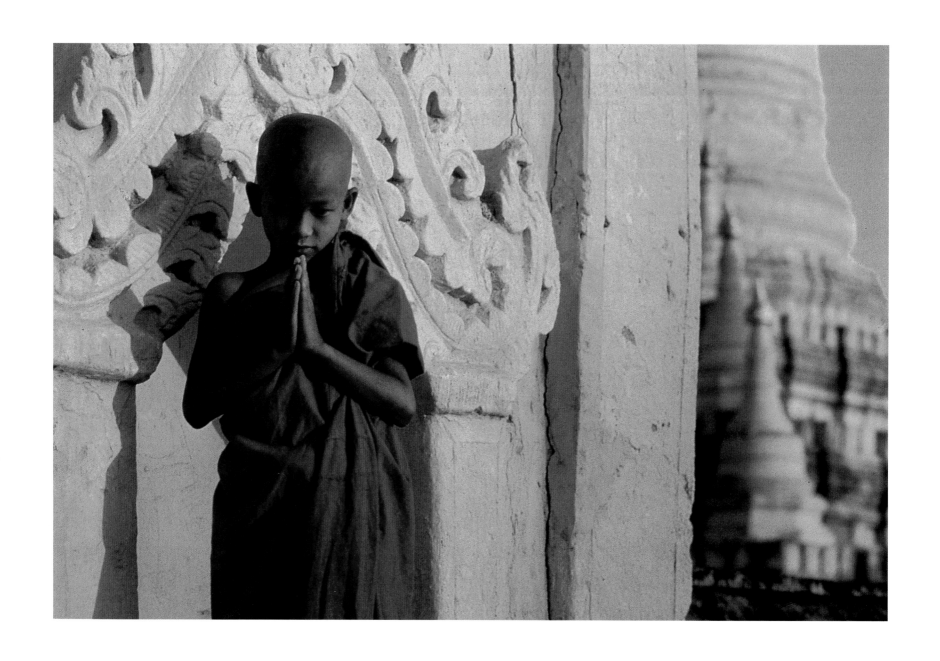

Dusk in Pagan. Myanmar was known as "Burma the Golden."

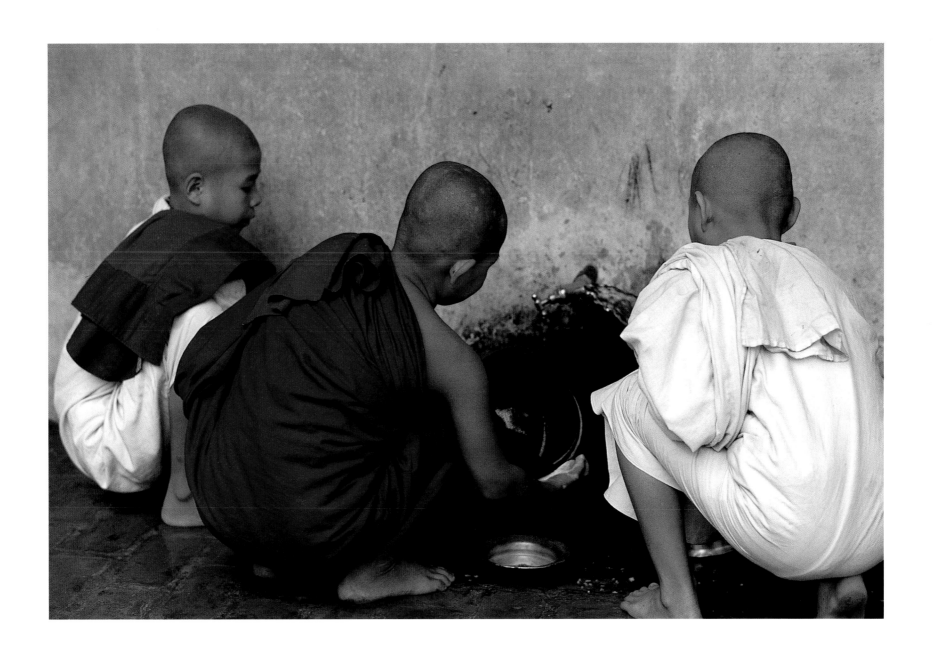

Young monks washing a pot at a monastery near Rangoon.

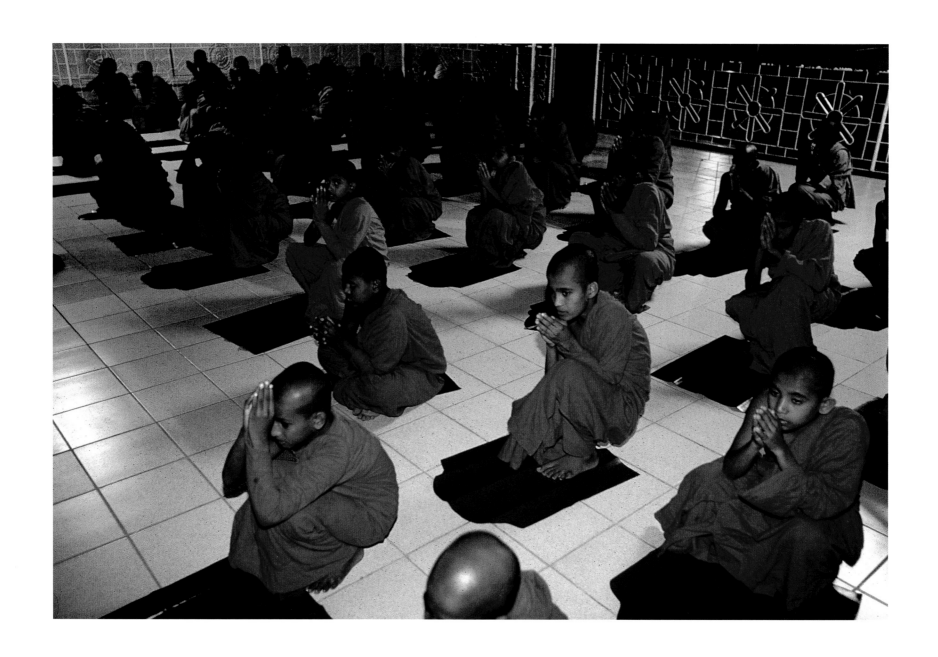

Sri Sarananda monastery, near Anuradhapura, Sri Lanka.

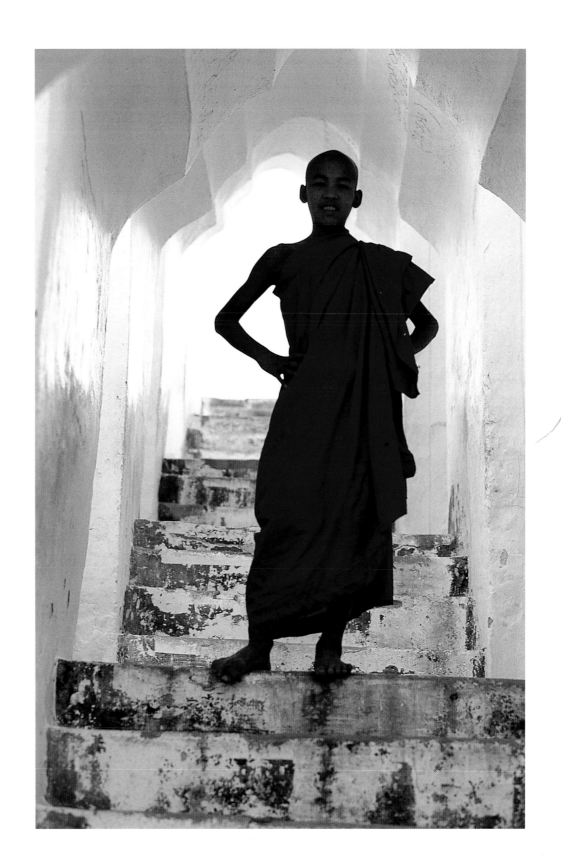

Young monk in a temple on the shore
of the Irrawaddy River.

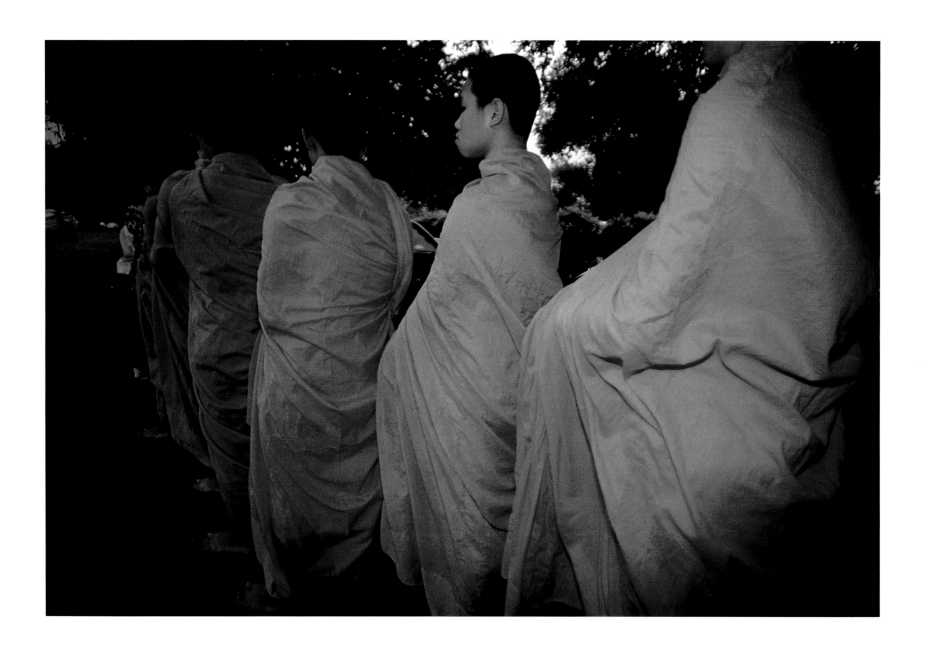

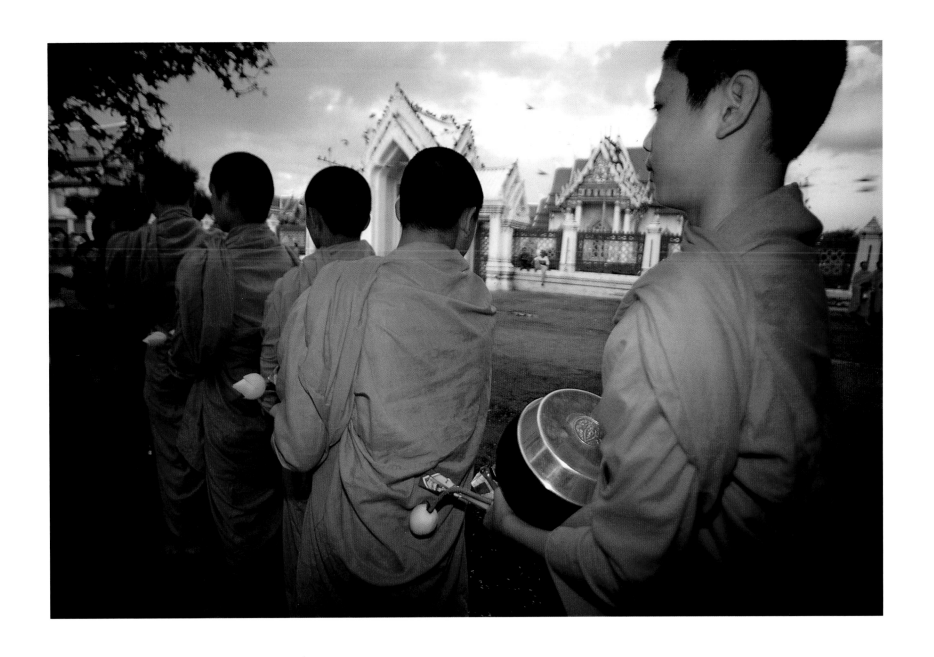

Monks in Bangkok file out to collect food at dawn.

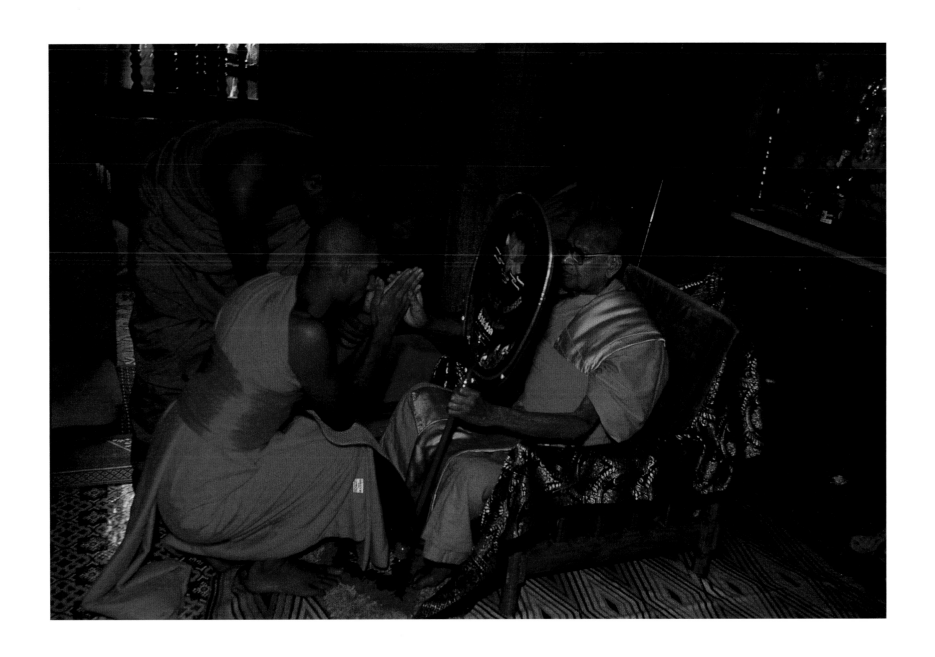

An ordination ceremony at the Gunaratana Chandananda Temple in Sri Lanka.

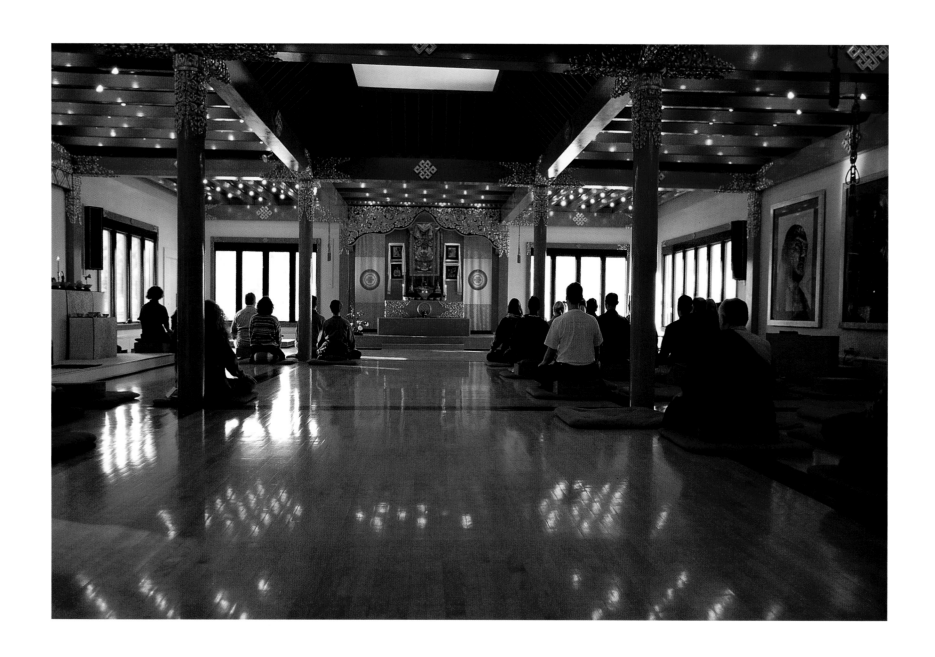

Main meditation hall, Karme Choling Buddhist Meditation and Study Center, Barnet, Vermont.

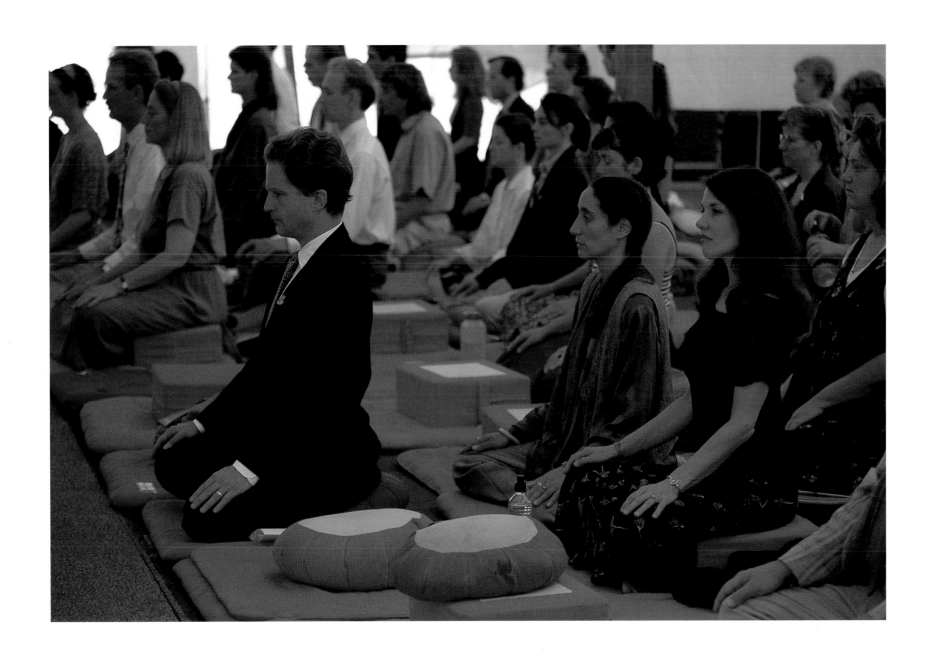

Rocky Mountain Shambhala, Red Feather Lakes, Colorado.

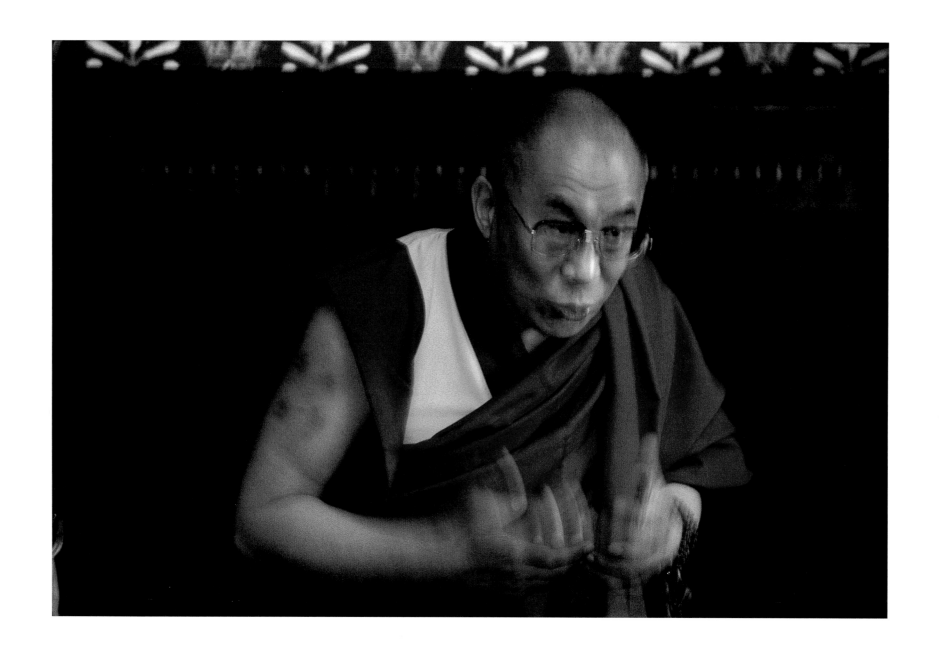

His Holiness, the Fourteenth Dalai Lama, addressing Parliament in London.

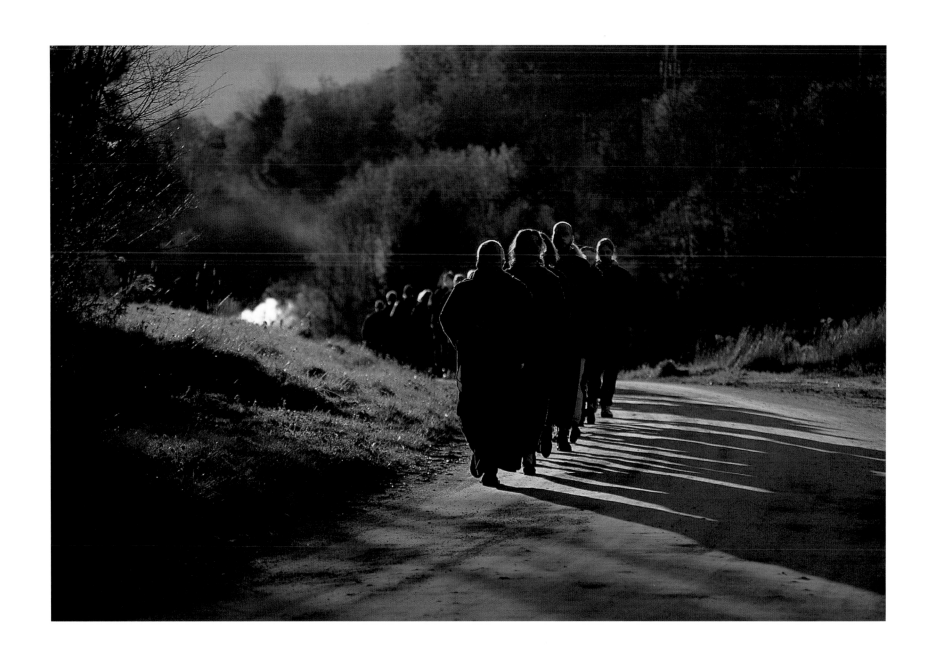

Early morning meditation walk, Karme Choling, Barnet, Vermont.

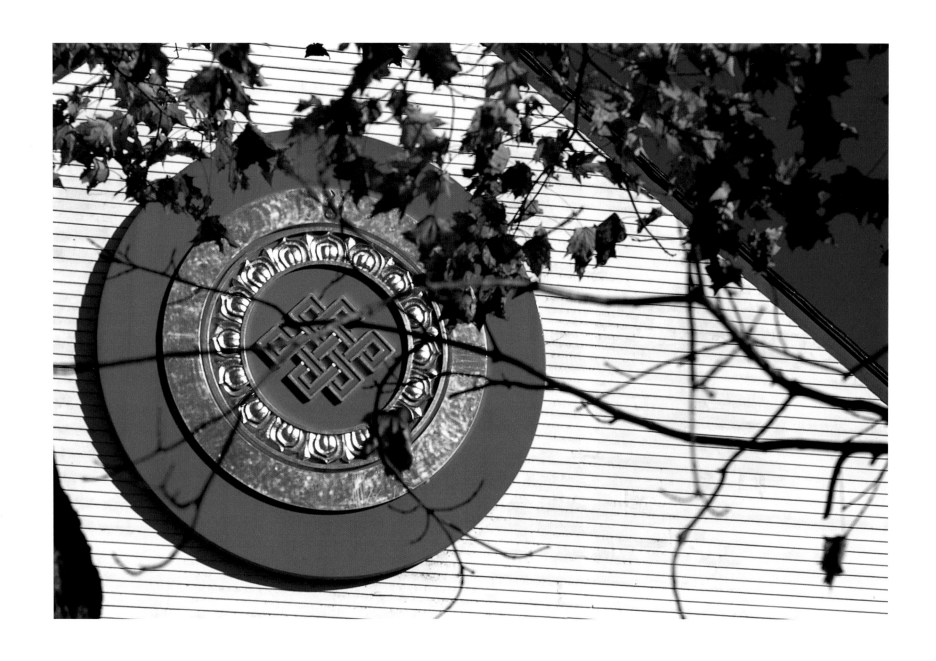

The knot of eternity, Karme Choling, Barnet, Vermont.

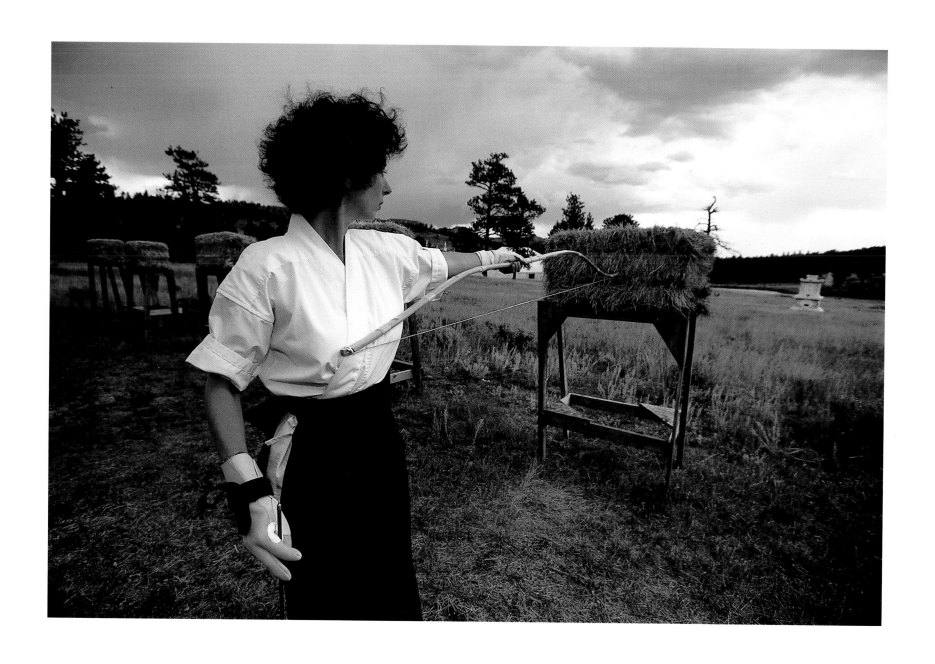

Kyudo archery, "the Zen Buddhist Way of the Bow," Rocky Mountain Shambhala Center, Red Feather Lakes, Colorado.

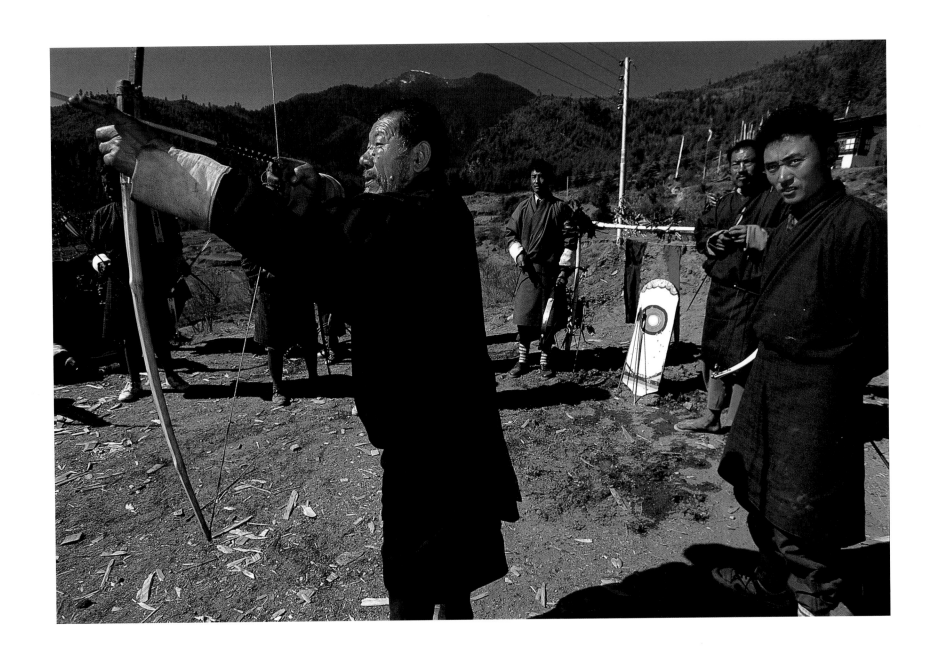

Paro Valley, Bhutan.

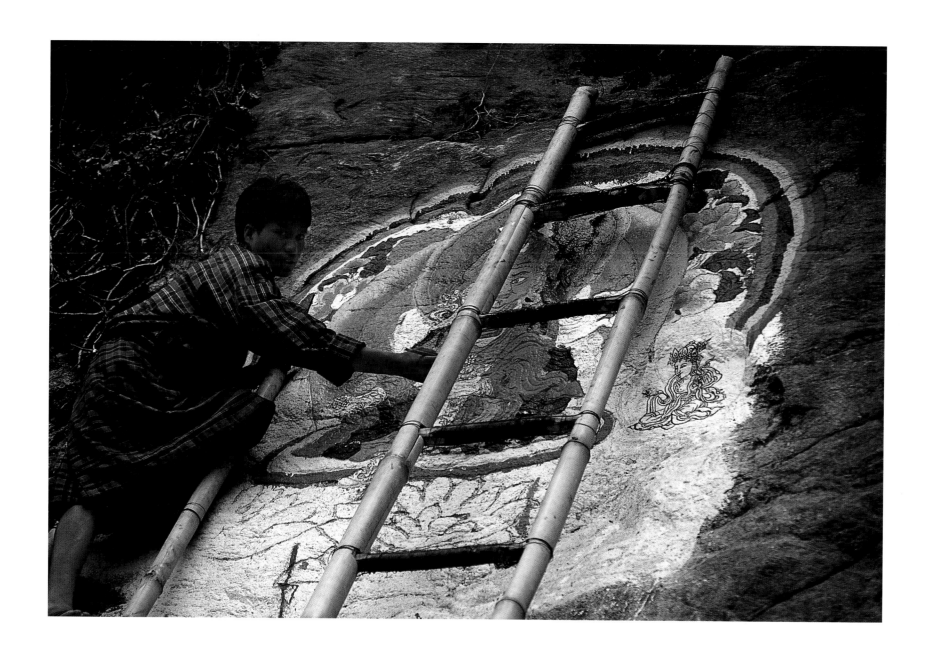

Decorating a roadside in Bhutan with a sacred painting.

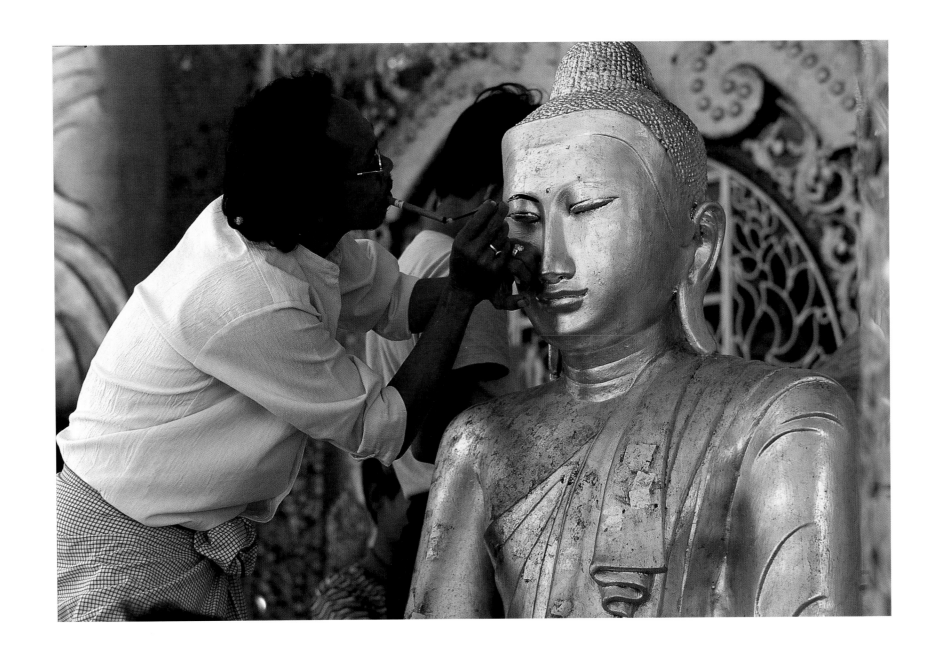

Touching up the Buddha at Shwedagon Pagoda, Rangoon.

A monk at Aluvihare, Matale, Sri Lanka.

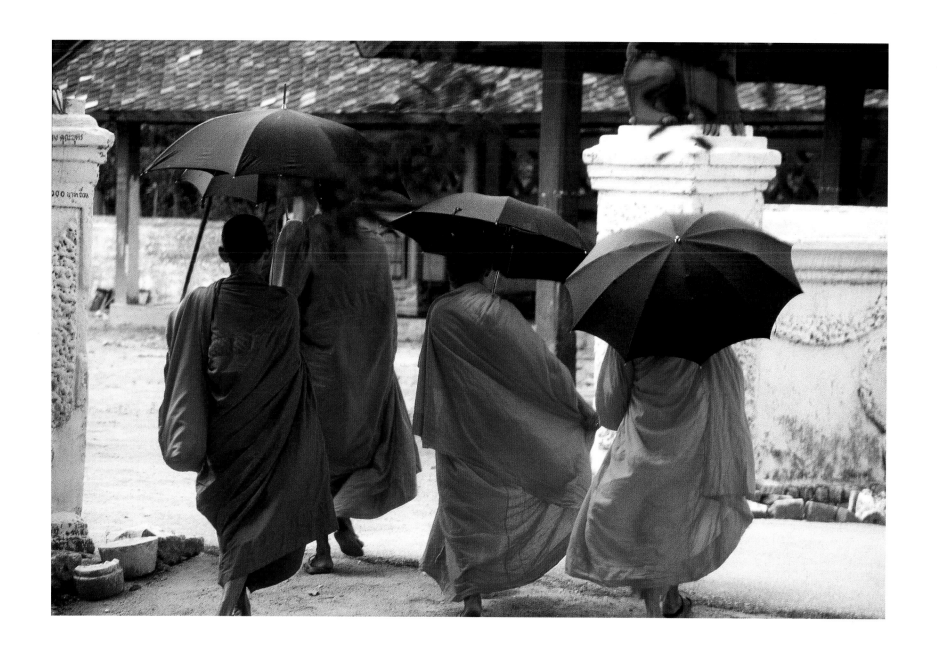

Monks at Chiang Mai, Thailand.

GLOSSARY

BODHISATTVA. Literally, "enlightened being" in Sanskrit. A bodhisattva strives for and sometimes achieves buddhahood, but chooses to teach others rather than enter nirvana. Bodhisattvas are compassionate and altruistic.

BUDDHA. Literally, "awakened one" in Sanskrit. A person who has achieved enlightenment and is released from the cycle of existence. The historical Buddha, Siddhartha Gautama, was born circa 566 B.C. in the foothills of the Himalayas in present-day Nepal. He was the son of a prince but chose to live as a wandering ascetic. When he was thirty-five he realized complete enlightenment through meditation. He spent the rest of his life teaching and died at the age of eighty. His relics are said to have been divided into eight parts and preserved in stupas. Siddhartha Gautama was neither the first nor the last buddha. Various branches of Buddhism accept various numbers of other buddhas in their teaching.

CHORTEN. The Tibetan word for "stupa," a characteristic element of Buddhist architecture. *Chortens* originally housed the remains of saints, but sometimes contain other sacred objects, or they are simply symbolic.

DALAI LAMA. The spiritual and temporal leader of Tibet, a descendant through reincarnation of the head of the Gelugpa, one of the four main schools of Tibetan Buddhism. The dalai lamas have been heads of state since the seventeenth century, when the fifth dalai lama was enthroned. The dalai lamas have also been great scholars and poets. The fourteenth dalai lama has been in exile since 1959.

DHARMA. The central notion of Buddhism. It has several different meanings, but refers in general to the universal truth of Buddhism—the law and the teaching of Buddha.

DZONG. In Bhutan and Tibet, a fortified building that now often functions as a monastery or administrative center.

MANTRA. A syllable or phrase that evokes cosmic forces. Repetition of mantras is practiced as a form of meditation.

SUTRAS. Texts ascribed to the Buddha, through one of his students. They are introduced by the words "Thus I have heard." They are simple in style, and full of parables and allegories.

STUPA. Originally a shrine for relics, stupas are characteristic of Buddhist architecture. The word *stupa* means, literally, "hair knot" in Sanskrit, and is a reference to the circular shape of the base and the spire that extends above it. The pagoda is an East Asian variant of the stupa.

ACKNOWLEDGMENTS

THE LATE PAUL CUSHING CHILD INTRODUCED ME TO THE CAMERA when I was at school at Avon Old Farms, Connecticut. His widow, Julia Child, awakened a curious palate. Harold Evans suggested the theme of this book and was encouraging during the process of preparing it. His wife, Tina Brown, expressed continuing support of the project. Mark Holborn, my editor, is the artistic genius who sorted out several thousand slides and created the scroll-like layout. Bill Mc-Keever of the Asia Society in New York, my closest Buddhist friend, provided the key to important contacts during my travels. He is a man of true tolerance and compassion, and his knowledge of Buddhism is encyclopedic. Sharon DeLano came to the rescue with extraordinary writing and organizational skills. I am grateful for her professional approach, her hard work, and her good humor. The expertise of Noelle O'Connor, professor of Asian art history at the Fashion Institute of Technology in New York, was also invaluable. The photographic workshop courses of my teachers and friends Sam Abell and Galen Rowell, the top photographers in their field, provided both inspiration and practical help. My wife, Dorothy Trimingham, put up with me when we were traveling, kept track of the photographic equipment, wrote copious notes, and was an intrepid researcher. Barrie Van Dyck, my daughter and literary agent, diplomatically guided me through the unfamiliar and sometimes confusing byways of the publishing world.

—deFOREST W. TRIMINGHAM

THANK YOU TO MICHAEL HOFMANN AND MY MOTHER, PROFESSOR Nandini Iyer, for giving wonderfully inspired and informed readings of my introduction, as wise as they were compassionate.

—PICO IYER

ABOUT THE CONTRIBUTORS

deForest W. Trimingham, C.B.E., was born in Bermuda and was educated at the University of Virginia. He was a member of the Bermuda Parliament for twenty-three years, during which time he served in the cabinet as minister of tourism. He is a well-known international yachtsman. His photographs have appeared in several magazines in the United States and he has exhibited at the Bermuda National Gallery and the Leica Gallery in New York.

Pico Iyer is a longtime essayist for *Time,* whose articles appear regularly in such magazines as *The New York Review of Books, Harper's, Sports Illustrated,* and *Tricycle: The Buddhist Review.* His books include *Video Night in Kathmandu, The Lady and the Monk, Falling Off the Map, Cuba and the Night* (a novel), and, most recently, *Tropical Classical.* He has lived for many years in Kyoto, Japan.